THE OPEN UNIVERSITY

An Arts Foundation Course
Units 16, 17 and 18

Introduction to Art

Prepared by Aaron Scharf and Stephen Bayley for the Course Team

The Open University Press

Cover Frontispiece to Grandville Scenes de la vie privée et publiques des animaux, *1842, in S. Appelbaum (1974)* Bizarreries and fantasies of Grandville, *Dover Publications, Inc.*

The Open University Press
Walton Hall, Milton Keynes
MK7 6AA

First published 1978

Designed by the Media Development Group of the Open University.

Printed in Great Britain by
EYRE AND SPOTTISWOODE LIMITED
AT GROSVENOR PRESS PORTSMOUTH

ISBN 0 335 05416 1

This text forms part of an Open University course. The complete list of units in the course appears at the end of this text.

For general availability of supporting material referred to in this text, please write to Open University Educational Enterprises Ltd., 12 Cofferidge Close, Stony Stratford, Milton Keynes, MK11 1BY, Great Britain.

Further information on Open University courses may be obtained from the Admissions Office, The Open University, P.O. Box 48, Walton Hall, Milton Keynes, MK7 6AB.

1.1

CONTENTS INTRODUCTION TO ART

IMPORTANT NOTE

As you work through these units you will need to consult the set books E. H. Gombrich (1978, or earlier editions) *The Story of Art*, Phaidon and Peter and Linda Murray (1969) *A Dictionary of Art and Artists*, Penguin. You will also need the Colour Supplement, the Supplementary Texts and the reproduction of the Ghent Altarpiece.

The broadcasts associated with these units are television programmes 16, *The Ghent Altarpiece*, 17, *The Natural History Museum*, and 18, *Art and Music* and radio programmes 16, *Donors and Patrons*, 17, *The Houses of Parliament Competition* and 18, *The Florentine Renaissance*.

INTRODUCTORY GUIDE TO UNITS 16-18

Read this before you begin the units.

The principal objective of these three units is to do as it says: to *introduce* you to art or, more precisely, to the variety of styles in the visual arts, and to the theory and methods of the history of art as an academic discipline.

No one, in so short a space and time, could with reason hope to deal in any comprehensive way with even an introduction to so vast a subject and one moreover which is not just historically based but, in its theoretical nature, touches on several other fields of study. Because of this, you shouldn't put your expectations too high, nor should you be unduly concerned if everything doesn't register the first time. Learning and the ability to learn is a cumulative process. In the present climate it is all too easy to fall into the trap of wanting knowledge and understanding to come more or less instantaneously. Nothing worth having comes easily, and the study of art history (a term of convenience for what in practice is much more than history), no less than other areas of study, must be allowed to 'ripen' in the mind as one's general experience grows. That takes time.

Art history is, in a way, a deceptive study. For it is all too easy to think that 'just looking at pictures' is not only a pleasant and relaxing way of spending one's time, but that it can't really require much hard work. Nothing is further from the truth. But such an attitude does rather account for an army of pundits who write and declaim about art but whose acquaintance with art history is often very superficial.

The main categories to be investigated in Units 16–18, *Introduction to Art*, are set out in the contents lists. The constituents of each are also given. *If you have not yet looked at these lists you should turn to them now (pages 9, 63 and 135).*

In introducing art to you our further aims when writing these units have been as follows:

1 To use examples of art from many diverse periods and places.

2 To go beyond painting, sculpture and architecture where feasible and bring into the context of our discussion prints, drawings, photographs, pottery and other kinds of visual art. The emphasis, however, remains on painting and architecture.

3 To follow the course team's instructions and favour examples from the Renaissance and from nineteenth-century Europe.

4 To anticipate later courses presented by the Faculty as multidisciplinary studies and those which are specialist in art history.

5 To concentrate on one work of art in a more detailed way: the *Ghent Altarpiece.*

6 To incorporate some element which is interdisciplinary in character in these units. This will be found in a few of the broadcasts and in the first part of Unit 18 where the psychology of perception is coupled with art history and theory. The aim here is to explore the relationship between the eye and brain particularly as it pertains to art.

7 To remind you, where relevant, of related aspects of the discussion with which you will have dealt earlier in the course – to alert you to the interdisciplinary nature of various elements of the course.

8 To exercise you in the analysis of visual works of art. This is a skill which can be developed. We attempt to do this in a concentrated way in the final section of the units. There, the material is presented as sets of illustrated works of art to

5

compare. Each set is based on one of the major categories of visual form: line, shape, tone, colour, space, movement, in that order.

Now, to ease your mind, a word of warning. It is not usually our intention to elicit from you in the self-assessment questions or exercises answers which conform to our own. In many, if not most, cases no single answer is the correct one. This is art, not mathematics! Indeed, it is perfectly possible that your answers may be more perceptive than ours. What we want from you essentially is careful thought and then commitment. For we believe that only by declaring yourself (even to yourself), whatever the nature of your answer, you thus prepare yourself for greater sensitivity and understanding later. Learning, surely, cannot really proceed unless we are willing to stick our necks out and risk making mistakes.

Many, though not all, artists referred to in these units are included in the Murray *Dictionary of Art and Artists*. Consequently we will often mention them without providing much biographical data. We feel there is a positive value in requiring you to look them up yourself, for in addition to the specific information you will obtain by consulting Murray, there is always the advantage, in browsing through dictionaries, of finding useful material accidentally and in a pleasantly casual manner, and of giving a free flow to the imagination. Moreover, many terms describing artistic techniques or different characteristics of form[1] are included in Murray and you should also use the *Dictionary* to enlighten yourself about them.

The Gombrich set book poses a problem. At the time of writing we learn that *The Story of Art* will later be going into its thirteenth edition. Several, if not all, previous editions have been revised or 'enlarged and redesigned', with pagination and even illustrations changed. You may yourself own one of the earlier editions! It thus becomes difficult, if not impossible, to prepare a concordance of all the editions especially without the thirteenth in hand. So please bear with us if the references we make both to text and illustration in this book are somewhat general in nature and do not specifically point to page and figure numbers. It is as well also to keep in mind that the quality of colour reproduction varies considerably from edition to edition. To take an example: Holbein's portrait of the German merchant in London, Georg Gisze, appears in the eleventh edition (hardcover) with a predominantly green cast (at least in the copy I've consulted), though with the forms in areas of shadow quite clearly legible. But in the twelfth edition (paperback) the cast is decidedly red with many objects in the darker areas of the reproduction obscured. This kind of problem is, regrettably, universal in reproductions of works of art, and in that respect at least, there is no substitute for the real thing. Nevertheless, despite this fault, we are convinced that *The Story of Art* is unique among its kind and we recommend that you make as liberal a use of it as time and inclination permit.

Before you start Part 2 of Unit 16 'What is Art History?' you should read Gombrich's chapter on 'The Conquest of Reality'. It gives a stimulating account of the background to and the development of painting in the fifteenth century. It is also quite handy for looking up illustrations of work by artists mentioned in the text, although you should not expect to find an illustration of everything you want.

We would even go further and say that it would be greatly to your advantage if you'd put these units aside for a day or two and read right through *The Story of Art* or, at least, thoroughly acquaint yourself with its general structure and with its illustrations. If time is really short, then read the Introduction, and the chapters on the Renaissance, particularly 'The Conquest of Reality' and 'Harmony Attained'. Also, to become more familiar with the nineteenth century, read 'The Break in Tradition', 'Permanent Revolution', and 'In Search of New Standards'.

[1]'Form', used as a general term in art, refers to all those constituent parts which combine in some artistic composition, e.g. colour, line, shape, tone, the use of space, and many other pictorial or sculptural devices.

Those five chapters amount roughly to 128 pages or one-quarter the length of the book. While reading Gombrich you should keep the following two questions in mind:

1 Why do styles in art change?
2 How does one describe a work of art?

If you have time you will also find it useful to read the selection from the writings of Erwin Panofsky which are reproduced in the Supplementary Texts, but do not worry if you find them very difficult and disconcerting at this stage.

The recommended reading lists given after each unit are what they say, 'recommended', and not required reading. You must use them at your own discretion. Similarly, works referred to in the units may be consulted with regard to your special interests and the time available – and, of course, to the library facilities open to you. But there is no requirement that these be pursued.

We hope the material of the units will stimulate you to take advantage of the permanent collections of art in your region and of temporary exhibitions as they occur. It would be misleading and romantic to insist upon it, for confronting an original work of art is not necessarily a more rewarding experience that that you get from a book. But it can be a rich and very different kind of experience, its substance of quite another nature from art book art – but your experience will depend largely on what you bring to it.

UNIT 16 WHAT IS ART? WHAT IS ART HISTORY?
CONTENTS

PART 1 WHAT IS ART?

1 INTRODUCTION: WHAT ISN'T ART?

What isn't art? The question is a deceptive one. For implicit in it are a complex of further questions which ought at least to be asked. Even if no complete answers are possible, we can learn much from speculative activity, by the very kind of questions we pose: 'What is the nature of the creative process?'; 'What is the character of the object called a work of art?'; 'What is the quality of the spectator's response to a work of art?'. Moreover, we can pursue these questions even further: 'Does a work of art have to be created?' Or can it be found in nature, an evocatively shaped stone, for example, or a piece of driftwood – the kind shown in the painter Paul Nash's photograph reproduced here (Figure 1). No doubt its 'artful' qualities made him wonder whether this too was a work of art. Another example. Can a strictly utilitarian manufactured object become an object of art as in this bottle rack (Figure 2)? It was treated by the artist Marcel Duchamp if not as a work of art, then as a vehicle for questioning the traditional concept 'Art'. Thus a further question arises: 'Is something a work of art because an artist says it is?'. Jasper Johns' bronze copy of two beer tins (Figure 3) may not have been designated as 'Fine Art' by the artist, but despite the mundane subject it was rendered as art, and has been treated as art, exhibited, coveted, and sold for a substantial sum of money. Is it an art object because it was made by the artist so that the signs of the hand are evident? Is it because it is cast in bronze, a material which traditionally has associations with the art of sculpture? Could Johns have declared an actual tin of beer to be art and would it have been so if it had been exhibited, sold and placed in some famous gallery – that is to say,

Figure 1 Paul Nash, Monster field, 1938 (Photo: Tate Gallery, London).

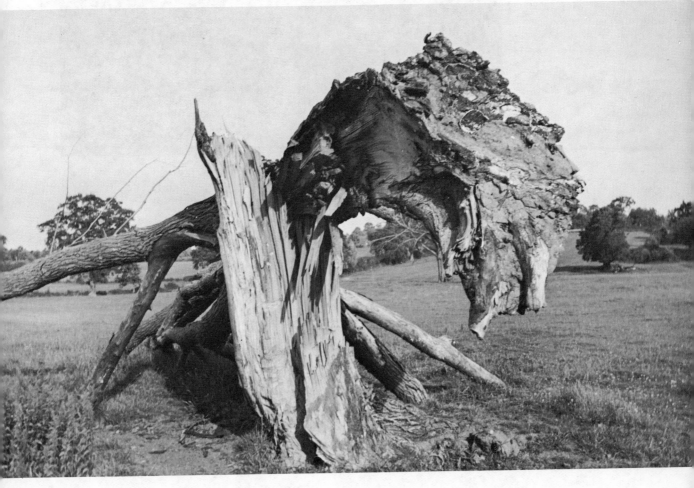

11

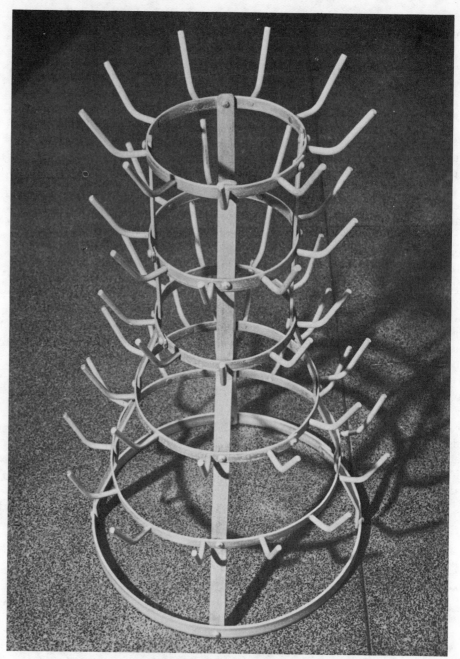

Figure 2 Marcel Duchamp, Bottle-rack, 1914 (Arturo Schwarz, Milan).

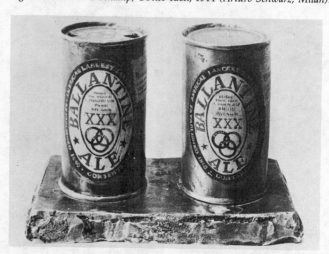

Figure 3 Jasper Johns, Painted bronze, 1960, 4¾ × 5½ × 8 ins
(Photo: Leo Castelli. Reproduced by courtesy of Jasper Johns and Dr
Peter Ludwig, Aachen).

enveloped in an aura of art? What if you are not an artist? Can you yourself decide what is or what is not an object for admiration? How justifiably can I argue with you if you insist on that vexing cliché: 'I don't know anything about art, but I know what I like!'? And might you not also get back at me by producing the equally vexing statement spread about to denigrate the historian and theoretician of art: 'I know everything about art, but I don't know what I like!'? So, it is possible that the spectator too has a say in what is and what isn't art, not to mention the role of museums in that respect. Indeed, some philosophers concerned with aesthetic theory worked more from the viewpoint of the spectator than from that of the artist or the work of art itself.

Here is yet another irksome question about the meaning of art: Does an artist have even to *produce* some tangible object to create art? Cannot art exist in the mind alone? I do not say this facetiously, for just preceding the high period of Romanticism at the beginning of the nineteenth century, the idea was expounded in Charles Nodier's *Peintre de Salzbourg* of 1803 in which the tragic hero, Charles Munster declares that there is no need to produce any work of art, as his genius rested on sensibility alone. Indeed, there are close parallels with this in contemporary art today. I am thinking of the various species of 'conceptual art' in which the physical element is minimized, virtually eliminated, the communication of the idea dominating. Hence the deliberate and calculated triviality in the token object or message actually presented (Figure 4).

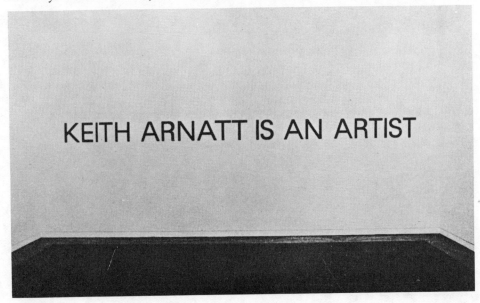

Figure 4 Keith Arnatt, Wall inscription, Tate Gallery Exhibition, *1972.*

What can be said about the meanings given historically for the word 'art'? Some societies, primitive societies especially, had, and in some cases still have, no word for art as we understand it. That of course went a long way in obviating the kind of philosophical dilemmas which for generation upon generation have, in Western cultures, preoccupied artists and aestheticians alike. Even when the word 'art' itself was in popular currency, it meant different things at different times. R. G. Collingwood in *The Principles of Art* discusses the word *ars* in Greek and Roman antiquity, a term which designated a craft or a variety of skills. Thus a blacksmith or a surgeon or a boatbuilder might all three be thought of as 'artists'. Even poetry was included under the umbrella of crafts:

> It is difficult for us to realise this fact, and still more so to realise its implications. If people have no word for a certain kind of thing, it is because they are not aware of it as a distinct kind. Admiring as we do the art of the ancient Greeks we naturally suppose that they admired it as a kind of art, where the word 'art' carries with it all the subtle and elaborate implications of the modern European aesthetic consciousness. (Collingwood *The Principles of Art*, 1970 edition, page 6.)

13

In mediaeval European society, the Latin term *ars* applied at least as much, and possibly more, to intellectual activities including grammar and astrology as to the 'plastic'[1] or graphic arts (i.e. painting, sculpture, architecture, or lettering and manuscript illumination). In much of the Renaissance, artists belonged to the same guilds as barbers and surgeons – the last two not infrequently embodied in the same person. We have only to read Cennino Cennini (see Murray, *Dictionary of Art and Artists*) to gauge the degree to which the tradition of craftsmanship still dominated in all the visual arts during the early Renaissance. Indeed, many Renaissance artists known to us as painters or sculptors, worked in several other media: goldsmithing, theatrical design, the design of military fortifications, etc. But all this changed. Jumping ahead to the late eighteenth century a more categorical distinction finally emerged which held up two species of arts: 'Fine' art, predicated on the idea of 'beauty' and 'Useful' art based on the crafts.

In the last hundred years the whole issue of what is and what isn't art has become thoroughly ambiguous. For the egalitarian mood of the period has tended to undermine the pedestal on which 'High Art' stood while elevating the position of the lowly utilitarian arts. Moreover, to complicate things further, early in the present century a movement in art was gathering strength which perversely flew the flag of 'anti-art', while at the same time it willingly reaped all the benefits bestowed traditionally on 'High Art'.

[1] A term referring to the substantive (or palpable) quality of the medium as in painting and sculpture.

14

2 THE ORIGINS OF ART

Before we examine some of the questions about the probability of a fundamental creative drive in humans (a 'necessity' for art) and its manifestations in early human societies, I'd like you to re-read Arnold Kettle's discussion, 'The Artist and Society' in Units 1 and 2A, *An Introduction to the Study of the Humanities* (pp. 31–8). This should be a valuable exercise as it prepares the ground very well for the section on origins here by placing the activity we call 'art' in a many-faceted cultural context.

In trying to find some answer to the question 'What is art?', it has been considered advantageous to seek for it in the origins of art; in the paintings, engravings and sculpture of the palaeolithic cave-dwellers; in the designs of primitives, in the drawings of children – even in the simple graphic fumblings of anthropoid apes. But still, no easy or conclusive answer to the question has been found. Perhaps it never will be found? Perhaps it is better that way? A number of stimulating and intriguing arguments, often contradictory ones, have been rolled out of the intellectual armouries of archaeologists, cultural anthropologists, psychologists, philosophers and art historians. Though this interminable conflict has produced no victors, it has nevertheless provoked serious and subtle thoughts about art.

The propensity for turning to apparently simple societies, or to the untutored, has gained momentum since the last quarter of the nineteenth century. At the same time public and private collections of primitive art have been amassed, there have been exhibitions of such art in Europe especially, and increasing importance has been attached by art critics to anthropology and psychology.

One controversy over the origins of art focuses on the work of palaeolithic cave painters and sculptors active from 10000 to 20000 years ago. Had the highly naturalistic style of the cave artists evolved intellectually from abstract and geometrical beginnings, or were the first graphic signs already an intuitive but undeveloped form of naturalism, stimulated possibly by structural accidents in rock forms suggesting the shapes or contours of animals and other natural objects (Figure 5)? Was there in the caveman, and is there in us, some 'will to

Figure 5 Cave wall with sculpted forms. Relief of a reclining woman at La Magdeleine, Tarn, France, c. 12 000 BC (Yan (Jean Dieuzaide) Toulouse).

form', some compulsive need to impose a structural organization on our perception and representation of natural objects? Is there some inner force at work in the higher primates, removed from obvious biological necessities, to arrange, to embellish, to wring order out of chaos?

That view, though expressed here in a conveniently simplified way, was held by the distinguished art historian Alois Riegl and expounded in his book *Stilfragen (Questions of Style)*, 1893. Here, naturalism was given primacy. Conversely, it was later argued by Gottfried Semper in 1860 (*Der Stil in den technischen und tektonischen Kuensten, Style in the Technical and Tectonic Arts,* i.e. crafts), that the beginnings of art lay in the abstract visual forms which presented themselves out of the material and structural necessities of the crafts, and that an imitative naturalism slowly evolved from that through a series of technical and pictorial refinements.

Was it possible then, that, without any apparent antecedents in an abstract, non-naturalistic art such as we find in modern primitive societies the palaeolithic cave-painters could have arrived at the considerable technical competence and visual understanding required in the execution of their highly naturalistic works (Figure 6)? There is little to show that the artists of Les Eyzies in south central

Figure 6 Engraved figures of ibexes, horses, bears, reindeer at Les Combarelles, c. 1300 BC (Photo from A and G Sieveking (1962) The Caves of France and Northern Spain, Studio Vista, Fig. 16.)

France or Altamira in Northern Spain or any others like them had some foundation in a more rudimentary and non-naturalistic pictographic convention whereby their works could be seen to be the fulfilment of a cumulative tradition of artistic knowledge moving from the general and the abstract to the specific. Nor is there any evidence of a tradition of crafts such as would support Semper's argument.

Figure 7 Stone engraved with deer, Bout-de-Monde, France (copy) Upper Palaeolithic, c. 15 000–8 000 BC (Photo: N. K. Sandars (1968) Prehistoric art in Europe, Penguin, Fig. 15(b) Reproduced by courtesy of G. C. Sansoni Editore Nuova S.p.A., Florence).

Now look and consider the laborious evolution of Renaissance naturalism, that sequence of pictorial discoveries from Cimabue to Giotto through Masaccio to Piero della Francesca and finally to Leonardo, Raphael and Michelangelo (look again at the illustrations of these artists' works in Gombrich). When we do this it becomes increasingly hard to believe that the cave-painter could have burst into full flower without inheriting from his artistic antecedents a whole set of conventions which would enable him to master the techniques necessary to reproduce with such optical accuracy; and to reproduce not only what he had seen at rest, but even what must surely have taxed his vision, the more subtle phases of animal movement (Figure 7).

Often the work of the palaeolithic artist is compared with that of children, sometimes to strengthen the case against the concept of a spontaneous naturalism. Is that really a valid comparison to make? How would one justify such an assertion? I think this kind of comparison has little to recommend it. The palaeolithic artist was very likely engaged in a magical act (hence the secrecy of the ritual deep in the cave) in which accuracy of observation and representation was imperative, for life itself depended on it. It is possible that the success of the hunt was thought to be preordained by its fulfilment in art (Figure 8). But the child, with far less urgency, is most often concerned with conveying sensory experiences and need not consult nature beyond those images already seen and stored away in the memory (Figure 9).

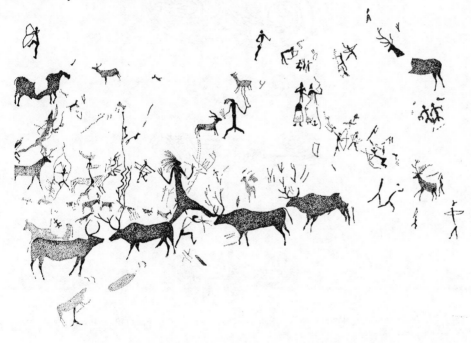

Figure 8 Animals and hunters. Paintings at Alpera, Albacete, Spain. Mesolithic, c. 8000–2000 BC (Photo from N. K. Sandars (1968) Prehistoric art in Europe, Penguin, Fig. 35).

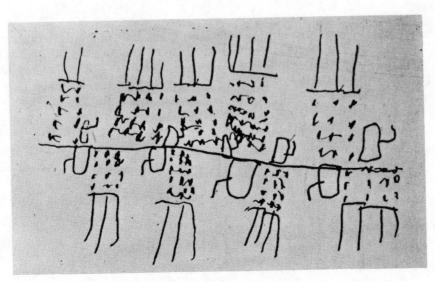

Figure 9 Child's drawing representing a street.

Is it conceivable then that given certain extremes in social conditions a full-blown naturalistic art can emerge within the space of a few generations without any technical or visual precursorship? It is strange, we must admit, that evidence of such a precursorship is so lacking. But then in those great expanses of prehistoric time with technological innovation a rare and infrequent occurrence, it is possible, I suppose, that the earlier artistic models simply disappeared, buffeted or pulverized by climatic and geological upheavals.

So the question remains: was art, or is art, essentially imitation? Should naturalism be given primacy, and a more decorative, abstract set of forms assumed to have developed from it? Or is it the other way around? We can see such a transition here in these copies (Figure 10) of New Guinea frigate bird (top three) and crocodile designs (bottom three) in which, reading from top to bottom, the representations, changing in time, become increasingly geometrical. Or does the style, as some anthropologists believe, depend both on the social needs of the artist and on the more autonomous demands made by artistic tradition?

Figure 10 New Guinea frigate bird and crocodile designs (Photo from F. Boas (1955) Primitive art, Dover *Publications, Inc., p. 116).*

Whatever the ideas concerning stylistic development, there seems to be general agreement that there exists in humans a drive to produce art, to go beyond purely utilitarian needs, to give expression to an intuitive feeling for form. Even in the magical act of cave-painting, it is hard to escape the conviction that the work to a large extent was produced *for its own sake and was self-rewarding.*

3 THE ART OF APES

One of the earliest and most notable scientifically controlled studies of the behaviour and the intelligence of apes was undertaken by Wolfgang Köhler on the island of Tenerife between 1913 and 1917. While Köhler concentrated on the way his chimpanzees used and made instruments to solve specially designed problems, or moved in rhythmic patterns in their dances, it was his observations of the optical sensitivity of apes which are of particular interest to us here. Unlike later investigators, he didn't attempt any elaborate experiments with drawing or painting, but his report[1] on the responses of his subjects to photographs has some bearing on our study. Once introduced to hand-held mirrors the apes became quite absorbed with their reflected images which they then enthusiastically discovered in pieces of metal, glass, or broken bits of glazed pottery. Narcissus-like they paid particular attention to their reflections and to alterations in their expressions in pools of water. When presented with photographs of themselves and of bunches of bananas and other, less appetizing objects, in a series of trials, the conclusion was that the chimps had no trouble in recognizing these objects so long as the photographs were reasonably sharp and clear. Now what makes this so interesting, and which may cast light on our little investigation, is that several similar experiments had been made before and after Köhler, showing photographs to primitive groups of humans. In all cases that I have been able to discover, the subjects had an initial and often protracted difficulty in understanding what the photographs represented.

To cite only a few examples: in the nineteenth century Sir John Lubbock reported in his book, *The Origin of Civilization* (London 1870) that Bushmen could not recognize their own images in photographs. Michel Braive describes the work in 1958 in the Moi uplands in the southern part of Vietnam of the French photographer, J. D. Lajoux. The people of the Dié tribe had never seen a photograph and made little of the peculiar flat images of themselves. But gradually, with assistance, they were able to recognize in the photographs their own likenesses. About ten years ago *Life* magazine (23 December 1966) yielded this macabre information: 'Some years ago a missionary who wanted to make contact with a primitive South American tribe flew over the area first and dropped, along with gifts, several pictures of himself. He hoped the photographs would help the tribe recognize him as a generous and friendly visitor when he came in person later. Unfortunately, the natives could make no sense of the shadowy language of the pictures, and when the missionary arrived they ate him.'

QUESTION

Now what should we make of this? Do we conclude that Köhler's apes were more intelligent than primitive people? Or is there some vital factor hidden here? Why, in the cases cited, did these people find the photograph so unintelligible?

This is a difficult one, so think carefully about it before going on to the discussion. But do not put your reasons down in writing here. Remember that the photographs are recorded on a *two-dimensional plane*, and see if you can come up with a plausible reason for this 'blindness' among primitives. Don't be overly concerned if your suggestion does not match mine. I mainly want you to think of the implications of such a phenomenon and of the different explanations possible.

[1]*The Mentality of Apes*, 1917, 1925, trans. Ella Winter, 1957, Pelican.

DISCUSSION

One analysis that I favour would be that as each of the groups of primitives had their own traditional art forms, these often rendered flat on plane surfaces, the difficulty in recognizing the camera image stems from the kind of 'mental set' (as psychologists call it) in which the photographic images did not concur with their conventional graphic expectations. That is to say that the particular character of pictorial representation in any society tends to exert a powerful hold on the way images, if not natural objects themselves, are seen, conditioning the eye (i.e. the 'mind's eye') *so that unfamiliar graphic forms present problems of interpretation.* We have much more evidence of such optical and stylistic phenomena in the history of art. And that we shall come to later in these units.

So, far from being extra-perceptive, we might conclude that the apes had little difficulty in recognizing the flat images of photographs because they had no *tradition* of art (i.e. representation) to confuse them. However, this does not mean that an artistic impulse was impossible for them. Experiments by Dr Desmond Morris at the London Zoo in 1962 and those of his colleagues in other countries concentrated on the character of what appears to be some kind of rudimentary artistic drive in some, though not all, higher apes. What I think Dr Morris succeeded in showing is first, that certain apes had an apparently inherent urge to make graphic marks while others had little inclination to do so. Second, some of his chimps, especially one called Congo, showed that they had an embryonic sense of design. For in cleverly constructed experiments, Congo, for example, responded not only to the edges of the paper set before him, but more subtly to other forms already registered on the drawing ground. They amount to 'infilling' or completion responses. But even more surprising is the possibility that this ape had a crude sense of symmetry (as in the dance) in which attempts appear to be made to balance either given configurations such as squares (Figure 11) and even the displacement of vertically ruled lines dividing the area into different segments. Morris found that human infants were not as adept in such compositional nuances, though in calligraphic exploration they seemed superior (*The Biology of Art*).

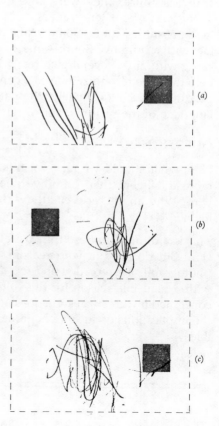

Figure 11 Congo, ape drawing (Photo from D. Morris (1962) The Biology of Art *..., Methuen, p. 81, Fig. 20. (Reproduced by courtesy of Associated Book Publishers Ltd., London.)*

4 THEORIES OF ART

If we accept the proposition that art is the result of an inherent necessity in the higher primates, what do we make of the vast collective array of philosophical notions as to the secondary reasons for this creative drive?

From Plato and Aristotle and ceaselessly through the ages philosophers, critics and artists themselves have offered special and often very subtle reasons which underlined this apparent necessity for art. We call this field of enquiry, 'Aesthetics'. The pivot on which Classical aesthetic theory turned was that art, essentially, was imitation. And hinging on that, was the question of beauty and its inevitable concomitant in ugliness. Later, in the first few centuries AD, emerged the idea of the exceptionally gifted individual, anticipating by seventeen or eighteen centuries the Romantic movement and its adulation of genius. Renaissance aesthetics was, not surprisingly, based on concepts originating in antiquity. During the High Renaissance of the sixteenth century, and through the seventeenth, the conviction grew that the artist was capable of creating a beauty so ideal, that it far surpassed anything that nature could produce. This conviction took on preposterous proportions, but it wasn't until the eighteenth century that the thesis of mimesis (i.e. imitation) as a fundamental concern of art was seriously challenged. Now, 'imagination' is in the ascendancy and has ruled supreme to this day. Moreover, the emphasis is shifted from the object, the work of art itself, to the observer and the experience of art. Consequently taste, pleasure, judgement, are the concepts which dominate, and a propensity for formal analysis may now be detected. Thus, in harmony with his age, David Hume (1711–76), philosopher of the 'Enlightenment' could speak in his essay, *Of the Standard of Taste* (1757), of a reasonable man of sensibility, with some experience of art, who could not but 'judge of its beauty' and a man of just taste who could not but bring to it 'a sound understanding'.[1] It is typical of a mind nurtured on the idea of a harmonious and civilizing intelligence that Hume could claim, as he did, that the principles of taste were universal. But by the time we get to Friedrich Nietzsche (1844–1900) it comes as no surprise that art is seen in *his* world as an aggressive instrument of the will, triumphing over the cruelties of life: 'Art affirms'; 'Art perfects existence' (*The Will to Power* 1896).

And in an antithetical vein, four years later, we have the theory of the Finnish philosopher Yrjö Hirn (1870–1952) which proposes that art is a matter of catharsis, that it emerges from the need to obtain emotional relief from psychological pressures – a means towards mental well-being (*The Origins of Art: a Psychological and Sociological Inquiry,* 1900).

The aesthetic theories of Benedetto Croce and Henri Bergson, which were of considerable influence on artists in the twentieth century, are based on the importance of intuition rather than intellect. The idea was that art seeks neither knowledge nor truth but is impelled by *a need to create images* (in whatever medium), and its importance lies in the stimulation of the imagination.

Obviously, these thumbnail definitions distort by the very reason of their brevity, and they only touch on the multitudinous theories formulated about art. But the purpose here is to make you aware that such a variety of ideas exist in the field of aesthetics and that *no one of them alone,* can account for this perennial need to make and experience art.

[1] The painter Sir Joshua Reynolds similarly believed in the possibility of establishing a standard of taste at the time.

5 OUTER NATURE: INNER NATURE

Now, I've mentioned above the importance given to mimetic art since antiquity.[1] Many artists in history, and those who wrote about art claimed, or came near to claiming, that the purpose of art was imitative and that the artist could not do better than to produce an exact replica of nature. But you may well ask, 'Is there only one universal and objective "truth to nature"?' We shall return to this question in Unit 18, but now, I would like to demonstrate the difficulty inherent in the idea of imitation in art.

In the Colour Supplement (pp. 5–6) are four reproductions of paintings produced centuries apart, yet in the first three cases it was claimed by contemporary writers, that the works of those artists were so lifelike that they seemed indistinguishable from the reality itself (Unit 16 Plates 1–4). The fourth example in this group is highly suggestive of the quality of realism conveyed in a photograph. Now what might the differences in the four works suggest to us about art and actuality? Can we suppose that the idea of what constitutes pictorial reality changes in each historical period? Is that the main conclusion we might draw here?

Should we not wonder how it was that the Giotto painting, for example, could have been thought to be so real when to us its seems not that real at all? Could it be that at different times in history the external world is perceived in at least slightly different ways? Or perhaps we should say that pictorial realism is a *relative* thing, that the degree of 'truthful' representation achieved depends on pictorial antecedents? That is to say that Giotto's representations may really have seemed real in contrast with the styles of late mediaeval painting still pre-eminent in Italy at the time. Similarly, Chardin's still-lifes compared to contemporary or near-contemporary painting styles in France may have appeared more realistic partly because of the simplicity and lack of sophistication with which he treated his subjects and partly because of the palpable way in which he applied pigment. That is a more tenuous consideration though worth keeping in mind. Of course we know that despite the enthusiasm it was always understood that these works were *paintings* in the first place and that they were never *really* indistinguishable from reality. Now the realism of Holman Hunt, despite its punctilious attention to detail and high degree of optical accuracy is, on close inspection, not of the same quality as that of the Estes painting. I hesitate slightly to enter into an analysis of the two as it is bound to be somewhat complex in character. But, forewarned, you should try to follow the argument without becoming too distraught if it eludes you. In my opinion *part* of the drive behind Holman Hunt's painting was to beat photography (only thirteen years old then) at its own game; to go further in truthfully recording nature than even the photograph could with its loss of detail in the lightest and darkest parts of the image. This loss of detail in photographs at the time was due to the crudity of the emulsions used and the consequent inability to distinguish between the different colour tones in natural scenes. More than a half-century later, with the discovery of panchromatic emulsions, distortions of that kind could largely be eliminated. You can see such distortions of tone if you look carefully at the photograph of the American Civil War reproduced on page 31 (Figure 20) and Julia Margaret Cameron's portrait of Alice Liddell (Figure 22, page 32). Note how much 'more-than-photographic' Hunt's realism was, a feature commented upon by discerning critics in the mid-nineteenth century when it was painted.

[1] The fourth century (BC) Greek, Lysippus, is said to have used actual human casts in producing his sculpture. He worked for Alexander the Great, the only sculptor allowed, it is said, to make representations of the Emperor. His predecessors, the sculptor said, produced men in their 'natural' forms, but he did them 'such as they appeared' – an interesting distinction for us to consider.

Now the so-called 'Photo-Realist' painting of the restaurant front by Richard Estes (dated 1967) has a quality of illusionism rather different from Hunt's *Strayed Sheep* (as it is usually called). The differences in the textures of the two subjects notwithstanding (soft botanical forms, woolly fleeces as against the unresilient concrete, metal and glass), the tendency in the Hunt is to etch out the forms as though in relief, to give them volume. The signs of the brush are made evident. The painting has none of the sense of flatness characteristic of photographs. In the Estes painting, despite the accuracy of detail, the artist has attempted to make it appear as much like a photograph as possible, minimizing the signs of the human hand – machine-like in perfection, flat. It seems to me that one couldn't easily mistake the Hunt painting for a photograph. But it is easy to do so with the painting by Estes, especially reduced as it is here in reproduction. By his own admission, Estes could not have executed his painting without the aid of a photograph. Things just don't stand still long enough, and the light changes. Yet one way of ensuring that this oil on canvas was received as a painting was to make it large in size; its dimensions are 66²/₃ × 49²/₅ in. Behind the paintings of those who are called 'Photo-Realists' lurk subtle philosophical notions concerning the interplay between illusion and reality. These artists delight in asserting that a painting (that is to say a *made* object, a reality itself), remains a painting even if it is entirely dependent on a photograph which is itself only a copy of reality – only the product of a mechanism which intercedes between one actuality and another.

Despite the foregoing concern with physical realities, most often in aesthetic theory it is and has been argued that art should go deeper than outward appearances, that there is an inner nature to all things and it is this *inner* nature with which art should be concerned. One of the most evocative analogies ever drawn to illuminate this province of art, was that made by the philosopher Arthur Schopenhauer (1788–1860) in *The World as Will and Idea* (1818, 1844) in which he set the pattern for generations to come in extolling music as the supremely pure art, in analysing its constituents (bass, melody, etc.) and holding it up as a model for all the other arts.

Music, Schopenhauer says, unlike the other arts, is entirely *independent of the external physical world,* though some composers might disagree with him here. Its effect is direct, deep and infallible. It is, he claims in his enthusiasm, a universal language and is instantly understood by all. Music passes over the representation of particular things to the larger 'ideas' which underlie them (by which we may suppose he means moods, emotional states, *elemental* physical forces and the like). 'Music is thus by no means like the other arts, the copy of the Ideas, but *the copy of the will itself* . . . This is why the effect of music is so much more powerful and penetrating than that of the other arts, for *they* speak only of shadows, but *it* speaks of the thing itself.' (My emphases. Schopenhauer *The World as Will and Idea,* reprinted in part in Sesonske *What is Art?*, pp. 302–39).

So while Schopenhauer rejects the unrelieved imitation of nature as art, and points to wax figures which leave nothing for the imagination to do, he still attributes even to imitative painting and sculpture a certain appeal to the imagination: painting because it gives us the colour of nature, but only the illusion of form; sculpture only the form but without the colour. But given the artistic and social circumstances of the nineteenth century and our own, illusionism in most cases was not enough.

I don't think Schopenhauer meant that artists should simply produce visual equivalents to music as Walt Disney did in *Fantasia,* or as others, such as Wassily Kandinsky in the twentieth century did in a more clinical way in keeping with both the scientific and metaphysical propensities of the era (Colour Supplement, Unit 16 Plate 5, page 7). The philosophers' ideas were probably more fully realized in the paintings, for example, of the Romantic Eugène Delacroix (Colour Supplement, Unit 16 Plate 6, page 7). But not as much I think in the work of James McNeill Whistler whose paintings called *Symphonies* and *Nocturnes* (Colour Supplement, Unit 16 Plate 7, page 8) were more an obeisance to the idea that

all arts ought to aspire to the conditions of music, than a fully digested assimilation of it. The same might be said of the painter Paul Klee in his *Fugues*.

What I think Schopenhauer was trying to say was that like music, the visual arts among others communicated abstractly, through subtle combinations of form which transcended subject matter and, like music, *appealed directly to the senses*.

6 ILLUSION AND REALITY

Through much of the history of the visual arts, whatever the arguments put forward concerning the precise nature of art, one central discussion has persisted: that is the distinction between illusion and reality. Illusion may be said to hinge on optical sensations such as natural views seen in perspective with their differences in the scale of objects, as in this view of Venice by Canaletto (Figure 12); reality, on our knowing that the figures in what appears to be the middle

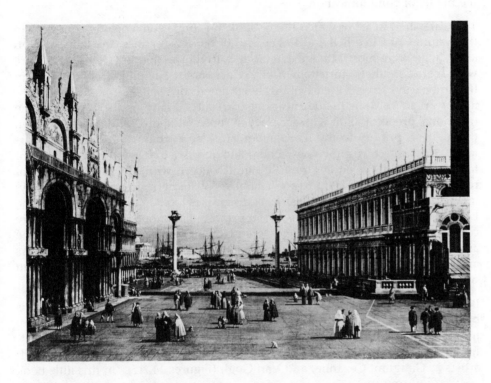

Figure 12 Antonio Canale Canaletto (1697–1768) View down the Piazetta, Venice *(Mansell Collection).*

and far distance are really the same size as those in the foreground. The prevailing terminology would call the first perspectival condition 'real', and the second, as we can see in this drawing from an Aztec codex illustrating a battle with the Spanish invaders (Figure 13), 'unreal'.

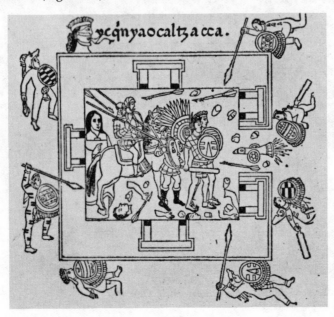

Figure 13 Drawing from an Aztec codex, sixteenth century, showing Aztecs besieging Spanish and Tlaxcalans at Palace of Axayacatl.

Now this distinction between illusion (with its connotation of fallacy and self-deception) and reality had a kind of watershed in the late nineteenth and twentieth century. After five hundred years of artistic striving for visual accuracy, and with considerable accomplishment in illusionistic technique, following the advent of the photographic camera, artist and critics began seriously to question whether or not since the beginning of the Renaissance things had been stood on their heads, and that 'reality' *really* had at least as much and possibly more to do with what was *known* to exist in external nature than with what one saw. 'Reality' then was considered as much a quality of mind, as it was of matter. Obviously, such subversive ideas were bound to create, in art as well as in philosophy, no end of problems in language and definition. Moreover these problems have been exacerbated in the last hundred years with the unprecedented growth in the media of communication.

The watershed in art of which I have spoken is quite conveniently conveyed in the writings of Clive Bell and Roger Fry, two English critics, the latter also an artist, who were most active from about 1910 till the thirties. Obviously, there were scores of others – artists, writers, critics, not to say philosophers – who in their own ways gave evidence of this heightened consciousness about the meaning of art in relation to the meaning of reality. Many of them rejected the traditional preoccupation with accuracy in representation, giving equal, or even the highest, priority to the more imaginative and arbitrary use of form. Certainly, the subject was not a new one. Plato and Aristotle were only the distant forebears of a never ending philosophical concern with the question. But for reasons quite likely related to the character of modern life and its (arguably) inevitable effect on art, these historical discourses took on a new urgency in the last hundred years or so. They became more clamorous and certainly more complex. For better or worse they were given an unprecedented currency, the arguments dispersed to a much broader cultural audience than ever before. As art itself became less circumscribed, it was more difficult to define, a condition which, as you must know, looms in immense proportions before us today.

Bell's essay, 'The Aesthetic Hypothesis' appeared as the initial chapter in his book called *Art*, first published in 1914, not many years after he and Fry were instrumental in bringing to Britain the first large scale exhibitions of Post-Impressionist paintings from the continent; that is to say the works of such artists as Gauguin, Cézanne, and Van Gogh (Figures 14, 15). 'In this little book

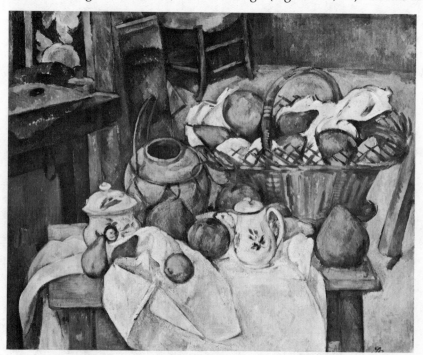

Figure 14 Paul Cézanne, Still-life with fruit basket, *c. 1888–90, 25⅝ × 31⅞ ins (Louvre: Cliché des Musées Nationaux, Paris).*

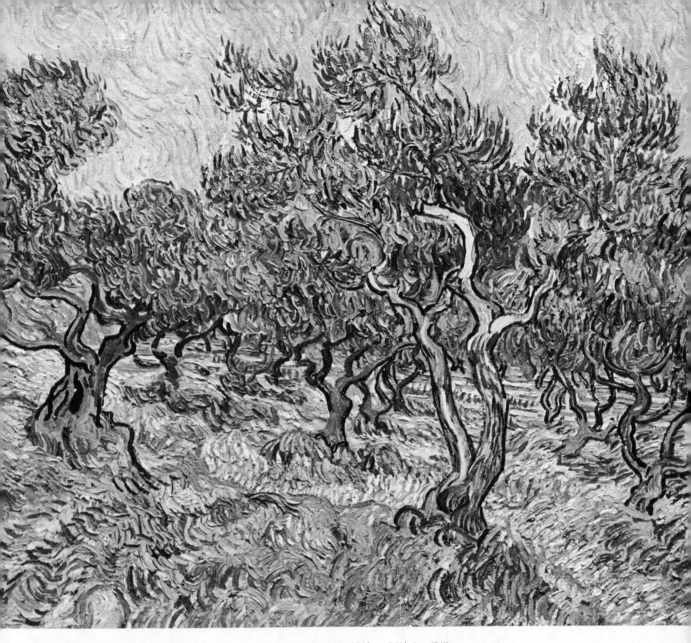

Figure 15 Vincent van Gogh, An olive orchard at St Rémy, *c. 1889, 28⅜ × 36¼ ins (Rijksmuseum Kröller-Muller, Otterlo).*

[Bell writes in the preface] I have tried to develop a complete theory of visual art.' It is not without meaning that Fry particularly, in his written work, incorporates in his discussions the art of non-European cultures and that of primitive and prehistoric man – works of art which often at the time in Europe, were condescendingly described as 'ethnological specimens' and 'cultural curiosities'. Moreover, it was not just the arts of painting and sculpture with which these critics were concerned, but also pottery, textiles, and such crafted objects traditionally designated the 'useful' or 'minor' or 'practical' or 'industrial' arts.

Writing of African Negro sculpture in 1920 Fry begins his essay with the words:

> What a comfortable mental furniture the generations of a century ago must have afforded! What a right little, tight little, round little world it was and Greece was the only source of culture, when Greek art, even in Roman copies, was the only indisputable a:t, except for some Renaissance repetitions! (Fry 'Negro Sculpture' in *Vision and Design*, 1929 ed. page 99.)

Echoes of Schopenhauer resound in Fry's essay, as he describes the way in which such African sculpture is conceived. He speaks of the Negro artist's

27

'plastic sense' and the way in which, contrary to European styles, the three-dimensionality of the carving is 'underlined' (Figure 16):

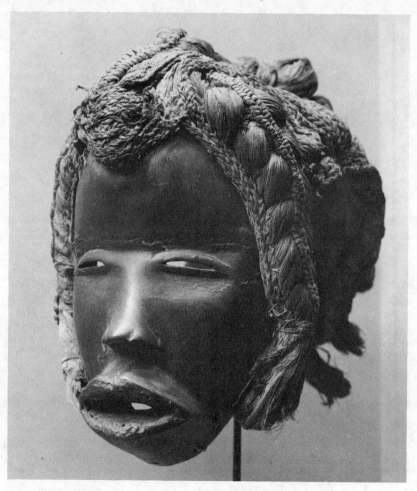

Figure 16 Dan mask in wood, West Africa (Photo: Hélène Adant, Paris; Collection of Morris J. Pinto, Paris).

It is in some such way, I suspect, that he manages to give to his forms their disconcerting vitality, the suggestion that they make of being not mere echoes of actual figures but of possessing an inner life of their own. If a negro artist wanted to make people believe in the potency of his idols he certainly set about it in the right way. (Fry *Vision and Design*, 1929 ed. page 102.)

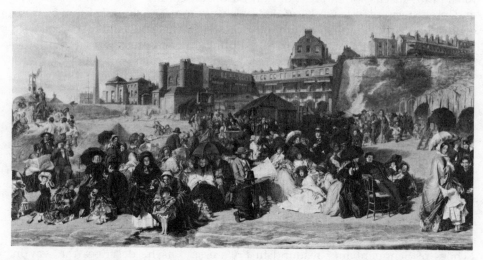

Figure 17 William Powell Frith, Ramsgate sands *c. 1854 (Reproduced by gracious permission of Her Majesty the Queen).*

Bell tried to convince his readers that painters such as Edwin Landseer (who sculpted the lions at Trafalgar Square), William Powell Frith (Figure 17) and Luke Fildes were not artists at all, but 'descriptive' painters producing pictures that told stories, reconstructing history or recording contemporary life and landscape *not* as 'objects of emotion', but merely (he believed) as means for conveying information or 'suggesting' emotion:

> Of course many descriptive pictures possess, amongst other qualities, formal significance, and are therefore works of art: but many more do not. They interest us; they may move us too in a hundred different ways, but they do not move us aesthetically. According to my hypothesis they are not works of art. (Bell 'The Aesthetic Hypothesis', in *Art* 1931 ed. page 17.)

You may be surprised at the apparent narrowness of Bell's assertion and you may disagree strongly. But think of the state of art at the time, and of the 'abominations' (as no doubt Bell would describe them) featuring in the officially sponsored Salon and Academy exhibitions, a few examples of which we reproduce here (Figures 18, 19). But we must not throw the baby out with the bath water. For it is difficult to distinguish between apparently trivial works and

Figure 18 Croizy, Le Nid, *c. 1880.*

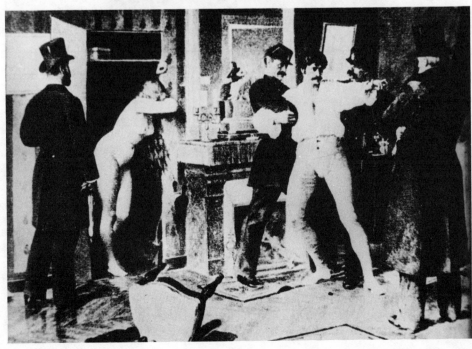

Figure 19 Garnier, En flagrant delit, *c. 1880.*

those descriptive pictures which, as even Bell concedes, possess 'formal significance' and ought to be regarded as works of art. But what, we might ask, what makes some works of art more significant than others?

EXERCISE

Compare Unit 16 Plates 3 and 8 of the Colour Supplement (pp. 6 and 8) and say which of these 'descriptive' paintings you think would have been seen by Bell as having the required 'formal significance'. Try also to say what more specifically Bell meant by 'formal significance' and how it is manifested in the picture you chose. Write your answer, say 50 to 100 words, in the answer box provided here, before going on to the discussion.

DISCUSSION

Though in his criticism Bell concentrated on contemporary art, his repugnance for 'exact representation' extended as far back as palaeolithic cave paintings. He was as much repelled by the 'descriptive preoccupations' of Renaissance painters as with artists of his own time. Comparing Campin's *Mérode Altarpiece* with Holman Hunt's *Strayed Sheep* (Colour Supplement, pp. 8 and 6), would you agree with me that the former painting would most likely have appealed more to Bell than the latter? In my opinion both paintings are highly descriptive, the Campin possibly more.

You may argue with this but I think that it was not so much descriptiveness in art which roused Bell but the particular *manner of representation*. I think he'd have found attractive the somewhat 'primitive' character of the altarpiece and its attempt to be highly illusionistic. For it is the precision with which the details are handled, yet the lack of cohesiveness in the total scene which gives the painting

such eloquence. The *Strayed Sheep* conveys (as we have already noted) a more-than-photographic rendering of detail and reflected colours. And the cropping of the sheep by the frame to simulate a cut-off segment of reality would no doubt have been too natural, or even photographic in form to please Bell. In the same way the random effects of rock and foliage forms meant to convey a greater sense of naturalism would, I think, have irritated Bell *because* they would seem too much a 'slice of life'. You must now know what is meant by 'form' in this context: line, colour, tone, space and other pictorial and compositional elements which no image could be without. But would you agree that by 'formal significance' Bell must have meant particular arrangements and combinations of form which strike us or (better) *move* us, or excite us, in a special way distinct from our everyday perception of things?

Bell's persistent use of the term 'Significant Form' as the necessary ingredient in a genuine work of art, is, I think, understandable in the context of the art and social life of the period. With little doubt that term was given greater currency due to a relatively new technology and its consequent development from about the mid-nineteenth century. The technology to which I refer was photography and the development of photomechanical printing processes. Without exaggeration both of these caused a great upheaval not only in conventional attitudes to art, but quite obviously in social consciousness as well. But photography and its mechanical progeny was more an accomplice than the main perpetrator of the aesthetic disorder which followed its invention in the 1830s. For with it came the rise in many countries of a pictorial press aided and abetted by the camera. The consequent flood of images profoundly touched both the spirit and imagination of a large part of humanity (Figures 20, 21). Pictures were now 'a dime a dozen' and the distinctions between the artist and the picture maker as a mechanic became subject to a much more rigid scrutiny.

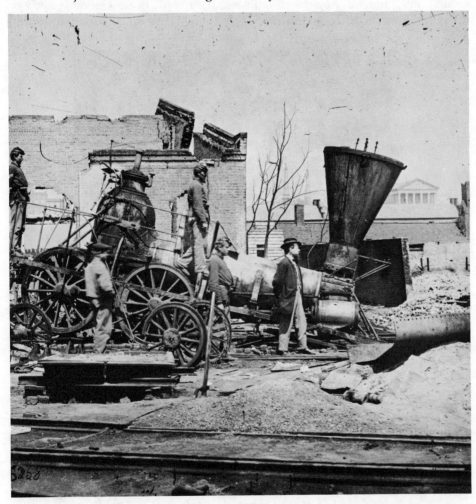

Figure 20 Mathew B. Brady, Richmond in ruins, *April 1865 (Courtesy of the Library of Congress).*

31

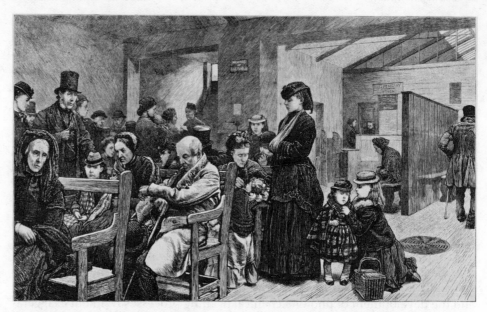

Figure 21 Charles Green, The out-patients' room in University College Hospital, *engraving from* The Graphic, *6 January 1872.*

I'd be the last person to encourage the view that photography was merely a mechanical recording process, an 'eye', so to speak, without a 'brain'. Quite the contrary. For even the photographic camera, in the hands of the artistically sensible, is quite susceptible of generating evocative (that is to say 'significant') form. Even Clive Bell would be hard put to deny the aesthetic value of such photographs. Indeed, Roger Fry confirmed their value in a memorable essay on the portraits of the Victorian photographer Julia Margaret Cameron (Figure 22).

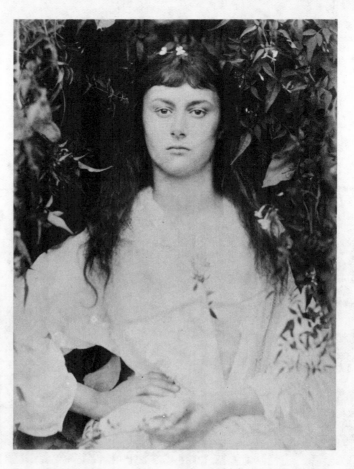

Figure 22 Julia Margaret Cameron, Alice Liddell, *1872 (Royal Photographic Society of Great Britain).*

But Bell, though not Fry, perhaps for effect, exaggerated the aesthetic value of form alone even to the extent of saying that accurate representation (i.e. the portrayal of specific subject matter), *whatever the style used*, was fatal, as even in the case of palaeolithic art, for inevitably it reduced form to a subservient role; ' . . . if a representative form has value, it is as form, not as representation. The representative element in a work of art may or may not be harmful; always it is irrelevant.' ('The Aesthetic Hypothesis' in *Art*, page 25.) This, one is bound to say, is quite a mouthful, for at one stroke it reduces the importance of subject matter in the art of Greek and Roman antiquity, most Renaissance art, and much of the art which followed: Spanish and Dutch *genre*[1] and landscape in the sixteenth century, Neo-classicism later and even the best nineteenth-century art, not excluding Impressionism. Bell's assertions as already suggested may well have been calculated to shock his readers and thus force them into thinking more carefully about what art meant. We can forgive him the belligerent manner in which he carries his aesthetic banner. No other art, he says, moves us so profoundly as primitive art: 'In primitive art you will find no accurate representation; you will find only significant form.'

But is Bell correct in saying this? Look at the reproduction of a picture in the Colour Supplement, Unit 16 Plate 9, page 9, executed by a largely unschooled peasant painter at a Commune in Shensi province, China. Is it not accurate in its representation, descriptive without being illusionistic? Does accuracy necessarily require a high degree of illusionism and cannot even illusionism be coupled with evocative form (or subject) to the advantage of both, as in the seventeenth-century still life with fruit and vegetables by the Spaniard Cotán (Figure 23) – and as Surrealists such as René Magritte in this century well knew (Figure 24)?

Bell discusses the art of South and Central America before the invasions of Europeans: ' . . . in every case we observe three common characteristics –

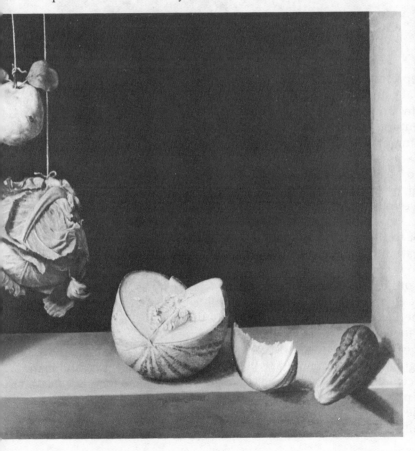

Figure 23 Juan Sanchez Cotán, Quince, cabbage, melon and cucumber, *c. 1602–3, 33 ⅜ × 39 ⅔ ins (Fine Arts Gallery, San Diego).*

[1]See Murray for a discussion of this term.

Figure 24 René Magritte, La lunette d'approche (The binoculars), *1963, 69 × 45 ¼ ins (Menil Foundation Collection, Houston; courtesy Mme Magritte).*

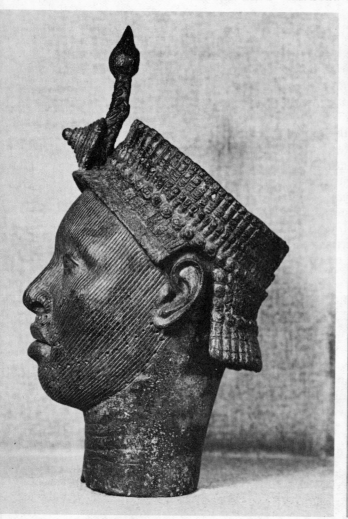

Figure 25 Benin bronze head, Yoruba of Ife, Nigeria, c. thirteenth century (Trustees of the British Museum).

Figure 26 Clay figure of seated man holding a rattle, Andes region, Santarem, Brazil (University Museum, University of Pennsylvania).

absence of representation, absence of technical swagger, sublimely impressive form.' Look at our reproduction of two objects (Figures 25, 26). One is from pre-Columban, pre-Pizarro Peru. The other was made in Africa probably in the thirteenth century. There is no absence of representation in either of these works. Looking at them, does it not become increasingly difficult for us to support Bell's assertion that 'formal significance loses itself in preoccupation with exact representation and ostentatious cunning'? In a footnote Bell qualifies his statement by saying that though a perfectly represented form may be significant (we must presume he means significant in an aesthetic sense), it is fatal he insists 'to sacrifice significance to representation'. Now, I think there *is* an element of truth here, resting on the possibility that too engaging a subject and too accurate a representation of it poses a danger that the formal character of the work, however brilliant, may be obscured by too strong an emotional involvement of the spectator with the subject, especially as the artist has in a sense done it all and left little for what I'd call 'creative detachment', for the exercise of the imagination. This is notoriously the case in Victorian narrative paintings as, for example, in the work of Frith (Figure 17, page 28). However, in practice, in the most telling works of art, as in the paintings, say, of Piero della Francesca (Figure 27) or Rembrandt, or Velasquez or Goya, the successful marriage of subject matter (highly descriptive though it may be) and form is *mutually enhancing*. It produces much more than the sum of the parts, enriching the *content*[1] of the work, a term which we shall consider more fully in the final section of Unit 18.

[1]Briefly, the term 'content' is meant to convey the overall feeling or mood produced by the combination of subject and form: vitality, sorrow, gaiety, terror, disquiet, serenity, chaos etc. That is to say, the quintessential, abstract, message – something akin to Schopenhauer's 'Idea'.

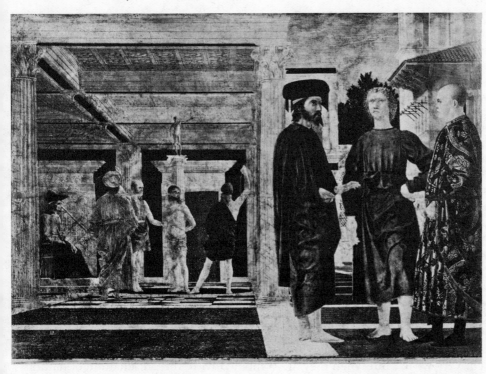

Figure 27 Piero della Francesca, The Flagellation of Christ, *1458–66, Ducal Palace, Urbino (Mansell Collection).*

7 . FORM AND FEELING

With regard to the jettisoning of descriptive subject matter to make way for the emergence of a purer art, we turn to the much more discerning observations of Fry. Fry is also an advocate of the abstract virtues of 'Significant Form', though he doesn't employ the concept in the way that Bell does. In his 'Essay in Aesthetics' first published in 1909 (collected with other writings in *Vision and Design)*, Fry singles out several basic elements of form: rhythm, mass, space, light and shade, and colour. The emotional potentials of these he says, 'are connected with essential conditions of our physical existence'. Thus rhythm may be coupled with muscular activity and auditory sensations, mass to our responses to gravity, and the others with our day to day experience of them. To colour, surprisingly, Fry attributes a less profound meaning in life though it might be mentioned that precisely at that time some important and fairly well publicized investigations by psychologists into colour phenomena were in progress in parallel with the concern and writings of artists such as Wassily Kandinsky on the subject of Synaesthesia and the attributes of colour in the correspondences of the senses.[1] Now if these elements were presented pictorially in simple diagrammatic terms, says Fry, then 'this effect on the emotions is, it must be confessed, very weak'. But when they are combined with 'the presentation of natural appearances, above all with the appearance of the human body, we find that this effect is indefinitely heightened.'

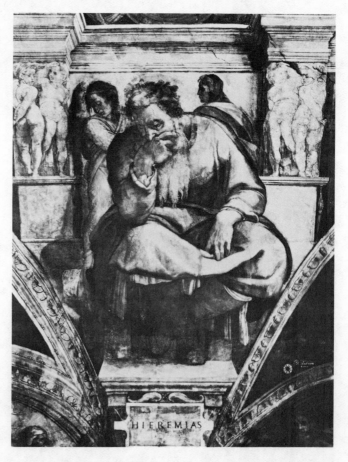

Figure 28 Michelangelo, Jeremiah, *from the Sistine ceiling (Mansell Collection).*

[1]That is to say, the way colour may conjure up musical and other sensations in the mind of the spectator. Such analogies extend to shapes, numbers, even sensations of taste. Thus one might associate the colour blue with the sound of the viola, or yellow with the shrillness of the bugle, and that with the taste of kirsch or dry curaçao.

Fry cites Michelangelo's *Jeremiah* (Figure 28), one of the more astounding figures in the Sistine Ceiling fresco, as a case in point.

EXERCISE

Study the reproduction of the *Jeremiah* here and try to say what it might have been in the representation that produced a strong emotional effect on Fry. Please write your answer in the answer box provided here.

DISCUSSION

I wonder if you feel the power of the figure as I do – and, I suppose, as Fry did – that power vested in its massiveness and the way in which that massiveness is conveyed? Have you commented on the compactness of the form, with care taken by the artist to avoid any projections from the block-like structure locked up in a tight and unresilient (even explosive) contour? You'd have done well if you've seen that. The strong juxtapositions of dark and light areas too (typical of the ceiling frescoes as a whole, but perhaps even stronger here) reinforce the Herculean aspect of the subject and suggest, in the pensive position of head and hand, the preoccupation with some gigantic inner conflict. I don't want to labour the formal analysis, and the above should suffice. But we might have pondered on the way in which Michelangelo uses form to augment the character of the prophet, to drive home the message of his role as judge and denouncer of all the wicked ways of Israel. We might also have considered in a more prosaic way the distance of the ceiling from the viewer and the subdued light of the chapel during part of the day (especially if the windows, as is now believed, were of coloured glass), though obviously I would not expect you to have prior knowledge of this. But that may be yet another reason for aggrandizing the form and accentuating its lighting. The practice was not unknown earlier in the Renaissance, in the carved panels of pulpits, for example, where it was found necessary to handle the forms in a broader way so that the message might be received by those among the faithful far removed from the pulpit itself.

Now nature according to Fry, harbours all such efficacious combinations of form; 'emotional elements' he calls them, associated with the fundamental con-

ditions of our physical existence – a theme, incidentally, developed by several artists and theorists from the last quarter of the nineteenth century. Fry then poses the hypothetical question that if Nature is a repository for such forms and combinations of form, then should not the artist simply imitate it?

> But alas! Nature is heartlessly indifferent to the needs of the imaginative life; God causes his rain to fall upon the just and upon the unjust . . . Assuredly we have no guarantee that in nature the emotional elements will be combined appropriately with the demands of the imaginative life, and it is, I think, the great occupation of the graphic [ie. visual] arts to give us first of all order and variety in the sensuous plane, and then so to arrange the sensuous presentment of objects that the emotional elements are elicited with an order and appropriateness altogether beyond what Nature herself provides. (Fry *Vision and Design*, pp. 36–7.)

Now, clearly, if you interpret this passage as I have, then reproducing a natural scene, or a face in portraiture for that matter, to 'take' a likeness of Nature may be a test of skill in observation and representation, but according to Fry, it is in most cases ('we have no guarantee') not art. How, then, are we to respond to the many claims made throughout the history of art, by those distinguished as artists, or as critics of art, that whatever else art may be, to paint Nature as it is, ingenuously and without pretension to some lofty aesthetic status, is not only a means of producing art, but is the way of the best artists?

How would you answer this? Would you agree with me if I suggested that such painters produced art in spite of themselves? For even in imitating a natural scene with the maximum veracity at one's command, artistic traditions assert themselves in the very way the artist perceives (and thus interprets) objects in nature. Don't be too concerned if this seems a bit difficult at the moment. We will enlarge on the idea in Unit 18.

8 A WORD ON 'BEAUTY'

Now, even today, in ordinary conversations having to do with art the word 'beauty' or 'beautiful', with its multiple meanings will frequently emerge. And, of course, the word is a linguistic trap. For in certain cases, awkwardness, plainness, even ugliness may be portrayed in such a way as to be enthusiastically acclaimed 'beautiful'. Is there not 'beauty' in Degas' paintings of tired, homely-looking dancers at the Paris Opera ballet (Figure 29)? And in Rubens' sorrowful *Descent from the Cross* is there not an element of 'beauty' too (Colour Supplement, Unit 16 Plate 10, page 9)?

Figure 29 Edgar Degas, Foyer before the dance, 1879, 19¼ × 25¾ ins (Durand-Ruel et Cie, Paris).

Historically, one of the most persistent criteria of art was the creation and contemplation of beauty, yet its precise meaning evaded even the most assiduous philosophers and scholars. Why? I've little doubt that you've guessed that the idea of beauty is so utterly subjective (despite certain generalized norms which emerge in every cultural group) that to arrive at any universal and timeless characteristics for beauty would be logically impossible. Examples often cited, of stretched lips, necks and ear lobes of certain African tribes, or of the old Chinese practice of binding the feet of women are quite obvious. But look at the faces, the gestures, and the general deportment of actors and actresses in films made as recently as the thirties and forties and you will no doubt agree that the pin-ups of that era appear old-fashioned, or even strange and foreign to our eyes.

Nevertheless, however much these criteria alter from generation to generation, there was more agreement as to what constituted beauty at an abstract and metaphysical level. In nature, in music certainly, and in the visual arts, peculiar characteristics of form: rhythms, cadences, harmonies, symmetries and carefully constructed asymmetries, tonalities, certain attractive and compelling juxtapositions of colours, and sounds, took on aspects of universality which rather strengthen Fry's proposition that such things carried strong associations with our physical natures and their relation to the nature of the external world.

But the idea of Beauty as *the essential* element in art, though questioned earlier, was given the coup de grâce in 1898. The instrument was a literary one: Leo Tolstoy's extensive essay, *What is Art?*

EXERCISE

Here is a passage from that essay which must I fear be brief, but one which I would like you to read and think about. Then attempt to answer the question which follows.

> To evoke in oneself a feeling one has once experienced and having evoked it in oneself, then, by means of movements, lines, colours, sounds, or forms expressed in words, so to transmit that feeling that others may experience the same feeling – this is the activity of art.
>
> Art is a human activity, consisting in this, that one man consciously, by means of certain external signs, hands on to others feelings he has lived through, and that other people are infected by these feelings, and also experience them.
>
> Art is not, as the metaphysicians say, the manifestation of some mysterious Idea of beauty, or God; it is not, as the aesthetical physiologists say, a game in which man lets off his excess of stored-up energy; it is not the expression of man's emotions by external signs; it is not the production of pleasing objects; and above all, it is not pleasure; but it is a means of union among men, joining them together in the same feelings, and indispensable for the life and progress towards well-being of individuals and of humanity. (From Tolstoy, *What is Art? and Essays on Art* translated by Aylmer Maude, cf. A. Sesonske, *What is Art? Aesthetic Theory from Plato to Tolstoy.*)

Obviously, reading only a small part of Tolstoy's work has serious drawbacks. Yet we may still glean from this some idea of his special approach to art. It was to be immensely influential in years to come. Try to list three or four characteristics of art which Tolstoy identifies here.

Please write your answer in the answer box given below.

DISCUSSION

These are some characteristics I should include:

1 The evocation of feelings which have embedded themselves in the memory.

2 The communication of those feelings to others, sharing them, art as 'a human activity'.

3 These feelings may not evoke beauty, suggesting that feelings which are motivated by fear, ugliness, unpleasantness, may also be communicated as art.

One has only to think of Tolstoy's novels such as *War and Peace* and especially the play, *Power of Darkness* (which dwells 'beautifully' on the misery, ugliness, and brutality of peasant life in Russia), or of the works of his contemporary Dostoevsky, to know that beauty or pleasure are only two of the many possible constituents of art.

4 Art 'is not the expression of man's emotions by external signs'. This, you may have noticed seems to contradict what Tolstoy says in the first paragraph. But looking more carefully at the precise words used (assuming that the translation is accurate and sensitive), he seems to distinguish between 'emotions' and 'feelings', emotion being a spontaneous, ephemeral, and thus lesser, thing, while feeling is something more permanent, an experience digested, considered. Indeed, it is such subtle differences as these which have in history plagued the study of aesthetics while at the same time providing the philosophically-minded with an intriguing diet of verbal nuances on which to ruminate.

5 Finally, and perhaps of supreme importance in Tolstoy's philosophy, art is seen as an indispensable vehicle for social harmony, 'a means of union among men . . .'

In brief then, Tolstoy's criteria for art is that above all, it should be moral. He rejects, as you can see in the passage quoted, the ideas of art as beauty or pleasure, as expressions of physiological or psychological needs (letting off steam) or of aesthetic emotions. Bell's 'significant form' would be anathema to him.

Yet we must return again to discuss the term 'beauty'. For even to convey a sense of evil or ugliness or catastrophe, the artist must employ form (whether he be a painter, musician or writer) in such a way as to communicate his feelings and ideas about the subject, and to engage his audience. Now, there is, and has long been, a use of the word, beauty, which is meant to convey the *way* in which a work of art is made – its very construction. Thus, Flaubert's horrifying amputation scene in *Madame Bovary* is said to be beautifully, because exquisitely, done and, despite the grisly subject, it is *beautiful* as a work of art. This idea too, had been debated from antiquity, but from the eighteenth century it was seen in higher relief. In the visual arts this same kind of beauty existed in the works of such so-called Realists as Gustave Courbet and the more bucolic Jean-François Millet – purveyors of ugliness as they were called by many of their contemporaries (Figure 30). Or, more recently, the ugliness of life in German urban society of the 1920s is exquisitely (can we therefore say beautifully?) rendered in the fine, sensitive drawings of George Grosz (Figure 31).

There is a further point in this regard. That is that beauty may be heightened by being contrasted with ugliness, and ugliness made even more painful when juxtaposed with beauty (Figure 32). Often, such contrasts are employed in the films of Alfred Hitchcock, both visually and, in *The Rear Window* for example, opposing terror with sweetness when the foil for the horrific murder scene is pleasant café music floating up from the street below. Here, one might refer to the language of dialecticians, where one speaks of powerful syntheses being a unity of opposites. This, in turn, brings to mind some fundamental ideas in artistic practice having to do with rhythm, repetition, asymmetry, and contrasting elements used to augment pictorial, or musical, or architectural or literary

effects. We return to a discussion of the artist's formal means in the final section of Unit 18, where we will look at these things more closely. Now it is time to move on to Stephen Bayley's discussion of the purposes of art history as an academic study, its means, its methods, and the kind of problems peculiar to the discipline.

Figure 30 Jean-François Millet, The Sower, 1850, 39¾ × 32½ ins (Courtesy Museum of Fine Arts, Boston).

Figure 31 *George Grosz, Parasites, 1918, pen and ink drawing (Photo supplied by the Arts Council of Great Britain).*

Figure 32 *Leonardo da Vinci, Old man and youth facing each other chalk drawing, Uffizi, Florence (Mansell Collection).*

PART 2 WHAT IS ART HISTORY?
1 FOREWORD

This section of Unit 16 is called 'What is Art History?' but is not in itself art history. It is an introduction to some aspects of the subject which uses as its central theme the Ghent Altarpiece, a large picture with a religious subject painted in the early fifteenth century for the cathedral in Ghent, in the country which we now call Belgium. It is still there today, surrounded by tourists.

Whole books have been written about the Ghent Altarpiece and I am not trying either to imitate or to replace them. The purpose of the following is to be a guide to the ways of understanding a major work of art and a survey of some of the methods used by art historians. Briefly, I want to be able to place the work in

1 historical context

and

2 cultural context

as well as

3 to find out what it means

and also

4 to find out who painted it.

This written material has been conceived in conjunction with television programme 16 which offers a specific approach to the understanding of the Ghent Altarpiece adapted largely from the ideas of Erwin Panofsky (see Recommended Reading). It is a complement to this text, as is radio programme 16, *Donors and Patrons*, which is intended to put the cultural life of the time in its social context.

I am not an historian of the fifteenth century and neither should you expect to be on the basis of reading this half unit. I chose the Ghent Altarpiece as a focus for our study because it is a large, dramatic and mysterious work posing art historical problems which have attracted much specialist investigation. I could have chosen Leeds Town Hall, the Rockefeller Centre or Géricault's *Raft of the Medusa* and done the same thing: they are large and dramatic works of art too; it is the purpose of this text to introduce you to the academic study of such works of art by means of looking at one of them.

Although you should be prepared to get used to reading academic books with lots of scholarly footnotes and extensive bibliographies, I have deliberately suppressed them here so that you have a chance to run through the text and look at the pictures without interruption. The time you save not reading footnotes should be spent reading the unit again and making notes in the margins.

2 WHAT IS ART HISTORY?

You have already read Aaron Scharf's interpretation of art, now you are going to read mine. Art is the opposite of nature. At least, that was the old meaning. 'Art' has the same root as the word *artifice* and this idea of things done or made by ingenuity is brought out in the line of that old hymn which speaks of objects 'by art or nature wrought'. Art is common to all cultures and art history is the study of it; at the moment art historians generally restrict themselves to the study of painting, architecture, sculpture and the decorative arts but more and more they are turning towards other artefacts and applying the methods of art history to everyday objects. Art history is certainly a clumsy term: if you say to someone you are studying 'art history' they often interpret it as 'artistry', but the term is exactly the same in all European languages – the French call it *histoire de l'art*, the Italians *storia dell'arte* and the Germans *Kunstgeschichte*.

The purpose of art history is to find out why people make things the way they do, why things appear in a certain way, but it is done in a manner which often has a more theoretical than historical approach. Man is the only animal whose artefacts are charged with meaning, because they are the only objects on earth which have been created as an act of will. Furthermore, visual objects (say a church, or Stonehenge, or Manet's picture of the bar at the *Folies Bergère*) are the chief monuments of periods of civilization, remembered when court documents, elegant conversations or festivals are long forgotten and brought to mind far quicker than ecclesiastical records or obscure novels or philosophical tracts.

The broad purpose of art history in education is

1 to present the artefacts of a particular historical period

and

2 to train students to use their eyes in study.

It is in this second point that art history differs from other subjects in the Humanities.[1] The art historian needs the same skill at handling old documents and texts as the political or economic historian, but he also has to have sensitive eyes. In studying art history you are educating your sight to discriminate between what is good and what is mediocre. Both can be interesting, but you should be certain that you always know why.

But do not be fooled into thinking that art history is the same as art appreciation. It is not. There really is no such thing as a naïve viewer. Whether you realize it or not, every time you look at something you interpret it. Art history helps you to analyse your responses. Certainly, it is not much fun to look at something which you do not appreciate. Art history and art appreciation should complement one another; they are not interchangeable. Let me quote you one of my heroes, the American art historian, Erwin Panofsky, who died in 1968: 'He who teaches innocent people to understand art without bothering about classical languages, boresome historical methods and dusty old documents, deprives naïveté of its charm without correcting its errors.' ('The History of Art as a Humanistic Discipline' in *Meaning in the Visual Arts*, p.43.) We do not expect you to learn classical languages (these are only, in fact, necessary if you intend to specialize in the art of the Renaissance or the Middle Ages), nor is it feasible for you to study Panofsky's 'dusty old documents', but it is possible to lose your naïveté. Remember that in art, no less than in politics, few things happen by accident. It is the duty of educated people to ask 'Why?'

[1]Much of what Arthur Marwick says in Units 3–5 *Introduction to History* applies to art history too; art history, after all, is only a species of history. Rightly, he stresses that the study of history is not a sentimental interest in the past, but an academic reconstruction of it. Yet the analysis of works of art, however, often involves the use of psychology and philosophy which makes it much more than just history. 'Art history' is just a term of convenience.

45

EXERCISE

Read the two passages which follow. Each discusses the same imaginary work by an imaginary artist. Would you care to say what are the characteristics of each one?

> 1 In the marrow-chilling marshlands of East Flanders, in the face of the hostile winds blowing off the Meuse, there is the little church of Sint Jan oop de Kriek . . . In this church, which turns its back to the chill, there stands a remarkably beautiful picture by that towering master of the Renaissance in Flanders, Gerrit Wronk. A genius inspired by God, Wronk needed no apprenticeship and passed straight into the unrivalled style of his maturity; his handling of the paint, like the touch of an angel's wing, combines with the pure effulgence of tooled gold to impress on the awe-struck visitor that Gerrit was in touch with the seat of the human spirit. Indeed, who could argue that it is no less than the inevitability of man's destiny that is the message of Gerrit's virtuoso efforts in the Sint Jan retable?

> 2 Three documents relating to the career of Gerrit Wronk are preserved in the Staatsarchiv at Kriekberg. The first relates to his apprenticeship with the itinerant Italian master, Ludovico Ignoto (1374–1437), in his workshop at Sillenaar (Staatsarchiv,ms. vern.1234,fol.23v). From these articles of agreement it appears that Gerrit had an unusually long apprenticeship, from December 1st 1412 to November 30th 1427. The second document records a commission from the Canons of Sint Jan for an altarpiece to be supplied by Gerrit and his *kinderen* for the fee of 50 shillings to be painted and delivered between June 1st 1432 and June 1st 1433 (Staatsarchiv.ms.vern.5678, fol.16r). The fact that a third document (Staatsarchiv.ms.lat.0001,fol.7v) records Gerrit's employment on a diplomatic mission to Sardinia at the behest of Duc Nicolas le Canard from June 5th 1432 through June 2nd 1433 suggests that the altarpiece presently standing in Sint Jan is largely the work of Gerrit's *kinderen* (assistants), perhaps relying on a drawing supplied by the master before his departure for Sardinia.

DISCUSSION

1 This is an example of enthusiastic, but ill-informed writing about art, the author being too fond of rushing to grand conclusions without the evidence to support them.

2 This is, admittedly, a rather dry piece of writing, but it is good art history. The author plainly admires the work of Gerrit Wronk (otherwise he would presumably not be bothering to talk about it in the first place), but he has taken the trouble to go to the Staatsarchiv to check the documentary evidence before writing about the master. His discoveries there refute entirely the assumptions made by the first author. Far from being a natural genius we could deduce from the long apprenticeship that Gerrit was probably a rather dull pupil and instead, as the first author said, of being inspired by God, as he would have liked to believe, it seems more likely that he drew the basis of his style from the example of his master, Ludovico Ignoto. Furthermore that he was in Sardinia during the period when the altarpiece was being painted suggests that instead of it being the profound work described by the ignorant first author, it is merely a hack piece of studio work turned out by his assistants.

This has been an absurdly exaggerated example, but it might serve to show what documentary evidence (in the most ideal circumstances) can produce.

3 THE RENAISSANCE AND ART HISTORY

In this section I want to suggest to you the idea of the Renaissance and at the same time sketch the development of art history.

Art historians concerned with western art divide the world up into four large chronological periods: Classical, Mediaeval, Renaissance and Modern. There are finer divisions, of course (Late Classical and Early Mediaeval come between Classical and Mediaeval and Baroque comes between Renaissance and Modern), but the distinctions still hold good.

The Renaissance was too subtle and complex a phenomenon to be able to sustain a simple definition. The more sophisticated you get, the more you will find that you resist all-embracing definitions. If anything at all, you could say that the Renaissance was a period which begins in Italy in the fourteenth century, a little later in the north, and lasts for about two hundred years. The Renaissance was a period when there was a widespread revival of learning and art history was an invention of it. Of course there were ancient writers who had something to say about art, but in their books art just took its place in a succession of different phenomena, natural and artificial, which the ancients used to like to describe. Such a writer was Pliny whose *Naturalis Historia (Natural History)* was written in the first century AD. It is our earliest encyclopaedic source of knowledge about the art of the ancient world and it served as a model for many of the writers of the Italian Renaissance.

Italian art history could be said to begin with Ghiberti's *Commentarii (Commentaries)*. It was Ghiberti's opinion that the decline in art which preceded the Renaissance was due to the interruption of the classical tradition. His auspicious follower was the most famous Renaissance art historian of all, Giorgio Vasari, whose *Le vite de piu eccellenti pittori, scultori ed architetti*, an imbroglio of gossip, half-truths and hoary traditions together with a great deal of intimate knowledge, appeared in 1550. Vasari's concern was, like ours, to find out the 'causes' of style.[1]

Both Ghiberti and Vasari were practising artists themselves. In their writing no distinction is made between art criticism and history. The specialization which we see now as a product of the Renaissance had not yet influenced writing about art. Vasari thought he knew what good art was. He had one idea of excellence and that was Michelangelo. All progress in art, he thought, was leading up to the conditions which made it possible for Michelangelo to create his great works. This idea of having one model which should be imitated was the spine of the academic system in Europe. From the Renaissance through to the nineteenth century artists were trained in Academies which accepted that there was a single type of art worth emulating. After the Renaissance, until the nineteenth century, art history was little more than the study of accepted standards in the academies of Europe. Generally speaking these standards were Michelangelo and certain selected works of the Greeks and Romans.

From this intellectually rather soft type of art history (although it was not called that) the Germans were the first people to diverge and give the study of art some academic, scholarly edge. The single work which most people isolate as being typical of this trend to specialize knowledge was Johann Joachim Winckelmann's *Geschichte der Kunst des Alterthums (History of Ancient Art)* which appeared in 1764 (Figure 33).

[1]There is an excerpt from Vasari in the Supplementary Texts (document A4 in the history section).

Figure 33 Title page from J. Winckelmann Geschichte der kunst des alterthums, *1764 (Crown copyright. British Library Board).*

Winckelmann believed that art demonstrated the national spirit; this was an idea (influenced by contemporary philosophy) which was to characterize much of German art historical writing in the next century. A tradition of serious research and publishing of art books was created in Germany and the first university chair of art history was established for Gustav Friedrich Wagen at Berlin in 1844:[1] England had to wait until 1932 before a permanent chair of art history was created at London University.

Throughout the nineteenth century art history was a staple of German education as much as philosophy and law and, according to the German method, was subject to just as rigid academic discipline as those two sombre subjects. One of the most significant developments in German art history towards the end of the nineteenth century was the idea that paintings – indeed, any art object – could

[1]Wagen was also the first writer to publish a modern account of the van Eycks. His *Über Hubert und Jan van Eyck* came out in 1822. The increasingly academic study of art in Germany was contemporary to the same development in the academic study of history, characterized by the work of the historian Ranke, mentioned in Units 3–5, *Introduction to History.*

be analysed in terms of pure form. At a time when the simple chronology of style and attribution of authors to pictures was still far from complete this was a revolutionary idea. The two men prominent in this field, Heinrich Wölfflin and Aloïs Riegl, were both influenced by contemporary trends in psychology and philosophy. So called 'introspectionist' psychologists were then laying emphasis on exactly the same attitude to the comprehension of the everyday world. At about the same time, photographic reproductions of works of art were becoming more widely available, replacing the older engravings which had hitherto been used in the study of art. The greater accuracy of the photographs made proper stylistic analyses possible for the first time.

In television programme 16 about the Ghent Altarpiece I employ the very opposite type of art history to that of Wölfflin. This was the type of art history sponsored by a man called Aby Warburg, first in Hamburg and then in London. The Warburg method was to treat works of art as packages of cultural information, full of symbols and ideas. The Warburg Institute (which is now part of London University) is specifically devoted to the study of the 'survival of the classics'. This approach, the very opposite to the innocent eye seeking novelties in form, line or space, is called iconography. Erwin Panofsky used the iconographic approach to art and although in his writings on the Italian Renaissance he did, as the Warburg Institute does, study the 'classical tradition', his greatest works were those in the area where the classical tradition was at its weakest: the Renaissance in the north of Europe. The bulk of this unit is about a picture which is often considered the single greatest work of art of the Renaissance in Northern Europe, the Ghent Altarpiece by Jan (and Hubert?) van Eyck, and in treating it I must admit my own allegiance to the method of Panofsky[1] which seems to me about the best method there is of understanding a Renaissance painting.

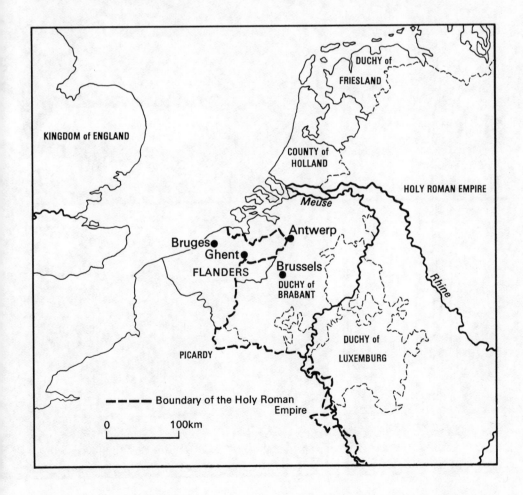

Figure 34 Map of Flanders in the fifteenth century.

[1]Although it is only fair to point out that recently Panofsky's particular brand of the Warburg approach has rather been overthrown, and absorbed into the wider field of art historical studies.

4 THE NORTHERN RENAISSANCE

Jan van Eyck was the most celebrated painter of the Northern Renaissance, but what was the Northern Renaissance?

You should remember that, although sophisticated Italians like Marsilio Ficino in the fifteenth century and Giorgio Vasari in the sixteenth century were conscious that changes had occurred in art in the fourteenth century, our notion of 'Renaissance' is, in fact, a modern one and would not have been comprehensible to Jan van Eyck himself.[1] In fact, in the north specific developments which characterize the idea of 'Renaissance' are even harder to spot than in Italy. The romantics were inclined to see the period as one of darkness, cruelty and gloom (but, then, they were just the things that the romantics liked); we are most inclined to admire the serene quality of stillness and harmony which we perceive in the paintings of the time.

[1]Our modern usage of the word 'Renaissance' goes back no further than the first half of the nineteenth century in France. It seems to have been used first in a specific historical sense in a French novel of 1829 and was 'canonized' when the historian Jules Michelet published *La Renaissance* in 1855.

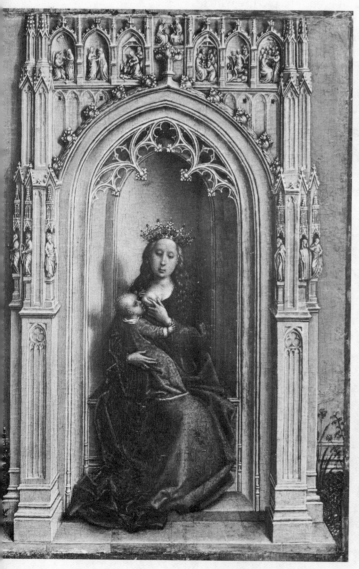

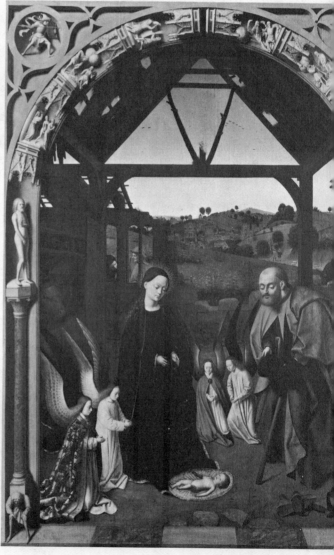

Figure 35 Rogier van de Weyden, Madonna enthroned *(Stichting Collectie Thyssen-Bornemisza, Amsterdam).*

Figure 36 Petrus Christus (c. 1410–72/3), The Nativity, *51¼ × 38¼ ins (National Gallery of Art, Washington D.C. : Andrew Mellon Collection).*

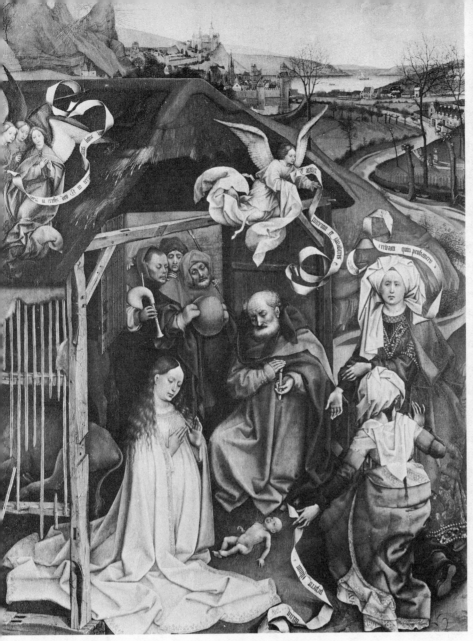

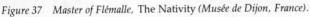

Figure 37 Master of Flémalle, The Nativity (Musée de Dijon, France).

Figure 38 Jan van Eyck (1380/1400–1441), The Annunciation, *transferred from wood to canvas, 36½ ×14⅜ ins (National Gallery of Art, Washington D.C.: Andrew Mellon Collection).*

We can speak of the Northern Renaissance only in relative terms. There was certainly an explosion of culture, in particular the music of Guillaume Dufay and Gilles Binchois, but it was much smaller than the one that had occurred in Italy. In the north the feudal society still remained while in Italy it had long since disappeared; the Renaissance in Italy saw a revolution in architecture while buildings in the north remained relatively unchanged; in Italy Vasari was only able to account for the innovations in art by saying that God intervened, otherwise he had no explanation for the changes. Even in our own century the government sponsored survey of Northern Renaissance art suggests that the northern painters were a little backward. It is called *Les Primitifs Flamands (The Flemish Primitives)*.

Jan van Eyck and his contemporaries lived in a garish world, working for Dukes and Princes who retained many of their feudal rights and privileges. Nowadays because we have left to us only the pious devout pictures we should not assume that they are necessarily a reflection of the sobriety of contemporary life (see Figures 35–38). Both Jan van Eyck and Roger van der Weyden painted hunting and bathing scenes which are now lost. One van Eyck bathing picture even employed his favoured mirror-in-the-picture device to allow the viewer to see both the front and rear aspects of a woman bather.

51

Almost incredible excess was common at the regular festivals held throughout the fifteenth century. In his *Mémoires* Olivier de la Marche described some of the spectacular activities at these indulgences – a pie with an orchestra inside it, a church sounding like an organ and a spectacle employing a giant dressed as an Arab, carrying a double headed axe, leading an elephant wearing a castle inhabited by a nun in white satin – and there is no reason to suppose that Jan van Eyck, who was an accomplished courtier and diplomat, was not familiar with such activities. The painter Melchior Broederlam was employed in the castle at Hesdin to service a device used for sprinkling water on surprised guests: you had to be robust to survive the Northern Renaissance.

Jan van Eyck was such a survivor. He has been famous to schoolchildren for generations as the inventor of oil painting and the 'founder' of the Flemish school of painters. Both are myths. The story of the invention of oil painting was due to the writings of an Italian called Bartolommeo Fazio who said that Jan of Gaul, as he called him, learnt his oil technique from Pliny's *Naturalis Historia*. Vasari calling him Giovanni da Bruggia (John of Bruges) said that he invented oil painting because he was interested in alchemy. Part of this Italian wonder about 'oil' paint was caused by their contemporary technique of using egg as a medium for painting. Oil painting, which allows an artist to use tiny brushes and work with very smooth, easy strokes (and makes Northern paintings look much the way they do in comparison to Italian egg tempera where areas of colour are built up with short strokes), was part of a northern tradition: Jan van Eyck inherited it, he did not invent it. And as for being the 'founder' of a school, we no longer speak in such dogmatic terms.

So how can we find out more about Jan van Eyck than either Fazio or Vasari did? We have to look at documents. Luckily for us Jan van Eyck is the best documented painter of the Northern Renaissance. Even without the documents (which are not very numerous) we would know about him because he signed more of his pictures than any of his contemporaries. The study of documents is one of the principal means an art historian has of finding out about an artist, or a picture, which interests him.

EXERCISE

Remember, in the fifteenth century, when the Ghent Altarpiece was painted there were no newspapers, indeed, no printed sources of any kind. What do you imagine the documents I am referring to might be and what difficulty do you imagine there might be in studying them?

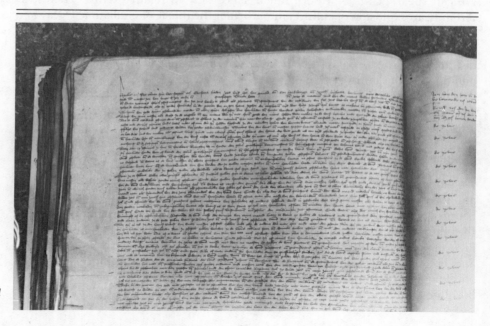

Figure 39 Foundation document of the Vijd Chapel Ghent (BBC-OU).

DISCUSSION

Many different types of documents relating to art are preserved. There might be bills of sale between merchants – for goods like *lapis lazuli* (to make the colour blue) or gold with which to gild a frame – and artists; there might be articles of apprenticeship; there might be municipal tax returns from an artist; ecclesiastical documents relating to commissions or inventories accounting for what remained in a painter's workshop after his death.

The difficulty in studying these documents is twofold:

1 In the north documents concerning painting are extremely scarce in comparison with the amount in Italy. (In many archives in Italy and other parts of mainland Europe there are still many hundreds of ancient, unread documents. There is no knowing what interesting information they contain until someone reads them.)

2 All these documents are, of course, written in manuscript and not printed (see Figure 39). Unless you are skilled in palaeography (the science of reading manuscripts) it is often simply *impossible* to read a fifteenth-century manuscript, even if you can understand the dog Latin it is most likely to be written in.

The amount of Jan van Eyck's signed works tell us something about his attitude to life; he was obviously an acutely self-conscious man, aware of his own existence and independence as a master of his art. He is not an anonymous workshop practitioner, but a single-minded individual. He was arrogant too. He signed his *Man with a Red Turban* (sometimes held to be a self-portrait) (Figure 40) with the motto 'Als ich kan'. It means, literally, 'As I can' but the idiom means 'Beat that!'

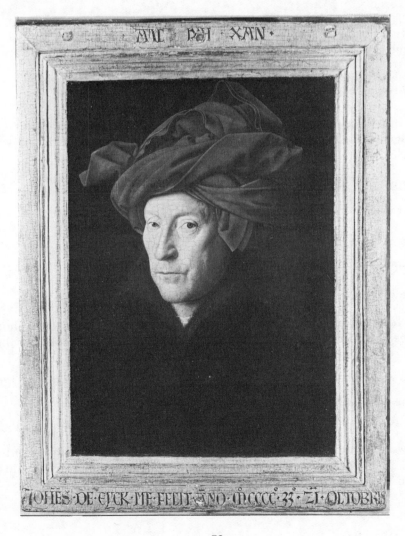

Figure 40 Jan van Eyck, Man with a red turban, 1433 (National Gallery, London).

5 THE GHENT ALTARPIECE

I have chosen the Ghent Altarpiece as a long example to illustrate the text of 'What is Art History?' because there is a single major problem involved in writing about it which is a good illustration of the type of problem art historians have to deal with, although you must not think that my own concentration on a single problem here fully reflects the range and breadth of art historical studies. The problem is a simple one. From an inscription on the frame of the altarpiece we know that the painting was finished in May, 1432. We know from documents (for instance, that in 1422 Jan van Eyck entered the service of John of Bavaria), and from the signed paintings, that Jan van Eyck was a well known character and an accomplished painter. Yet none of Jan van Eyck's signed pictures ante-date 1432. On the other hand, from an old copy of an inscription on a tombstone we know that a certain Hubert van Eyck died in September 1426. Jan died in 1441 and it has been assumed, on account of these dates, that Hubert was the elder brother of Jan. There would be nothing unusual about this were it not for the extraordinary statement made in the inscription on the frame. Students of Eyckiana know of this inscription as the *quatrain*.

It reads

> Pictor Hubertus e Eyck, maior quo nemo repertus
> Incepit pondus q[ue] Johannes, arte secundus,
> [Frater per] fecit, Judoci Vyd prece fretus,
> Versu sexta Mai vos collocat acta tueri

In English this reads:

> Hubert van Eyck, the most famous painter ever known,
> started this work; his brother Jan, the second in art,
> finished the momentous commission at the request of Joos Vijd.
> With this verse the donor consigns the work to your charge.

In the Latin verse the letters m c c c l l x v v v v i i in the last line are picked out in red, giving the date in Roman numerals as 6 May (mentioned in the verse itself) 1432.

EXERCISE

What problems do you think the discovery of the quatrain created?

DISCUSSION

From what I have already told you about the career of Jan van Eyck you should have been able to work out at least the following questions about the Ghent Altarpiece:

1 Who was Hubert van Eyck and why do no documents exist relating to him?

2 Is the quatrain a forgery?

3 If it is genuine then who painted what parts of the Ghent Altarpiece?

4 Why are no other works by Hubert van Eyck ('Maior quo nemo repertus') known? That is to say, if he was as good as the inscription claims, why do we know so little about him?

and

5 The altarpiece was not finished until six years after Hubert's death, so Jan van Eyck must, surely, have played a considerable part in its execution.

In fact, scientific tests using x-rays have shown the quatrain to be original so we must therefore seek a solution to the questions it poses. And, furthermore, there are *some* documentary references to Hubert, but they are only very slight.

W. H. J. Weale, the great English historian of the Northern Renaissance, listed the following:

1 A payment by magistrates to a *Meester Luberecht* in 1425 for two sketches of a *tableau*.

2 Another payment from magistrates in 1425 to the apprentices of *Meester Ubrecht*.

3 Instructions given in 1426 for the completion of an altarpiece in the church of St Sauveur to *Meester Huberechte*.

and

4 A receipt, dated after 18 September 1426, for death duties paid by the heirs of Lubrecht van Heyke.

To these scattered documents Panofsky added

5 A reference to a nun in a convent near Gravelines being bequeathed a painting by a 'Hubert'.

Not much to go on, certainly, especially with the variation in the name occurring in every reference, but this should not put you off too much because spellings were not standardized before the invention of printing, and not always even after that.

Were it not for the testimony of the quatrain the problem of authorship would scarcely have arisen and the crepuscular figure of Hubert would have dissolved into the dark parts of history. Yet, look at the altarpiece and you will see that the styles are different throughout the picture. I think the scene of the *Adoration of the Lamb* looks more archaic than the *Annunciation* scene on the outside of the altarpiece, but perhaps that is to be expected in a painting which took so long to finish during a period when changes in art were being made rapidly. Also, differences in the styles of individual panels of the altarpiece might be caused by the artist, or artists, deciding to treat heavenly scenes in a different manner to the earthly ones. Look at the folding card of the altarpiece very carefully and decide whether *you* think all the panels, on stylistic evidence, could have been painted by one man.

The people of Ghent have always favoured the idea that Hubert, who lived and died there, was the 'founder' of the Flemish School of Painting and the creator of the Ghent Altarpiece. The people of Bruges, on the other hand, favour the sole authorship of Jan. Thus the van Eyck problem has for a long time been tied up with local municipal rivalry: in 1913 amid much pomp, a van Eyck monument was unveiled in Ghent, showing clearly, in story book fashion, the two brothers sitting side by side. So sure had the German art historian, Max Friedländer, become that Hubert did not exist that he refused to attend the unveiling ceremony of the monument, when invited to it by the King of the Belgians (Figure 41).

Here is a very abbreviated survey of what travellers and writers have had to say about the van Eycks' Ghent Altarpiece. Do not attempt to memorize this list, I am offering it only as a background so that you will be better prepared for the slightly fuller analysis of Panofsky's treatment of the altarpiece which I am going to discuss below.

Figure 41 Van Eyck monument, Ghent (A.C.L. Bruxelles).

Bartolommeo Fazio 1456

Fazio's *De Viris Illustribus* (*Of Famous Men*) was written in 1456. He claimed that Jan van Eyck 'judged the leading painter of our time', learned his oil painting technique from Pliny.

Albrecht Dürer

Dürer, the most truly 'Renaissance' of all northern painters, visited Ghent to see the altarpiece. He does not mention Hubert and calls the altarpiece a 'most precious painting of high understanding'.

Giorgio Vasari 1550

In his *Vite* (*Lives*), Vasari repeated Fazio's statement that Jan van Eyck invented oil painting. Did not mention the inscription.

Lucas de Heere 1559

De Heere was a Ghent painter active in the mid sixteenth century. He wrote a ninety-two line *Ode* and attached it to the wall of the Vijd Chapel where the altarpiece stands. He published his verse in 1565. In it he makes a claim for dual authorship of the altarpiece; historians who seek to disprove the existence of Hubert often like to point out that before De Heere there are only the references to Hubert which I have mentioned on page 54.

Mark van Vaernewyck 1562

Van Vaernewyck mentioned Jan van Eyck in his *Nieu tractaet ende curte beschryvinghe van dat edel graefscap van Vlaenderen* (*New Treatise and Brief Description of the Noble County of Flanders*) in 1562. In writing of Jan van Eyck he adapted Vasari's account of Giotto.

Ludovico Guicciardini 1567

In his *Discrittione di Tutti i Paesi Bassi* (*Description of all the Low Countries*) of 1567, Guicciardini, who had settled in Antwerp in 1550, continued the story that Jan van Eyck had invented oil painting, suggesting the year 1410 as the precise moment of the invention. He also said that the van Eyck brothers collaborated on an altarpiece.

Christophe van Huerne c.1616

A manuscript of copied inscriptions by van Huerne was discovered by the Belgian art historian, Emile Renders. He suggested that the brothers had a share in the completion of the altarpiece and that self-portraits of the two are included in the panel showing men on horseback.

Johann Wolfgang von Goethe

In an epigram called *Modernes* the German polymath compared Jan van Eyck to the Greek sculptor Phidias (doyen, if you like, of the 'classical' school) as preeminent masters in very different schools.

W. H. J. Weale 1904

In an article in the *Burlington Magazine*, the most respected English language art periodical, Weale attempted to separate from the generalized van Eyck oeuvre certain individual works by Hubert.

Max Friedländer 1924–31

In a monumental series of monographs on *Die Altniederländische Malerei* (*The Old Dutch Masters*), Friedländer, a towering authority in his field, did not believe that any works by Hubert existed.

Emile Renders 1933

In his *Hubert van Eyck: Personage de Legende* (*Hubert van Eyck: the legendary Person*) Renders finally, as he would have had it, separated Jan from the 'imaginary' Hubert, suggesting that Hubert did not exist.

Laboratoire Central des Musées de Belgique 1951

When the Ghent Altarpiece was scientifically examined a result was achieved that appeared to lend weight to the opinion of Friedländer and Renders that no works by Hubert existed. The final report said 'We have examined the picture both superficially and in depth to see if it was possible to discover the hand of a second great master, but in vain.'

Maurice Brockwell 1954

In his highly eccentric and unreliable account, *The Van Eyck Problem*, Brockwell, who had once been a colleague of Weale, suggested that Lucas de Heere's *Ode* was a forgery and that all 'tales' about Hubert van Eyck were 'specious'. He set out only to prove one thing – that Hubert van Eyck was an imaginary character – and sided with anybody, no matter how bizarre and inaccurate their opinions, who offered even a scrap of evidence in support of this thesis.

Lotte Brand Philip 1971

The latest author to write a full scale study of the Ghent Altarpiece suggests the novel idea, in some ways inspired by Panofsky, that the whole altarpiece was once in the form of architectural reliquary. She claims that the upper seven panels appear as they do because they were once in an architectural setting: the musical angels were meant to be in an open space, underneath an imitation flying buttress. Philip also suggested that the altarpiece was an elaborate form of *kinema* and calculated that if each separate panel were hinged, there would be ninety-eight possible combinations of pictures. That number exactly corresponds to the number of ecclesiastical festivals.

I have left the discussion of Erwin Panofsky's account of the Ghent Altarpiece to the end because it is, in my opinion, by far the most discerning and intelligent of all. Panofsky tempers superb scholarship with wit. In Section 6, I am going to compare Panofsky's writing with Brockwell's. Panofsky is fastidious and eleg-

ant, while Brockwell is clumsy and turgid. I hope that it will prove to be an instructive comparison.

Let me remind you again that Panofsky's approach to looking at a painting, any painting, was an iconographical one. That does not, of course, mean he ignores stylistic considerations as we shall see. He divided his method of studying pictures into three parts:

1 *Primary subject matter* (natural subject matter)
What does the painting show? This is a pre-iconographical description. The primary subject matter of the Ghent Altarpiece would be a list something like this:

> One woman with wings
> Three women dressed in blue
> One man in green holding a lamb
> One man in red, sitting down, with a jewelled hat
> Seventy-six assorted people wearing ecclesiastical robes etc.

This pre-iconographical account is what a literate, but uneducated, person could describe.

2 *Secondary subject matter* (conventional subject matter)
I have tried to show in television programme 16, that accompanies this unit, how the interpretation from primary to secondary subject matter develops. For instance, the 'one woman with wings' is an angel, 'the man in green holding a lamb' is St John the Baptist, while the 'man in red, sitting down, wearing a jewelled hat', is God.[1]

3 *Intrinsic meaning or content*
This is the interpretation of the subject matter. In the Ghent Altarpiece, as I have tried to show in the television programme, the intrinsic meaning is the Redemption of Man. Panofsky as well as having the sort of literary knowledge which is required to undertake an iconographical analysis of a painting also had a fine eye for style. He applied himself to the van Eyck problem and devoted almost one eighth of the text of his great book *Early Netherlandish Painting* (Recommended Reading) to the Hubert-and-or-Jan question. His analysis of the altarpiece was as follows:

(a) There is an anomaly in the way the altarpiece works. That is, the inner panels are painted round at the top, but are, in fact, square so that when the wings are shut the inside panels are only partially hidden.

(b) The vertical divisions of the frames on the lower part are not on the same axis as the upper ones.

(c) No artist would want to stretch the two figures of the *Annunciation* scene over four panels (that is to say leaving two of them empty) unless he were forced to. From these observations Panofsky deduced that the panels which comprise the Ghent Altarpiece are a more-or-less 'accidental assemblage'.

Panofsky's iconographic knowledge told him that the *Just Judges* panel was an unusual one for a religious picture. Usually only saints or donors are depicted in altarpieces and Panofsky, always ready to identify a saint on the slimmest of iconographical details, cannot recognize one saint among the *Judges*. He explained this by writing 'They are admitted to the hierarchies of the Blessed, not as an accepted category of saints but as the ideal representatives of a specific group of living dignitaries who hoped to be included with the Elect.' Now this is interesting because Panofsky's basis for saying this is the evidence of the documents dated 1425 which I mentioned on p.55. The magistrates these documents refer to, Panofsky says, wanted themselves, or at least, the legal profession, dignified in this way and it was they who commissioned the lower half of the altarpiece, the tableau referred to in the Meester Luberecht document.

[1]This very much compressed account of Panofsky's method is derived from his 'Introduction to the Study of Renaissance Art' in *Meaning in the Visual Arts*, p.55.

Panofsky goes on further to say that Hubert left these (and other) unrelated panels behind in his studio at his death and his brother Jan supplemented and finished them. He goes on to analyse further parts of the altarpiece and suggests that the musical angels are not related either to the *Adoration of the Lamb* panel or to the *Deësis* (the technical term for the interior, upper three panels showing God, the Baptist and the Virgin). He explains this by suggesting that they were originally intended as the painted shutters on an organ, supporting this idea by saying that they are the only wingless angels known in northern art of the fifteenth century and that this would have been appropriate for a relatively secular position on an organ, a less elevated (literally and metaphorically) position than they now occupy on the altarpiece.

Panofsky continues by saying that the *Adam and Eve* panels were ad hoc additions, their shape and proportions being dictated by the difference in width between the musical angels and the existing lower panels. He claims that (partly because the exterior is wholly coherent in iconographic terms) Jan was responsible for all the exterior. Parts of the *Lamb* panel, he says, are Jan's, especially the distant views which he felt were characteristic of his style.

Although Panofsky admitted that some of his statements were 'conjectural', I find his argument convincing particularly in his succinct summing-up. He says 'Hubert van Eyck appears as an artist less modern, cosmopolitan and polished than his brother Jan . . . In Hubert . . . we may sense a certain tension between the will to conquer volume and space and an allegiance to the more graphic tendencies of the past.' You do not have to agree with Panofsky, but you have to admire his methodical approach. Apart from his wide knowledge of Flemish art, in considering the Ghent Altarpiece he had little more evidence to go on than you have had. Would you have reached the same conclusion about the authorship of the panels?

6 CONCLUSION

In trying to give you some idea of the richness and complexity of art history I hope that I have neither sated you nor confused you. I have not been trying to offer a full account of the Ghent Altarpiece or of the van Eyck problem, but I have been trying to indicate to you – within this very limited space – what problems art historians face. There is nothing arcane about art history. I am sure that Panofsky can unwittingly explain it better than me. Compare the two following passages. In the first Maurice Brockwell is introducing his discussion of the van Eyck problem. In the second Panofsky is doing the same:

> 1 Any attempt at a solution of the Van Eyck problem is centred in the Ghent Polyptych. This, because the *quatrain* contains the names of both 'Hubert' (whose very existence has now been demolished) and Jan van Eyck – the one and only Master in early Netherlandish painting. The once accepted date of 1432, and the laudatory reference to 'Hubert' as *pictor Hubertus e Eyck maior quo nemo repertus,* have during the present generation become suspect. (Brockwell *The Van Eyck Problem,* p.10.)

> 2 In telling the story of the van Eyck brothers, whose shadows loom so large over our previous discussions, we can unhappily not begin at the beginning. It would seem natural to discuss the elder brother, Hubert, before the younger, Jan, and to take up the latter's works in chronological order. But of Hubert's style we have no authenticated example except his contributions to the Ghent altarpiece and these can be determined, if at all, only by an attempt to disentangle them from Jan's. Of Jan, on the other hand, we have no authenticated work unquestionably antedating the Ghent altarpiece. It is, therefore, from Jan's the later master's, later style that we must try to find our way back. (Panofsky *Early Netherlandish Painting,* p.178.)

I do not think that there can be any doubt, on reading these two passages which is written in better English and which is more careful and discriminating in making its case clear, but if you ever get the chance to read the whole of both books from which these passages are taken you would realize that not only is Panofsky a better scholar than Brockwell, but in bringing his argument up to a virtually irrefutable climax he employs not only his scholarship, but his eyesight as well. You do not have to want to emulate his approach to painting to be able to acknowledge that in his combination of scholarship and keen sight Erwin Panofsky represented to a very high degree the best qualities an art historian can have.

RECOMMENDED READING AND REFERENCES

PART 1 WHAT IS ART?

Bell, Clive (1914 and reprinted) *Art*, Chatto and Windus. Several generalized but provocative essays on such themes as: 'What is Art?', 'Art and Life', 'Christian Art', 'Society and Art', 'Art and Society'. Selective reading.

Braive, M. (1966) *The Era of the Photograph*, Thames and Hudson.

Collingwood, R. G. (1938, 1970) *The Principles of Art*, Oxford University Press. A philosophical work on aesthetic theory calling for selective reading. Consult the list of contents.

Fry, Roger (1920 and reprinted) *Vision and Design*, Chatto and Windus. A few essays on such themes as Bell's but mostly very perceptive pieces on art and artists favourable to the more imaginative critic of the early part of the century.

Morris, D. (1962) *The Biology of Art*, Methuen.

Read, Herbert, (1931 and reprinted) *The Meaning of Art*, Pelican. A concise and clearly organized series of section headings covering most themes relevant both to art theory and history. Somewhat biased in favour of 1930s avant garde attitudes about art, but usefully stimulating nevertheless. 67 illustrations.

Sesonske, A. (1965) *What is Art?*, Oxford University Press.

Tolstoy, L. (trs. Aylmer Maude) (1930) *What is Art? and Essays on Art*, Oxford University Press.

PART 2 WHAT IS ART HISTORY?

Brockwell, M. W. (1954) *The Van Eyck Problem*, Chatto and Windus. A highly eccentric piece which should be treated with the greatest caution but useful (in the sense of self-parody) in showing how complicated art history can be.

Huizinga, Johan (1965) *The Waning of the Middle Ages*, Peregrine. Huizinga specialized in that ill-defined academic hinterland which combines anthropology, history, literary criticism and sociology which we call *cultural history*. *The Waning of the Middle Ages* which deals with the development from the Middle Ages to the Renaissance in northern Europe is, in my opinion, one of the greatest pieces of historical writing ever done. It is a marvellous antidote to boredom or frustration with a subject: if you ever begin to doubt that it is worth studying history you should read Huizinga.

Panofsky, Erwin (1953) *Early Netherlandish Painting*, Harvard University Press. An enormous work in two volumes, Panofsky's magnum opus, but surprisingly easy to read. It is still considered by some people to be controversial.

Panofsky, Erwin 'The History of Art as a Humanistic Discipline', in *Meaning in the Visual Arts*, Doubleday, New York, 1955 and Peregrine, 1970. Don't let the pompous title of this essay put you off, it really is a very stimulating piece of writing.

Panofsky, Erwin *Renaissance and Renascences in Western Art*, Almqvist and Wiksells, Stockholm, 1965 and Paladin, London, 1970. A self-consciously clever book, but brilliant scholarship if you feel up to it.

Stechow, Wolfgang (1966) *Northern Renaissance Art 1400–1600*, Prentice-Hall, Englewood Cliffs, New Jersey. A very useful and intelligently edited collection of documents.

von Baldass, Ludwig (1952) *Jan van Eyck*, Phaidon. The standard work.

Venturi, Lionello (1964) *History of Art Criticism*, Dutton Vista, New York. The rather pedantic translation from the Italian does not make this complex book any simpler, but it is an irreplaceable guide to changing taste in art criticism and art history. Has a good bibliography.

UNIT 17 INVENTION AND CONVENTION
(STEPHEN BAYLEY)

CONTENTS

The Temple of Apollo, Bassae (National Tourist Organization of Greece).

Strasbourg Cathedral (Photographie Bulloz, Paris).

St George's Hall, Liverpool (Photo: A. F. Kersting).

Chateau de Pierrefonds, Compiègne (Caisse Nationale des Monuments Historiques, Paris. © Arch. Photo/
SPADEM, Paris, 1978).

1 INTRODUCTION

I want to show that art has no eternal values, that ideas give birth to forms and also that forms give birth to ideas. I want to show that ideas and forms develop and change and that the way people treat them is subject to variation too.

In *The Story of Art,* there are two chapters called 'Tradition and Innovation'. That could have been the title for this unit, but because Gombrich uses those very useful words to describe something rather different, I have decided instead to call it *Invention and Convention*: they are the ideas basic to this unit and two of the most important ideas for an understanding of art history, as well as of culture as a whole. In *What is Art History?* I suggested how art history could be used to interpret a single painting. What I intend to do here is to explain how a style is created (although, necessarily, my treatment of this will be very circumscribed), how it continues and how it is adapted. I want to show also how the same style, or psychological state, can be brought back to life many years after its real life became extinct. Sometimes when an imitation occurs or a convention is adopted the people responsible for it are removed by both historical and spiritual distance from the original style which they claim as their source. That's what I mean when I say that art has no eternal values.

This might seem very far removed from the type of art history I described in Unit 16, Part 2, but in fact it is very close indeed. The iconographic approach to the analysis of paintings, indeed, all images, is part of the technique of Aby Warburg and his followers in Hamburg and London. The Warburg method demands a concentration on images.[1] These images were conceived as a chain of progress: they were images which had helped to form the European mind and they stretched from antiquity throughout the ages. Look at Figures 1–6 and see if you understand what I mean.

Figure 1 *Maenad, from a Neo-Attic relief, Naples, Museo Nazionale (Alinari).*

Figure 2 *Bartoldo di Giovanni* Crucifixion, *Florence, Museo Nazionale (Alinari).*

[1]Almost any image would do. One of Warburg's last projects (he died in 1929) was to collect what he called a 'picture atlas' of images to be called *Mnemosyne* (the name, in Greek, of the mother of the muses which means memory) including unlikely subjects like photographs of lady golfers. Nowadays the word 'Mnemosyne' is inscribed over the entrance to the Warburg Institute in London.

Figure 3 Pedagogue from the Niobid Group, Florence, Uffizi (Alinari).

Figure 4 Andrea del Castagno David c. 1450, 45½ × 30½ ins (National Gallery of Art, Washington, DC, Widener Collection).

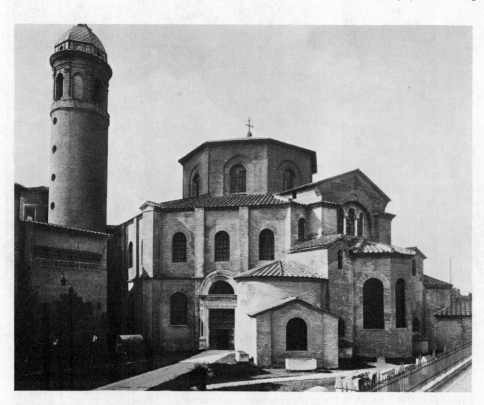

Figure 5 Church of San Vitale, Ravenna (Alinari).

In fact, the Warburg Institute does not study the history of art, but what Warburg called 'das Nachleben der Antike' (literally, 'the afterlife of antiquity'), what I called the classical tradition in the previous unit. This tradition has continued throughout civilization[1] and received its freshest charge in that chronological period we know as the Renaissance, when many of the artistic forms of antiquity were redeployed in art, as you can see in Figures 1–6.

The Renaissance is the most obvious example of 'tradition and innovation' in art, but there have been others besides. There have been, for instance, a number of

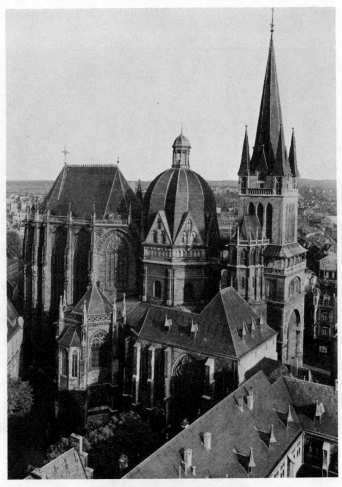

Figure 6 Palace Chapel, Aachen (Bildarchiv Foto Marburg, Marburg).

different 'Renaissances'. Historians speak of the Carolingian Renaissance of the ninth century and the Renaissance of the twelfth century. You see, the Renaissance which took place in Italy during the fourteenth, fifteenth and sixteenth centuries was only one part of a continuing process.

The Warburg Institute was interested only in the classical tradition, but I want to look at the *gothic* tradition as well, and instead of looking most of all at paintings I want to look at buildings and sculpture instead. You must have heard of these words 'classic' and 'gothic', but do you really know what they mean? Both words are, of course, in current usage, but gothic is perhaps a little more rare than classic or classical. If you look up the words in a dictionary you might get some illumination (depending, rather, on what dictionary you use), but probably not much – dictionary definitions are notoriously unhelpful, particularly in the case of words like these, which have acquired a significance beyond their original one. Not only, for instance, do we speak of classic French cooking, or a classical move in a game of football, we also speak of classical music and gothic novels.

[1]Some people would say that one of the most significant aspects of modern culture is, in fact, that the classical tradition has at last died out.

The words represent cultures and style characteristic of two poles of European culture, and two very different modes of expression. Classic suggests to us all that is cool, clear, rational, sanctified by age (by tradition, in fact) and suggests the best of its type, as in a 'classic dish'. Anything classical is also likely to be clean and ordered. Gothic, on the other hand, suggests darkness, spookiness, untidiness, passion in the place of rationality and mystery and fear in the place of dignity and order. This division applies elsewhere, too. When art historians discuss the way in which a picture is painted they sometimes refer to one as 'painterly' and the other as 'linear' (see Section 6). This would be the case with two French painters working in the first half of the nineteenth century, Delacroix and Ingres (see Figures 7 and 8).

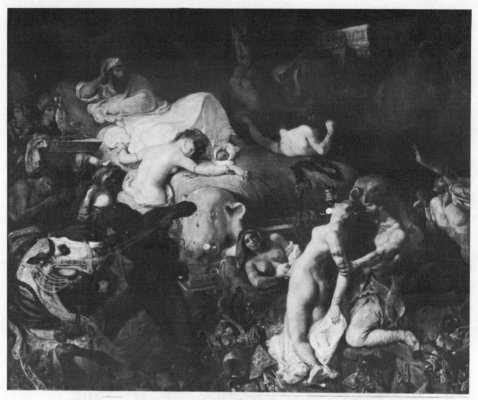

Figure 7 Eugene Delacroix The death of Sardanapalus, *Louvre (Cliché des Musées Nationaux, Paris).*

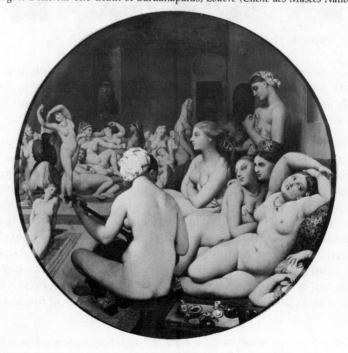

Figure 8 J.-D. Ingres Le Bain Turc, *Louvre (Cliché des Musées Nationaux, Paris).*

The difference in visual quality between two paintings by Delacroix and Ingres is very similar to the associations you should have in mind when you think of 'gothic' and 'classical', although I should make it clear that while it would in fact be true to say that the Ingres picture is to a degree 'classical' the Delacroix one is not really in any meaningful sense 'gothic'.

What do the words actually mean? 'Classic' derives from the same Greek root as 'call' and means the people as summoned together in an assembly. By extension, the word came to be used to indicate the different income groups and, therefore, to indicate rank as well. Eventually, the adjective came to be used to describe people of the very highest rank, the opposite of proletarian. So you see that, in antiquity, the word had nothing to do with cultural or intellectual values, as it does to us today, and it disappeared from usage entirely throughout the middle ages, being revived – appropriately enough! – only in the Renaissance.

In the first place, 'gothic' means pertaining to the tribe of barbarians called the Goths who over-ran the Roman Empire in the early Christian era. By extension, it came to suggest anything wild, fierce, grotesque and unkempt, and was first used in 1611 to refer to vernacular, instead of Latin, language, according to the *Oxford English Dictionary*. Although this sounds unfair to Germans, 'gothic' also came to suggest anything from Germany. Because of this we speak of gothic architecture, the style of church building which for a long time was believed to have originated in that country.

In the preface of his 1725 edition of Shakespeare, Alexander Pope called the dramatist 'gothic', but to find a full-blooded condemnation of the term we have to turn to Vasari, the first modern art historian. Vasari said that gothic (he calls it also 'il lavoro tedesco' that is 'German work') was monstrous and barbarous. In context, he said

> There are works of another sort that are called German, which differ greatly in ornament and proportion from the antique and the modern [i.e. Renaissance]. Today they are not employed by distinguished architects but are avoided by them as monstrous and barbarous, since they ignore every idea of order. (Vasari, from Chapter III of *Introduzione alle tre arti del disegno, architettura, scultura e pittura,* translated in Frankl. See 'Recommended Reading and References', page 131.)

Throughout his writing about architecture Vasari stresses always that gothic buildings lack order, even though he admits that in the time of Theodoric even Italian buildings were in the gothic style. He also says that gothic buildings look as though they are made out of paper, and not out of stone, as all true architecture should be.

The title of this unit, *Invention and Convention,* was chosen to suggest that after a style has been created, it is sometimes taken up and imitated. This is what happened with both the classical and the gothic styles in architecture. When we talk about the classical repertoire of anything – as in cooking – we almost imply this idea of imitation because the classical idea, or at least our concept of it, means selecting the best works from the past, and in the case of, say, classical sculpture, the past we are referring to is Greece in the fifth century BC. But this happened in the middle ages too. According to one very reliable authority,[1] as early as the fifteenth century in northern Europe the imitation of existing (gothic) buildings was often a stated requirement in architectural contracts. Masons like Villard de Honnecourt kept accurate records of details copied from buildings which they intended to imitate themselves.

So what is the educational purpose of this unit? Well, besides wanting to introduce you to the ideas of what was classical and what was gothic, I also want to familiarize you with the idea that to have a revival (when something is imitated) you have to be conscious of the past. The whole of the history of art is the story of the collection and analysis of the past. Artists are often contemptuous of this.

[1]John Harvey (1947) *Gothic England,* Batsford, pp. 23–4.

The American painter, Ad. Rhinehardt once said that the only use for art history was to show you what you needn't bother to do. I would rather recommend to you the comment of the great English antiquarian of the eighteenth century, William Stukeley:

> All things upon this voluble globe are but a succession, like the stream of a river: the higher you go, the purer the fluid, less tainted with corruptions of prejudice or craft, with the mud and soil of ignorance. Here are the things themselves to study upon; not words only, wherein too much learning has consisted. (William Stukeley *Itinerarium Curiosum*, 1776, page 2.)

That's precisely what I want you to do in this unit: use your eyes in looking at the figures. *They are very important.* It is they which will give you a real understanding of the classic and the gothic. Do not, as Stukeley says, worry too much about the words: there are perhaps too many of them and I am afraid that you might find all the different ideas expressed here a little confusing at first. But do not worry too much about that either. What I am trying to do here is quite novel: I want to be both a specialist and a universalist. You should try to be both.[1]

EXERCISE

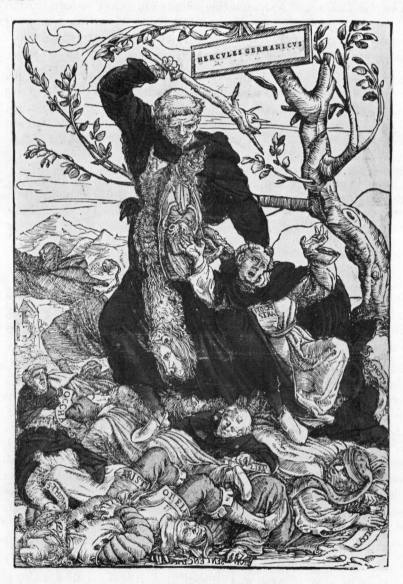

(a)

[1] A very great scholar indeed has said that 'Specialisation without universalism is blind. Universalism without specialisation is inane.' E. R. Curtius (1953) *European Literature and the Latin Middle Ages*, Pantheon Books, New York, p. lx.

(b)

If I tell you that (a) is a wood cut of Hans Holbein showing Martin Luther and that (b) is a sculpture of Herakles, the Greek mythological hero who killed his wife and his children in a fit of madness, what would you make of the comparison? (I recommend that you look very closely indeed at the Holbein woodcut. Incidentally Herakles and Hercules are the same name, Greek and Roman respectively.)

DISCUSSION

I am assuming in this exercise perhaps more historical knowledge than I have a right to, but I have given enough clues for you to be able to attempt an answer. If you have looked closely at the Holbein you will have seen a label on the tree saying 'Hercules Germanicus'. Even without any knowledge of Latin you should have been able to guess that this means 'German Hercules', that is to say Holbein is portraying Luther, the church reformer, as a 'German Hercules' (I expected you to know that Luther was a church reformer). Holbein shows him as the mythological Hercules, with his club and lion skin which are the conventional attributes of the mythological character. It is also conventional to show him as a very large man. Like the myth, also, he is shown to be in the act of slaying, but these are evidently not his children. Now, if you have looked at the

wood cut closely you will have seen that Luther-Hercules' victims all have name tags (except the pope, who is indecorously hanging around Luther's neck). Perhaps you don't actually recognize all the names (Aristotle, Nicolas of Lyra, Duns Scotus, St Thomas Aquinas), but you should have been able to guess that the woodcut is a symbolic representation of Luther's reforms. Holbein has employed the classical image of Hercules as a brawny giant, but transferred his mad slaying of his wife and children into the 'slaying' by Luther of the pillars of learning and of the church. I chose this picture as a representation of tradition, that is the classical tradition of Hercules, and of its imitation in the northern Renaissance.

2 THE CLASSIC

If we talk about classical architecture or sculpture we refer, by general consent, to the architecture and sculpture of Athens in the mid-fifth century BC, the time when, under Pericles, the city reached its greatest level of artistic and cultural achievement.[1] It was the works created in this period which are our 'classics', because for a long time they were considered to be the very best we had and all that was worth imitating. Sadly, we know virtually nothing about Greek painting, although we know quite a lot about the architecture and the sculpture. Most of the paintings were lost in the depredations of time and for any knowledge about them at all we have to turn to much later works like Pliny's *Natural History*, which I mentioned in Unit 16. However, to keep a sense of proportion you should bear in mind that the historical distance separating Pliny from the artists of Periclean Athens is about the same as the distance separating us from the Renaissance.

As far as architecture is concerned, we have little idea what Greek domestic buildings looked like, but we are all familiar with the appearance of their religious and civil architecture. Indeed, the forms created in Greece have been the prototype for architecture throughout the world, throughout the centuries.

Figure 9 Parthenon, Athens, from the Hill of Muses (Ronald Sheridan).

[1]There is a second level Open University course, A292 *Greece 478–336BC*, which describes these developments in detail.

Figure 10 *Pantheon, Rome (Ronald Sheridan).*

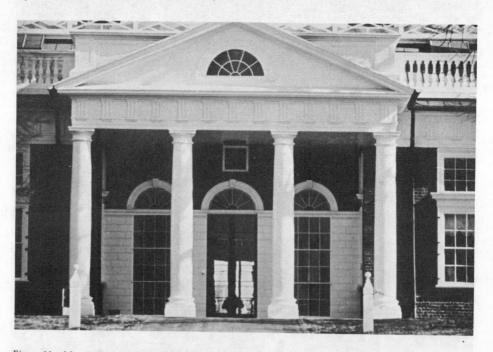

Figure 11 *Monticello, Virginia, East front (Tim Benton).*

Figure 12 The Bourse, Leningrad (Novosti Press Agency, London).

Figure 13 Radiator grille of a modern Rolls-Royce (Rolls-Royce Motors Ltd, Crewe).

Why has Greek architecture been so widely imitated? Obviously there can be no definite answer to this question, but I would suggest that it is partly because it represents the oldest western architecture with which we have contact through knowledge of contemporary literature. (I am discounting the pyramids and neolithic tumuli, etc.) Perhaps because Greek architecture is so obviously very *different* from nature, in the way that a contemporary Iron Age hill-fort in northern Europe is not. A classicist would say, though, that the real reason why Greek architecture has so often been imitated is because it is perfect and that it represents a standard from which there is no advantage in deviating. The idea of perfection is irretrievably tied up with the idea of what is classical. The notion that Greek temples really were perfect gained much impetus in the nineteenth century when Francis Cranmer Penrose (1817–1903) discovered what we call

refinements. The most well known of the refinements was the one which the Greeks called 'entasis', the deliberate bulging out of columns so that they *appear* to be straight. Refinements were a whole system of correcting the apparent optical distortions which any straight line takes on. For instance, Penrose would claim that the slight (in fact almost invisible in its own right) curvature on the stylobate (that is the base) of the Parthenon was done deliberately so that instead of appearing to sink, as any very long straight line would, it appears very straight. This explanation appealed to those who wanted to believe that the Greeks did everything perfectly, that proportion in both personal demeanour and in their buildings was a regular way of life to them, even to the extent of making artificial bulges to correct optical illusions. Rolls-Royce, in fact, do the same when they make radiator grilles for their motor-cars and model car manufacturers make their miniatures about one eighth wider than they should be to be true to scale, so that they appear more real. Yet, having said this, I have to record that many modern specialists, including Rhys Carpenter, one of the best known authorities on Greek architecture, now believe that the refinements so laboriously discovered and described by Penrose were, in fact, empirical and not the product of complicated mathematical reasoning.

One further reason why classical architecture may have been so widely imitated is that it offers a large range of decorative forms within an overall, clearly defined, framework. These particular forms are called the *orders*; the most well known are shown in Figure 14.

Figure 14 Three figures of the orders – Doric, Ionic, Corinthian. (From the Atlas of Kruse's Hellas, Plate 1, Section IV. *Reproduced by courtesy of the British Library Board).*

The Parthenon, perhaps the best known building in the world, is Doric. Nowadays we are inclined to regard it as a byword for formal, abstract beauty without a single fault of proportion. Certainly it would have appeared shockingly novel to a Greek familiar only with the dumpy, stocky architecture of the Greek colonies in southern Italy which we call Magna Graecia. Compare Figure 15, the Parthenon, with Figure 16, the Temple of Ceres. Yet it is worth recording that

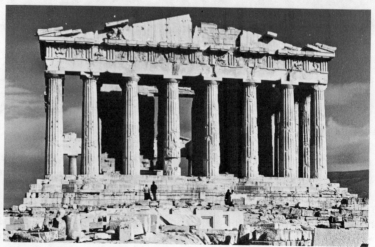

Figure 15 Parthenon, Athens (Ronald Sheridan).

80

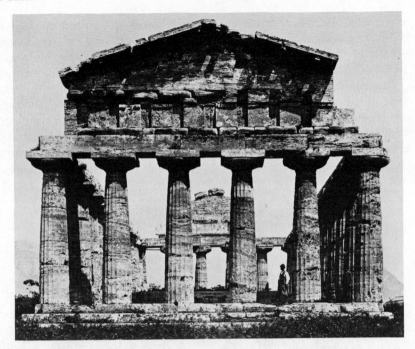

Figure 16 Temple of Ceres at Paestum (Alinari).

the ancients themselves did not think that the Parthenon was so very wonderful: when Antipater of Sidon was compiling his list of the Seven Wonders of the World, he left it out.

There is one simple mechanical principle which governs the appearance of the Parthenon as much as any other classical Greek building. This is the post and lintel form of construction, sometimes called trabeation. It is one of the basic methods of building. The posts (or, in the case of a temple, columns) support a lintel which holds the roof on. It is a simple method of balancing thrusts.

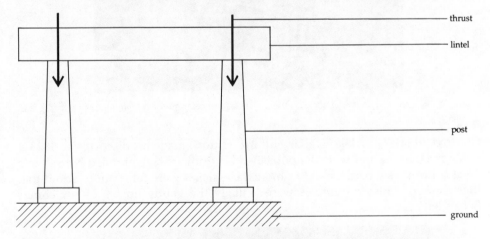

Figure 17 Schematic drawing showing post and lintel construction.

There are many theories about how Doric architecture came to evolve its distinctive repertoire of decorative details. All rely for their explanation on a notion that the details are reminiscences of forms that were all functional members in timber: that is, the flutes on the columns are a derivation from the grooves which might have been made in a timber tree trunk with an adze on a very primitive temple, the triglyphs represent the ends of the wooden beams which made up the old, primitive timber roof and the guttae represent the little wooden pegs which were once used to tie the beams down. Of course, as soon as these details become translated into stone their original functional meaning gets lost and a wholly decorative one takes over. I hope that you will see in the course of reading this unit that what happened to triglyphs and guttae is only one example of how forms are created and imitated in an artistic tradition. Often the imitation robbed from the detail of the form any of its real functional purpose.

Our conception of classical architecture is very much influenced by the state of ruined, bleached elegance which the temples are now in (see Figures 19 and 20): but sometimes modern tourist literature chooses to emphasize the 'romantic' aspect of the Parthenon, like the reproduction on page 10 of the Colour Supplement. You might be surprised to learn that when they were built the temples had none of the austerity we admire today and that, in fact, the garish tourist illustration of the postcard is perhaps nearer to the real thing than we would be happy to imagine. The temples were once gaudily painted in red, blue and gold. This was unknown for centuries (particularly those centuries when *classicism*, the servile adoration of all classical forms and ideals, ruled the arts) and was only properly discovered in the nineteenth century by two German architects,

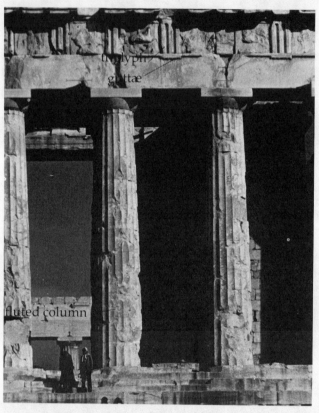

Figure 18 A view of a section of the Parthenon, Athens, showing fluted column, triglyphs, and guttae (Ronald Sheridan).

Gottfied Semper and Jakob Ignaz Hittorff. Hittorff made his discovery in 1823–4 in Magna Graecia and when he published his findings he embroiled himself in a great controversy, because old fashioned classicists were reluctant to admit that their beloved, austere temples were actually the gaudy homes of sometimes fierce deities.

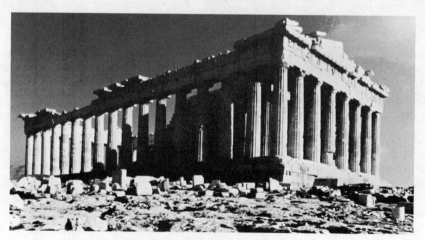

Figure 19 Three-quarters view of the Parthenon (Ronald Sheridan).

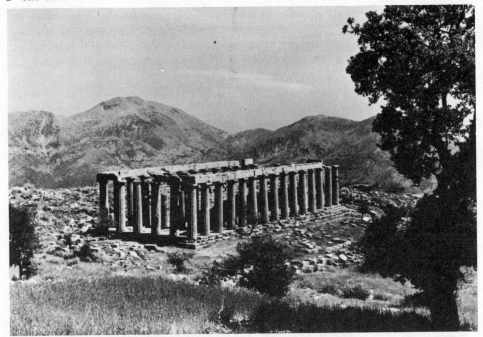

Figure 20 *Temple of Apollo at Bassae (National Tourist Organization of Greece).*

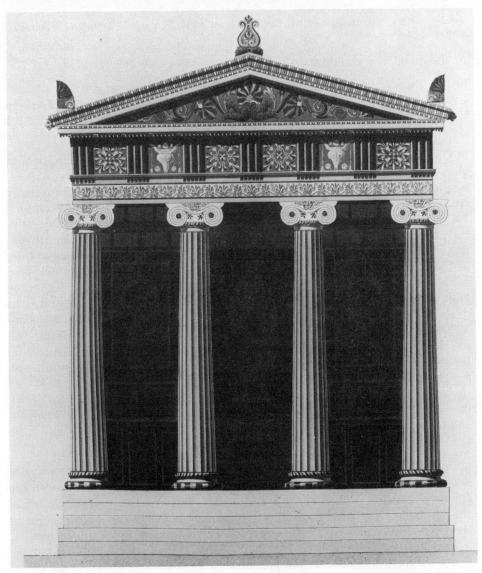

Figure 21 *Plate II of* Atlas, *from Jakob Ignaz Hittorf* Restitution du Temple d'Empedocle a Selinonte
. . . , *1851 (Bodleian Library, Oxford).*

Greek sculpture, like the architecture, was also painted, but that too was generally little known. Most often it was reproduced in nineteenth-century books to signify simple beauty, or nature made into an *ideal* form; and the authors and publishers found the unpainted Greek sculpture very much to their taste.

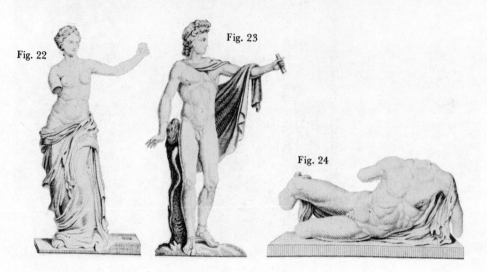

Fig. 22

Fig. 23

Fig. 24

Figure 22 *Venus di Milo.*
Figure 23 *Apollo Belvedere.*
Figure 24 *Ilissus, from the Parthenon.*
(Figures 22–4 from the Atlas of Kruse's Hellas, Plate 1, Section VI, Figures 8–10. Reproduced by courtesy of the British Library Board.)

At this point you should read Chapters 3–4 from Gombrich *The Story of Art.*

Just as the Parthenon became a 'standard' for architects, so certain pieces of Greek sculpture became 'standards' for sculptors. Do remember that this idea of having a 'standard' of any sort is one very much tied up with the idea of the classical.

In Greek the word κανων or *canon* meant the T-square used by architects, and also, by extension, it meant a rule. It refers also to a body of established writers, classical authors whose works are a literary *canon*. One Greek sculptor actually created a *canon* for sculpture, a model and a system for imitation. This sculptor's name was Polykleitos. The ancient writer, Galen, said that Polykleitos' sculpture, the *Doryphoros* (or spear-carrier), was an example of his *canon*, or his system of measurements. Each part was related in proportion to the other so that, as I said above, nature was made ideal. Pliny said of Polykleitos that 'He also made a statue which artists call the "canon" and from which they derive the basic forms of their art, as if from some kind of law; thus he alone of men is deemed to have rendered art itself into a work of art.' (Pliny *Natural History* XXXIV, 35, trans. in Pollitt *The Art of Greece*, page 88.) Polykleitos was also the first sculptor consciously to make his figures look as though they were putting their weight on one leg. His *Doryphoros*, like his *Diadoumenos*, (or man putting on a garland) became models for imitation throughout the Augustan age in Rome. In fact, like so many other Greek sculptors, we only know Polykleitos' work through Roman copies, made many years after his death (see Figures 25(a), (b) and (c)).

When Pliny said that Polykleitos was making art itself into a work of art he was getting at a very complex and intriguing idea. I have already said that *proportion* was fundamental to Greeks. Galen emphasized this: 'Beauty arises not in the commensurability of the constituent elements, but in the commensurability of the parts, such as that of finger to finger, and of all the fingers to the palm and the wrist, and of these to the forearm, and of the forearm to the upper arm. . .' (Galen *De Placitis Hippocratis et Platonis* V, trans. in Pollitt *The Art of Greece*, page 89.) Thus the system of internal proportions, each in careful ratio to the other, which Polykleitos devised, could be said to be perfectly representative of classi-

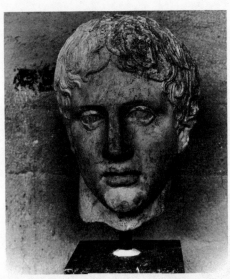

Figure 25 (a) Head of Doryphoros (Corinth Excavations, American School of Classical Studies, Athens).

cal sculpture. We have to turn to a seventeenth-century work to find a schematic illustration of this idea. The work is *The Lives of Modern Painters, Sculptors and Architects* written by the Italian classicist, Giovanni Pietro Bellori. He uses an engraving of the *Antinoos*, a famous Roman sculpture of the boyfriend of the Emperor Hadrian who was famed for his beauty and who met an untimely end drowning in a river (Figure 26).

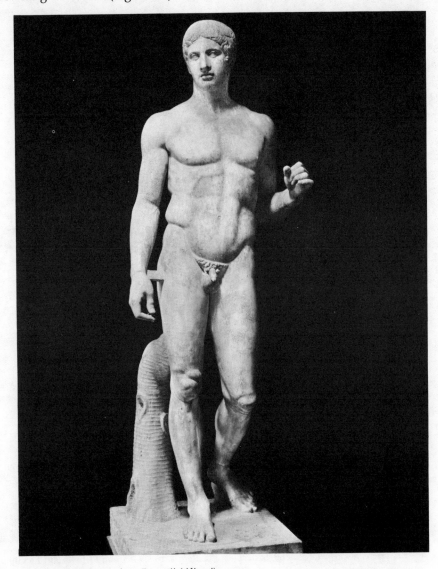

Figure 25 (b) Doryphoros, from Pompeii (Alinari).

Figure 25 (c) Relief of Doryphoros, from a cast; National Archaeological Museum, Athens (Photo: TAP Service, Athens).

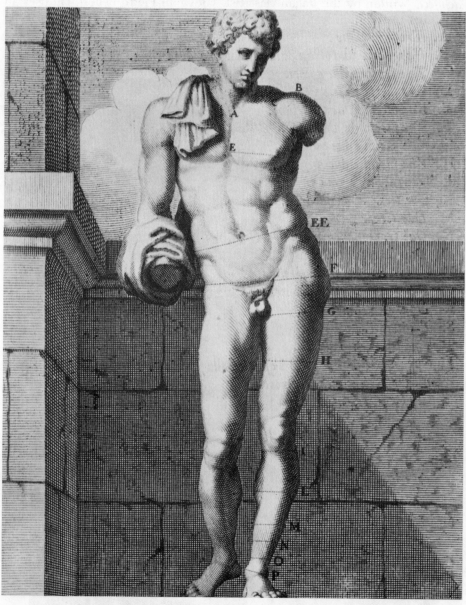

Figure 26 Example of a schematic illustration in classical sculpture, from Giovanni Pietro Bellori Le vite de pittori, scultori, architetti moderni, *1672, page 457 (Reproduced by courtesy of the British Library Board).*

Explaining the diagram, Bellori says that the measurement EE (i.e. the waist, in case you cannot see it on the diagram) should be equal to the width of one head and two thirds.

Proportion was the basis of classical sculpture,[1] but before sculpture reached the state it did in Rome when Greek originals were copied wholesale (as in the case of the *Antinoos* which Bellori illustrated), it passed through a phase which some have considered a decadent, corrupt and impure one: but that is a classical view of it. This phase is the so-called Hellenistic period which began with the activity of Alexander the Great in the late fourth century BC when Greece changed from a loose confederation of city states into a great conquering, war-like nation and, at the same time, absorbed the influence of the recently conquered near-Eastern nations. The Hellenistic period is usually said to have lasted from the death of Alexander the Great in 323BC to the victory of the Roman Emperor Augustus at the Battle of Actium in 31BC, although these dates are, of course, not meant precisely to define a specific period, but merely to indicate its general extent.

To a pure classicist, the art of the Hellenistic era would appear to be degenerate and depraved, abandoning all the formal qualities of pose, poise, proportion and restraint which we saw in Polykleitos and exchanging them for heightened realism and very forceful expressions of emotion. This change of emphasis in Greek sculpture is most often accounted for by the influence on art of Alexander's conquests: like his military operations, art, it was thought, was getting ambitious and exotic.

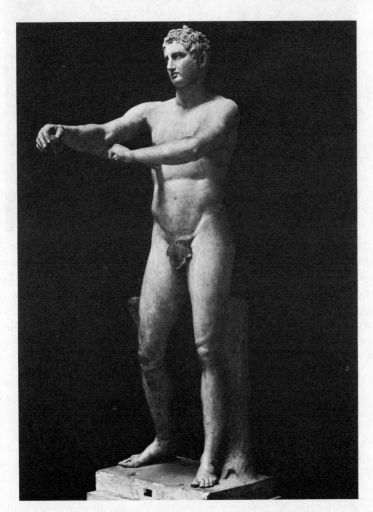

Figure 27 Apoxyomenos, 325–300 BC, Roman copy, Vatican Museum. Greek athletes used to be covered in oil and they would scrape themselves clean with a tool called a strigil. (Alinari).

[1]It should, perhaps, also be said that there was one other factor which influenced Greek sculpture and that was the philosophical principle that beauty had a moral character. That is to say, anyone who was beautiful was good, and vice versa – or at least, that was felt to be likely.

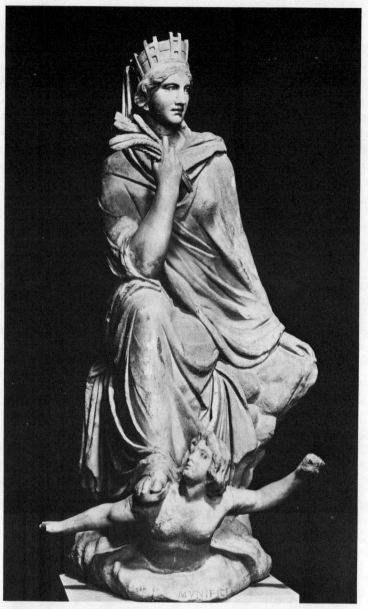

Figure 28 The Tyche of Antioch, after 300 BC, Roman copy, Vatican Museum (Alinari).

Hellenistic art is part of a cycle. It is sometimes said that the relationship of Hellenistic art to classical art is similar to that of Baroque art to the art of the Renaissance, or, to use a familiar analogy, to that of the bud to the flower, or, if you rather, of the bloom to the putrifying flower. After Greek art of the classical era was revived by the Romans it could be said that the first phase of the classical tradition was over.

How was the classical tradition transmitted? Two things affected the literary culture of antiquity, and our understanding of it, and these were both acts of destruction. The first was when the library at Alexandria was burned down, some say by Caesar, and the second was when that other Roman, Gregory the Great, burned the Museion. This destroyed much of antiquity's literary culture (much of what has been actually preserved is due, in fact, to Arab and Jewish scholars) and together with the loss or destruction of classical painting and sculpture it would not have been surprising if knowledge of classical Greece faded forever. Certainly, towards the end of the Roman Empire's influence in the west, Roman art had long since ceased to imitate Greek models. As you can see in Figure 29, which shows some of the sculpture decoration of Trajan's column in Rome, ideas of proportion and beauty have disappeared. This was the beginning of the period when conventionally (if a little inaccurately) Europe entered the Dark Ages, that is, when the classical tradition had almost died out.

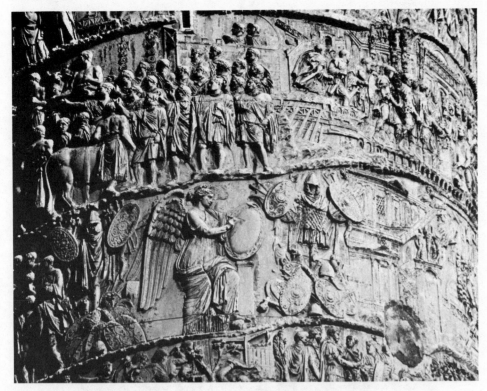

Figure 29 Detail from Trajan's Column, Rome (Ronald Sheridan).

After the Roman Empire's centre of gravity shifted east to Constantinople, Rome was left as the city of the popes. It was the only city in the west where there was a living tradition of great architecture throughout the early middle ages. Many of the early thinkers of the Christian west wanted to participate in what they rather vaguely felt to be the classical tradition which was embodied in Rome. In his *Decline and Fall of the Roman Empire*, Edward Gibbon elaborated this argument to explain the growth of the Christian religion in Rome.

The Frankish emperor, Charlemagne, aspired to the inheritance of Rome. He had himself crowned Holy Roman Emperor (a mythical, if grand, assumption of power which did not really exist) in his capital, Aachen, on Christmas Day, 800. Charlemagne's interest in the classical past was passionate if not profound. One of the early illustrations in this unit is of the Palace Chapel (Pfalzkapelle) which Charlemagne had built in imitation of the Roman church of San Vitale in Ravenna. Not all Carolingian architecture was as learned in its use of classical architecture as the Palace Chapel, even though Charlemagne's biographer, Einhardt, owned a manuscript of Vitruvius, the Roman architect. More typical of the mediaeval expression of classical architecture was the Carolingian gatehouse

Figure 30 Carolingian Torhalle, Lorsch (Bildarchiv Foto Marburg, Marburg).

at Lorsch where motifs of classical architecture are used in a debased way, in combination with an architectural form which is really German vernacular (Figure 30).

Charlemagne's renaissance was one of many. There was another identifiable one in the twelfth century which had its climax in the career of another Holy Roman Emperor, Frederick II Hohenstaufen, who consciously began to collect items from classical antiquity. In imitation of the Roman triumphal arches Frederick built the Triumphator arch at Capua (1234–9) (Figures 31 and 32). Frederick's arch has some claim to be the first 'renaissance' building in the sense we are familiar with, because, despite his German name, Frederick spent much of his time in Italy. He did much to create the conditions which led into the mature Italian Renaissance. When we speak of the Italian Renaissance and think of Brunelleschi, Bramante, Raphael and Leonardo, we are not really talking about a splendid, unexpected isolated occurrence, but about a development (of the highest quality) which formed part of an existing tradition of cultural activity and which had, in fact, been continuous.

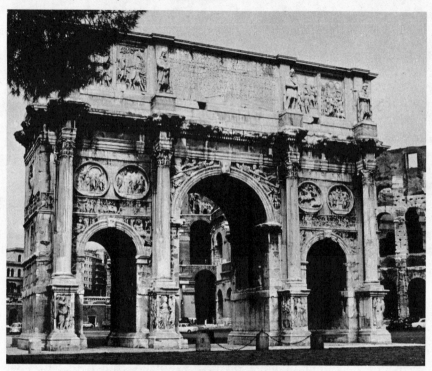

Figure 31 Arch of Constantine, Rome (Ronald Sheridan).

Figure 32 Sketch of Capuan Archway and Towers from a sixteenth-century manuscript (Bildarchiv, Öster-reichische Nationalbibliothek, Vienna).

EXERCISE

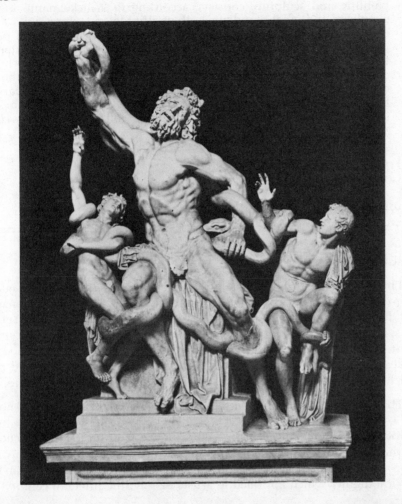

(a)

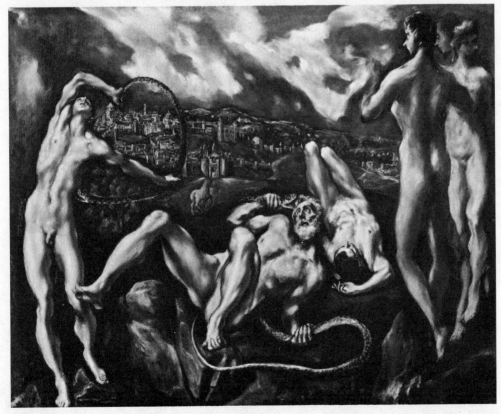

(b)

(c) The chief and universal characteristic of the Greek masterpieces in painting and sculpture consists, according to Winckelmann, in a noble simplicity and quiet grandeur, both of attitude and expression . . . so the expression in the figures of the Greeks reveals in the midst of passion a great and steadfast soul . . . such a soul is depicted in the countenance of the Laocoon, under sufferings the most intense. Nor is it depicted in the countenance only . . . we almost fancy we could detect it in the painful contraction of the abdomen alone . . . to express so noble a soul far outruns the constructive art of natural beauty. . . . (Gotthold Ephraim Lessing *Laokoon*, 1776. This translation from E. G. Holt *A Documentary History of Art*.)

1 Would you say that (a) is 'classical'?
2 Comment on (b).
and
3 What is your interpretation of passage (c)?

DISCUSSION

1 I hope you recognized this sculpture as the *Laokoon* which is illustrated in *The Story of Art*. It was rediscovered in 1506, at the height of the Italian Renaissance, and did much to influence contemporary ideas of what was classical. Yet, nowadays, because we have more categories than they did in the sixteenth century we call it 'Hellenistic'. You should have been able to say that its heightened realism makes it very different from the characteristics of dignity, order and restraint which I have been trying to suggest were typical of classical sculpture.

2 This is El Greco's painting of the *Laokoon*. I did not expect you to know that, but I did expect you to be able to say that it is evidently derived from the sculpture. Did you notice what qualities in the sculpture El Greco chooses to emphasize? He was interested in the *expression*, the heightened emotional expression which was of more interest to Mannerist painters like himself than was the classical dignity which appealed to artists of, say, the fifteenth century.

3 Lessing, writing in the late eighteenth century, has made no distinction between classic and Hellenistic. He evidently thinks that the *Laokoon* is a fine example of Greek sculpture. The ideals of classical beauty, order and restraint are evidently not of interest to him. In fact, he finds the *Laokoon* restrained, not over expressive.

These three examples were chosen to illustrate the idea that tastes change, although the subject with its *cachet* remains the same.

3 CLASSICISM AND NEO-CLASSICISM

Read *The Story of Art*, Chapters 12–15 and 21–23.

When you have read these chapters in *The Story of Art* and if you have been keeping up with your A101 course material, you should have a clear enough notion of what we mean when we speak of the Italian Renaissance. Good enough, at least, not to oblige me to have to say more about it here, except that for the purposes of my argument I want you to think of the Italian Renaissance as an example of *classicism*. The history of art, and other academic subjects besides, are notorious for their free use of the *-ism*, but classicism is, at least, one of the oldest of these *-ism* words.[1] Classicism suggests an adherence to a notion of the classical by a culture or a society some way removed from the classical period of ancient Greece. The writers and artists of fifteenth-century Italy knew relatively little about Greek art, but they were becoming very knowledgeable about Roman classicism and often took examples directly from Roman art and literature. *Apollo and the Muses* Figure 33 is derived from eight different classical sources.

Figure 33 '*Apollo and the Muses*' *from a manuscript,* Libellus de imaginibus deorum, *Vatican Library Ms. Reg. Lat. 1290, fol. 1v (Archivo Fotografico, Biblioteca Apostolica Vaticana, Vatican City).*

[1]'Antiquity' is sometimes used to cover a larger range of places: Greece, Rome, North Africa, etc. and a greater expanse of time – not just classical Greece.

The Renaissance came to northern Europe later than to Italy: in France the equivalent century to the fifteenth in Italy, was the seventeenth. French classicism of the seventeenth century was perhaps the purest sort there has ever been, because although the Italians inherited Roman classicism as a native tradition, the French adopted it with the fervour of the only recently converted. Bellori's dictionary of painters, the one from which I took the illustration of the sculpture of *Antinoos*, was actually dedicated to Colbert, the French minister of the arts and the man responsible for organizing the French *Académie*. The French painter of this period who most perfectly sums up the idea of classicism in art was Nicolas Poussin.

His self-portrait tells you something about the man. Figure 34 is the engraving of it which Bellori used in his dictionary. Poussin has emphasized what he felt to be his personal qualities: integrity, dedication and order. This is what he said about his personality

Figure 34 Nicolas Poussin, engraving, from Bellori Le vite pittori, scultori, architetti moderni, 1672 *(Reproduced by courtesy of the British Library Board).*

> Mon naturel me constraint de chercher et aimer les choses bien ordonnées, fuyent la confusion qui m'est aussi contraire et ennemie qu'est la lumière des obscures ténèbres.

> My nature requires me to seek out and admire only things which are well ordered, fleeing from confusion which is as contrary and inimical to me as is the light to the shadows.

That statement could almost be a definition of classicism as a state of mind. Bellori understood this and used an allegorical figure to illustrate his account of Poussin's life. In Figure 35 'Lumen' and 'Umbra' are, as in Poussin's dictum above, the Latin words for *light* and *dark*.

Figure 35 Excerpt from Bellori Le vite pittori, scultori, architetti moderni, *1672, page 407 (Reproduced by courtesy of the British Library Board).*

Bellori was himself a classicist and chose only those painters he knew to share his concerns. That is why he calls his book *The Lives of Modern Painters, Sculptors and Architects*. It is almost an unintentional guide to classicism, particularly in its illustrations. In one there is an allegorical figure sketching with a pencil, on a canvas supported on a block inscribed with the word IDEA. The figure holds a set of geometrical dividers in his left hand (Figure 36).

Figure 36 Excerpt from Bellori Le vite pittori, scultori, architetti moderni, *1672, page 3 (Reproduced by courtesy of the British Library Board).*

But what did a classicist painter like Nicolas Poussin put in his pictures? Well, he painted a lot of religious pictures which we can call 'classical' by extension of meaning rather than by their content. His *Extreme Unction* (Figure 37), for instance, has figures from the last Sacrament set like the figures in a classical frieze and the technical style of painting (the brushwork is very controlled and the colour is very tightly restrained) is suggestive of the ideas of order connected with the classical.

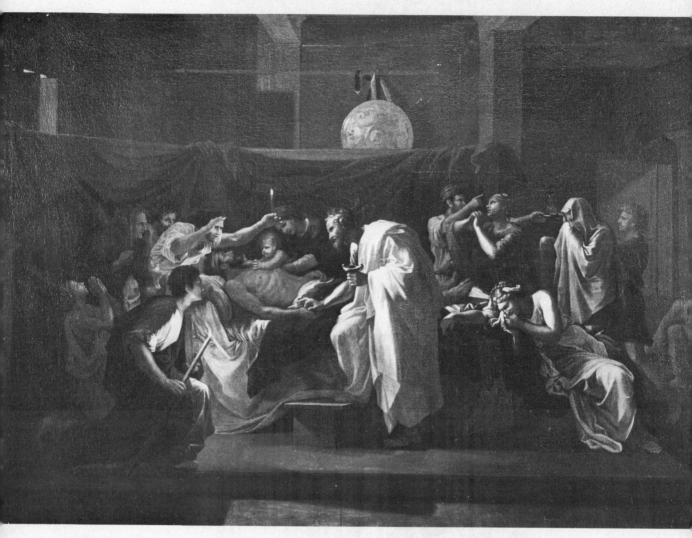

Figure 37 Nicolas Poussin Extreme Unction *(Duke of Sutherland Collection, on loan to the National Gallery of Scotland).*

More typical of Poussin as a painter of classicism are two pictures, one in Paris, the other in London (Figures 38 and 39). Arcadia is a geographical area, and is the actual setting of the Temple of Apollo at Bassae. The idea of *Et in Arcadia Ego* is to show the Arcadian shepherds living in a state of bliss, discovering a tomb inscribed with the words 'I too am in Arcadia'. This can be interpreted in two ways: either that the dead man was once, too, in Arcadia, or that in the midst of all the peace and charm of Arcadia there is death. Both ideas are classicist: *A Dance to the Music of Time* expressed a similar idea, that life is transient.

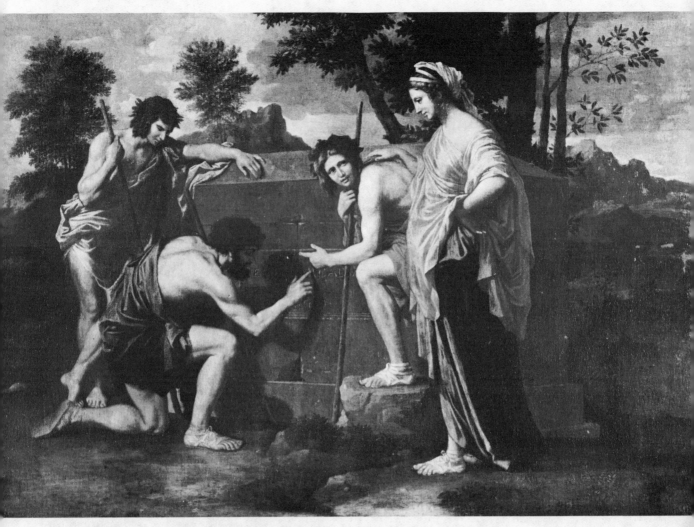

Figure 38 Nicolas Poussin Et in Arcadia Ego, *Louvre (Cliché de Musées Nationaux, Paris).*

In the eighteenth century the various cultural developments in France tended towards a rational interpretation of the world and man's place in it. We call this period the Age of Enlightenment.

One of the most characteristic productions of the Enlightenment in France, which was in many respects also an age when classicism dominated ideas about art, was the *Encyclopédie* (or Encyclopaedia) a compilation of all existing know-ledge and opinions (or, at least, that is what it was intended to be), collected by Diderot and d'Alembert. The section on 'Beau' (The Beautiful) is very revealing about contemporary taste and ideas on art. It was published separately after 1751. For his account of 'The Beautiful' Diderot adopted a passage from the Apocryphal Wisdom of Solomon (11:20), which describes God creating the world in terms of measure, number and weight (in fact all the classical qualities).

The cultural and artistic developments in France, we can see now, were all leading to a phase of European civilization called (but only recently so-called, you must remember) neo-classicism. I want to avoid chronological definitions in this unit, but for convenience, you can think of neo-classicism lasting from say 1760 to say 1840. The term 'neo-classicism' really defies precise definition. In

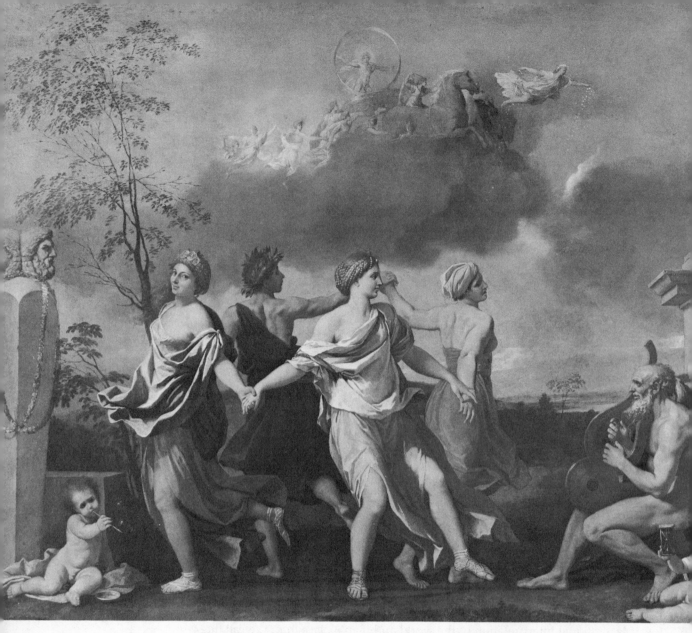

Figure 39 Nicolas Poussin Dance to the Music of Time *(Crown copyright, The Wallace Collection).*

many ways it is indistinguishable from ordinary classicism, except in so far as 'ordinary' classicism (if that's what you can call Poussin, for instance) was not self-conscious. Poussin hardly felt called upon to defend his taste. It seemed to him quite *natural* to be classical (remember he says 'Mon *naturel* me constraint' etc. . .). By the end of the eighteenth century there was a rival current of taste to classicism which we shall see a little later in the unit. Classicism became only an element of culture to be selected as a matter of choice by those who had a will to, not an unavoidable necessity for all men with pretensions to learning.

The French played an enormous role in the creation of neo-classicism not only through the works of writers of the *Encyclopédie* but also through the archaeologists who travelled to Greece to make scientific studies of the remains of ancient Greece.

Among the first, although very unscientific, was Julien-David Le Roi who published *Les Ruines de la Grèce* in 1758. The Comte de Caylus published his *Recueil d'Antiquités Egyptiennes, Etrusques, Grecques, Romaines et Gauloises* in 1759. The frontispiece of this book is on the classicist theme of 'Time Unveiling Truth' (Figure 40). The theme of the frontispiece could be said to be emblematic of neo-classicism. It was the element of truth in the new science of archaeology which was the greatest single influence on the development of neo-classicism. The British, too, played a vital role in the creation of a material base on which neo-classicism could flourish. It was James Stuart and Nicholas Revett who published the most complete survey of the surviving monuments of Athens.

Figure 40 *Frontispiece to A. C. P. le Comte de Caylus* Recueil d'Antiquites Egyptiennes . . . , *1752–67 (Reproduced by courtesy of the British Library Board).*

This book was *The Antiquities of Athens,* which appeared between 1756 and 1830 in five volumes, sponsored by a group of gentlemanly antiquaries calling themselves The Society of Dilettanti. Stuart and Revett's book gave rise to an enormous amount of straightforward imitations of the Athenian prototypes which they illustrated. James Stuart himself even used some of the antiquities he had measured and described in garden architecture (Figures 41 and 42).

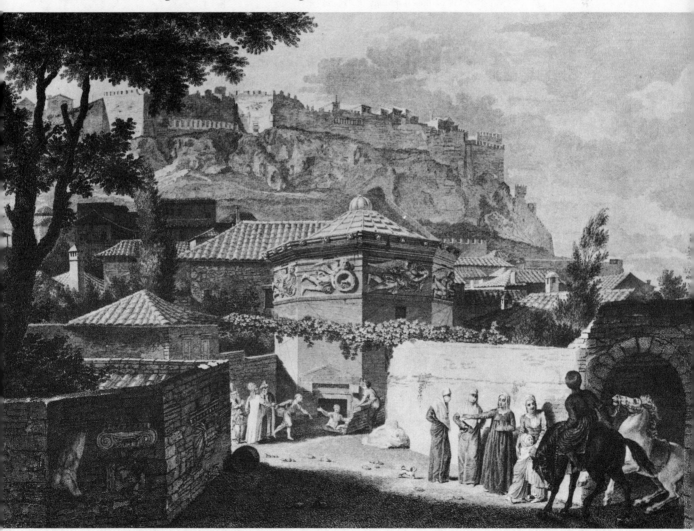

Figure 41 *'The Tower of the Winds', from James Stuart and Nicholas Revett* The antiquities of Athens, *1762, Vol. 1, Chapter III, plate I.*

Figure 42 The Tower of the Winds, Shugborough, (Photo by Cliff Guttridge. Reproduced by courtesy of the Museum of Staffordshire Life, Shugborough.)

Other architects who had been to Greece, like William Henry Inwood, also employed Greek motifs wholesale in their buildings. In his St Pancras New Church (almost opposite Euston Station in London) Inwood has a copy of the complete Erechtheion porch from the Acropolis in Athens (Figure 43).

Figure 43 St Pancras New Church, London, showing the Erechtheion porch (Photo: Douglas Pike).

Around the turn of the eighteenth and nineteenth centuries Greece was a playground for English (and Scottish) *milordi*. By 1800 Athens was a run down corner of the Ottoman Empire, the Greeks being oppressed by Turks and existing in a state of Mediterranean gloom, torpor and craftiness.

Figure 44 Cavalcade of Western travellers, *engraving from C. P. Bracken (1975)* Antiquities acquired
. . . , *David & Charles, page 103. (Reproduced by courtesy of David & Charles Ltd, and Crown copyright,*
Victoria and Albert Museum.)

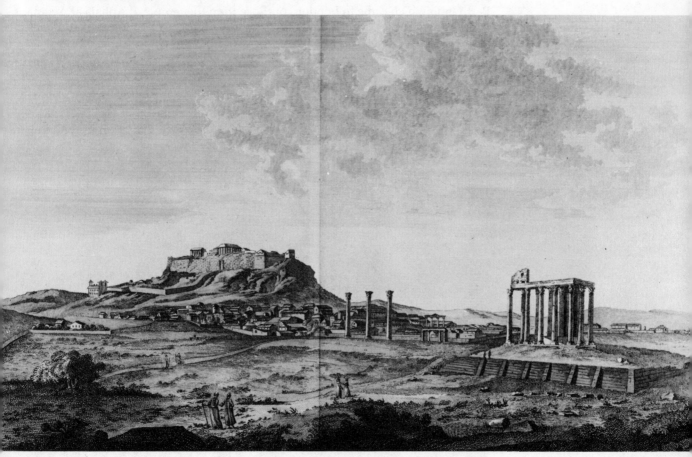

Figure 45 An early nineteenth-century impression of the Acropolis and Parthenon. From J. B. Le Chevalier
Recueil des cartes, plans, vues et medailles . . . de la Troade, *1802, plate IX. (Bodleian Library,*
Oxford.)

A contemporary view (Figure 45) by J. B. Le Chavalier does the Acropolis and the Parthenon more justice than they deserved. The Acropolis around 1800 in fact looked very odd indeed. In 1687 a bomb fired by the Venetians against the Turks had ignited a powder magazine there, and a thunderbolt had struck the Propylaea (gateway) in 1699. There was a Turkish mosque actually built inside the Parthenon. Neither Greeks nor Turks cared much for the sculpture of the Parthenon; one of the pedimental statues had fallen to earth and was buried, head down, with trunk and limbs exposed in the earth; the native Greeks, if they thought about the sculptures at all, thought of them as charms and liked to pick up fragments and put them over their doorways for good luck. Many an English collector enriched his collection of antique statuary by bribing a Greek to prise an odd piece of sculpture, or an architectural detail, out of a wall in which it had been embedded.

Such activities were common but it was not until the arrival of Thomas Bruce, Seventh Earl of Elgin (1766–1841) in Athens in 1802 that the collection, organization and acquisition of Greek antiquities really began to take on a professional look. Elgin was the ambassador to Constantinople, the capital city of the Ottoman Empire; he had stopped on his way there in Sicily in 1799 where he signed up the technicians and draughtsman he needed for his intended mission. At first the plan was only to draw and measure the remaining sculptures, but through a confusion of motives it was eventually decided that as many as possible should actually be removed.

It was this mission of Elgin's which made the British Museum the greatest single repository of Greek sculpture in the world, for from Athens he brought back (and later sold to the nation) what have become known as the Elgin marbles, Pheidias' sculptures for the Parthenon.[1] They became a model for imitation by younger artists studying in Europe, as you can see suggested in Figure 46, a painting by Købke. The arrival in Europe of sculptures such as those from the Parthenon which came to London, or those from the temple of Aphaia at Aegina which ended up in Munich, both confirmed a ruling taste in sculpture and gave some stimulus to new production in the classical style.

Figure 46 C. Købke Young artist studying the casts of the Elgin Marbles, 1830 (Den Hirschsprungske Samling, Copenhagen. Photo: Hans Petersen.)

[1]The whole story of how Greek sculpture came to be in Western museums is a very interesting one, but it is far too involved and complicated to be gone into here. Much deceit and connivance were the order of the day. Elgin's chaplain, the Rev Philip Hunt, actually wanted to take the whole Erechtheion porch back to England. Even the rather careless Greeks and Turks baulked at that suggestion. If you are interested in finding out some more about Elgin's and others' expeditions, C. P. Bracken (1975) *Antiquities Acquired*, David & Charles is both informed and readable.

There were no qualms – moral or political – felt about the looting which went on, because in the first place the Greeks did not for the most part complain about the activities of Elgin and his colleagues and, perhaps more importantly, it was generally considered that Britain had a duty to keep up with the 'collecting' which Napoleon was doing at the same time throughout the rest of Europe. The only questions asked in Parliament were, to Flaxman the sculptor, whether the Theseus from the Parthenon was better than the Apollo Belvedere which had hitherto been the standard of classical beauty, at least as understood in the west. This question (and it was considered in those less sophisticated days than ours that such questions could be answered) concerned a government intent on investing in art.

Neo-classical sculpture harked back to the classical past but, in fact, had a style all of its own (see Figures 47 and 48). The taste for neo-classical sculpture and architecture coincided with a massive amount of activity by writers on architecture who tried to establish theories of the origin of building. Most of the theorists tried to explain the appearance of buildings by saying that they were in some way derived from natural forms: that is to say that *mimesis*, or imitation, was the origin of architecture. Prominent among these theorists in the eighteenth century and one of the corner stones of French neo-classical architecture was the ex-Jesuit, Marc-Antoine Laugier. In 1753 Laugier published his *Essai sur l'architecture*. This was followed in 1765 by his *Observations sur l'architecture*.

Figure 47 Antonio Canova La charité instruisant, *bas-relief (Musée de Dijon, France).*

The belief that Laugier had that architecture must be able to trace itself back to man's early beginnings is an idea which was generated at the same time as Rousseau was popularizing his idea of the 'noble savage'. Laugier says that man first went into caves to seek shelter, but finding these unsatisfactory he became 'determined to compensate by his industry for the omissions and neglect of nature' (Rykwert *On Adam's House in Paradise*, page 43). Laugier says that the primitive hut was created when early man picked up some sticks and assembled

them in such a way that, bound to the trees, they created a pointed roof which was the antecedent of the triangular pediment of the classical temple. This idea was illustrated as the frontispiece of Laugier's *Essai* (Figure 49).

Figure 48 John Flaxman Sketch model for the monument to the Hon. Barbara Lowther *(Crown copyright, National Monuments Record).*

Figure 49 'The Personification of Architecture': frontispiece of Marc-Antoine Laugier Essai sur l'architecture, 1753 *(Bodleian Library).*

Thus man was lodged and, according to Laugier, the prototype of the magnificent architecture of classicism was founded. Now, you do not have to believe Laugier, but it is as well to know what he and his contemporaries were thinking about architecture. The notion that there was a straightforward explanation for both natural and man-made phenomena was typical of the rationalism of the eighteenth century.

Another aspect of this rationalism was the growth of the museum. Museums were, in fact, the most typical architectural products of the age of neo-classicism. You might be surprised to learn that although the collecting of Roman statues began in the Renaissance, the modern museum is a really very new idea. As I tried to point out in television programme 16, *The Ghent Altarpiece*, because art in the middle ages was not considered to be art (not in our sense, anyway – objects like altarpieces were considered as working tools of the liturgy), it could not be collected, nor, indeed, treated as art.

After the Revolution in France, state-sponsored institutions began to flourish, in conformation with Napoleon's policy of aggrandisement.[1] However, some of the visionary architects of pre-Revolutionary France had conceived the idea of a museum as a suitably grandiose scheme for their architectural fantasies. Such an architect was Boullée, who also employed a curious type of classical motif in his buildings (which were, alas, never actually erected) (see Figure 50).

[1]The Louvre, which had hitherto been a palace and offices, was turned into a museum by a decree of 27 September 1792.

104

Figure 50 Etienne-Louis Boullée, Project for a Museum, 1783 (Bibliothèque Nationale, Paris).

In France the royal collections in the Luxembourg Palace in Paris had actually been open to the public since 1750, while in England the origins of the British Museum had been created at a house in Montague Square and in Germany there had been quite a long tradition of the 'Kunst and Wunder Kammern' (Art and Curiosity Collections) in the hands of various noblemen. The first suggestion that a purpose-built museum be created came in Germany in the 1740s, when the patron and writer on art, Count Algarotti, made a proposal that one should be built in Dresden, which came to nothing. The first building which has a claim to be the earliest purpose-built museum is shown in Figure 51. Built at Kassel

Figure 51 Museum Fredicianum, Kassel (Photo: Staatliche Kunstsammlungen Kassel, West Germany).

between 1769–79 for the Landgrave Frederick II, it is very much in the tradition of the old aristocratic 'Kunst und Wunder Kammer' (Art and Curiosity Room), and not at all like Boullée's revolutionary project.

Because this was the age of rationalism, the age when educated men believed very sincerely that art had a civilizing influence the museum was a dominant theme in architectural prizes of the time, a regular subject, in fact, for the French *Académie d'Architecture's* Rome Prize at the end of the eighteenth century.

What is so interesting is that it was these very museums which were being built in the neo-classical style which were also the buildings intended to house the newly discovered and newly pampered Greek statuary.

Figure 52 Glyptothek, Munich (Photo: A. F. Kersting).

Figure 53 Altes Museum, Berlin (Photo: Bildarchiv Preussischer Kulturbesitz, Berlin).

Figure 54 National Gallery, London (Photo: Douglas Pike).

Figure 55 British Museum, London (Photo: Douglas Pike).

The idea of the museum is typical of the age of classicism. It is, I hope you will remember, a fundamental aspect of the classical attitude to art that there are certain examples of either architecture, sculpture or painting which are the *best* ones and it is these which should be copied and imitated. The museum provided the facilities for doing this.

In the Louvre for instance, artists were admitted every weekday and the public at the weekends. There was no charge for admission and – this was a great innovation – the pictures were labelled and a cheap catalogue was available. There were also guided tours!

The Glyptothek in Munich, which was designed by Leo von Klenze (who also designed a straightforward *copy* of the Parthenon near Regensburg) for the Crown Prince of Bavaria, was intended for public use.[1] It was built to house the statues from Aegina which had been discovered by an Anglo-German party of architects, archaeologists and travelling gentlemen; like the sculptures, the museum itself was in the purest Greek style.

Schinkel's Altes Museum in Berlin was in a less pure Greek style than von Klenze's Glyptothek in Munich, but it was no less characteristic of the age of neo-classicism, even if it did incorporate in its design a number of entirely novel features not known to the ancient Greeks themselves. The organization of the works of art inside the museum was typical of the ideas of hierarchy and order which we nowadays regard as the concomitants of classicism. The paintings were divided into fourteen classes and those in classes 10–14 were relegated to a back room where what were called 'sour tit-bits' (such as, one might add, Carlo Crivelli) could not damage the sensitivities of young, aspiring artists who went to the museum for inspiration. It should not surprise you to find out that it was Nicolas Poussin who was considered among the best painters in the museum's collection. A note from the architect, Schinkel, to the curator, C. F. Waagen, explains fully the ruling canons of taste:

> Among all the pictures those which one calls classic are undeniably the most important, that is those where the artist not only thinks truly and beautifully according to his subject, but is also in command of all the scientific and technical means which serve art and expresses them completely explicitly and in an easy and beautiful way. (Quoted in Helmut Seling 'The Genesis of the Museum' *Architectural Review*, February 1967, pp. 103–14.)

This is a complete statement of the idea of classic art, an idea which owes much to the ancient Greeks, but also owes something to the particular period of modern civilization in which it was formulated. The idea has continued in modern art history: in his essential book *Klassische Kunst* (*Classic Art*),[2] Heinrich Wölfflin crystallized the idea of having a select *canon* of old masters whose work reflected what was best in European art. The book is still in print today, and uses a Michelangelo painting as Wöfflin's interpretation of the classic.

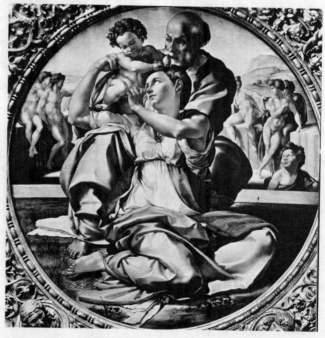

Figure 56 Michelangelo Tondo Doni (The Holy Family) *c. 1504 (Photo: Phaidon Press Ltd, reproduced by kind permission of Galleria degli Uffizi, Florence).*

[1]The word 'Glyptothek' is the German derivation from the Greek which means 'Sculpture Gallery'.
[2]First English edition, 1952, Phaidon Press Ltd.

In the period when these ideas were being formulated was there any *art history* or any *art historians* to account for what was going on? Johann Joachim Winckelmann,[1] as well as writing *Geschichte der Kunst des Altertums* had also written *Gedanken über die Nachamung der griechischen Werke in der Malerei und Bildhauerkunst* (*Thoughts on the Imitation of Greek Works in Painting and Sculpture*) in 1755. In this book Winckelmann set up the art of the Greeks as the ideal to be imitated.

The most famous inheritor of the literary-critical tradition of Winckelmann was Johann Wolfgang von Goethe, who was born in 1749. Yet before he committed himself to a study of the classics Goethe went through a youthful period in which he dedicated his considerable intellectual energies to the support of an aesthetic 'system' entirely different from the classic. It was the period when he wrote *Das Leid des jungen Werthers* (*The Sorrows of Young Werther*), a tempestuously emotional novel of unrequited love and suicide, and also the period when he was in Strasbourg, which was then, as it is today, in France. In Strasbourg Goethe, the greatest of modern classicists, fell in love with gothic architecture.

Goethe arrived in Strasbourg in 1770. Deeply impressed by the cathedral, he wrote a laudatory tract called *On German Architecture* and dedicated it to Erwin von Steinbach (who died 1318), the architect of the cathedral. It is one of the best known testaments to the ability of Gothic architecture to arouse our emotions. It belongs to the literary *genre* we know as 'Sturm und Drang' (storm and stress) and, although *On German Architecture* is, in fact, a spiritual attack on the neo-classical account of architecture given in Laugier's *Essai* of 1753, Goethe later came to be a little embarrassed about it. Nevertheless, it is an astonishing document which merits some lengthy quotation:

> But what use monuments! you have built the most magnificent of all to yourself, and if the ants which crawl around it do not care for your name, this is a fate which you share with the architect who raised mountains into the clouds . . . Enrich and animate the immense wall which you shall raise to the sky, let it rise like a lofty, wide spreading tree of God, declaring with a thousand branches, a million twigs, and with leaves numerous as the sands of the sea, the glory of the lord, its master . . . What unexpected emotions overcame me at the sight of the cathedral when finally I stood before it! one impression, whole and grand, filled my soul, an impression which, resulting from the harmony of a thousand separate parts, I could savour and enjoy, but neither explain nor understand. (In Goethe's *Werke*, Sophien Ausgabe, Weimar, 1896, I, Abtheil, XXXVII, pp. 137ff. This translation from Lorenz Eitner, pp. 74–9.)

It is, I think you will agree, an impressive piece of writing, but one which is very different both in content and style from – shall we say – the notes of Poussin reproduced earlier in the unit. Compare the two and you will begin to understand the differences in associative values between the words 'classic' and 'gothic' when used loosely.[2]

Goethe's *On German Architecture* was one of the most significant of the early expressions of enthusiasm for the Gothic style in European literature. Goethe overshadowed most of his contemporaries, but he did not wholly obscure the work of Frederick von Schlegel who, in his writings on architecture, committed himself to an enthusiastic account of the gothic style. Schlegel believed (as I do) that architecture is the basis of all other arts. On an architectural tour of 1804–5 on the road to Cambrai, he remarked, on seeing the distant cathedral:

> Wonderful style of architecture! . . . I have a decided predilection for the Gothic style of architecture; and when I am so fortunate as to discover any monument, however ruined or defaced, I examine every portion of it with unvaried zeal and attention, for it appears to me that from a neglect of such study the deep meaning and peculiar motive of Gothic architecture is seldom fully arrived at. (C. W. F. von Schlegel, 'Principles of Gothic Architecture' in *Aesthetic and Miscellaneous Works*, trans. by E. J. Millington, Henry G. Bohn, 1849, page 155.)

[1] I have mentioned Winckelmann already, in Unit 16.

[2] The suggestion of classic *v.* gothic was made in other literary works of the time, as for instance in Stendhal's *Racine et Shakespeare* of 1823.

Schlegel's enthusiasm for the gothic was typical of many an antiquarian of the time.

But what was this *Gothic* architecture everybody was enthusing about? Why was it different from the classical architecture and the classical art I have tried to familiarize you with in the past few pages? That is the subject of the next section.

EXERCISE

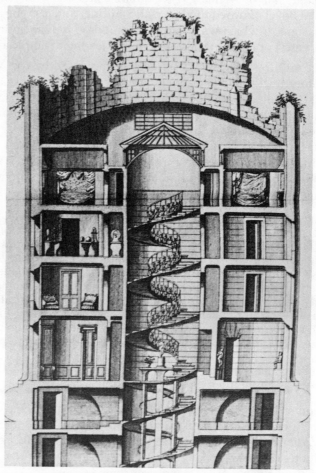

What have you got to say about this picture?

DISCUSSION

The ruined column house was built in the Desert de Retz, a rich Frenchman's eighteenth-century fantasy, and is almost the last word in the romantic taste for the classical. It is a house designed to look like the broken stump of a giant Greek column. You should have been able to deduce that it was an eighteenth-century monument, expressive of that same taste for ruins which influenced the archaeologists who travelled to Greece. There was a time when the ruins of Greece provoked philosophical musings in writers and travellers. One such musing was that if Greece itself – that finest and proudest of civilizations – could be ruined (as it appeared to be in the eighteenth century) – then, so too, could the modern world. The house in the Desert de Retz is expressive of this taste.

4 THE GOTHIC

Classical architecture is what we call the architectural style of ancient Greece and, by extension, all those other architectural styles which rely on it for inspiration across the ages. I hope that you understand, no matter how vaguely, that the word 'classical' can be applied to pictures and sculptures as well. It is much the same with the word 'gothic', but it is perhaps less easy to apply that word to pictures than to architecture or sculpture. (Before you go on read *The Story of Art*, Chapters 9–10.)

Gothic was the last, and consummate style of the middle ages. In its very essence it is quite different from classical architecture. Instead of relying on an architectural tradition going back to the most noble period of the history of ancient Greece, gothic architecture was the *vulgar* product of northern Europe, produced by local craftsmen: mediaeval sources mention 'constructa artificibus Gothis', that is buildings made by 'local' people.

The distribution of important classical and gothic buildings in Europe and the Near East divides into two complementary areas. If classic was the style of the Mediterranean, then gothic could be said to be the architectural expression of northern Europe.

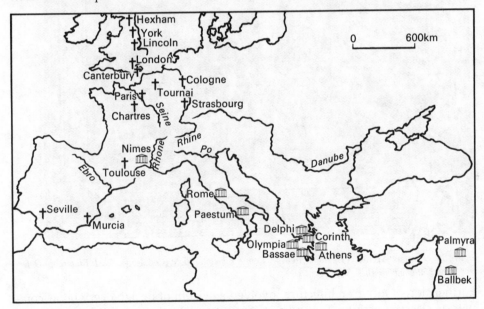

Figure 57 Schematic map of Europe and the Near East.

Yet there are many similarities between the system of classical architecture and gothic: because of what I have said do not get the impression that the gothic buildings of northern Europe are the rough and ready improvisations of more-or-less helpless itinerant craftsmen cut off from the sustaining life-blood of the classical tradition. If anything at all, I think it would be fair to say that the gothic mind (if we can speak of such a thing) was capable of greater subtlety and intricacy of thought than the classic one. Just like Bellori's figure illustrating *Idea*, the scholars of the middle ages thought God created the world as an architect would, with drawing instruments, as you can see in Figure 58, an illustration from a manuscript of a Bible *moralisée*. [1]

[1] *Moralisée* is the French word for moralized. In the middle ages scholars used to write commentaries on major works like the Bible or Ovid and make morals out of the stories.

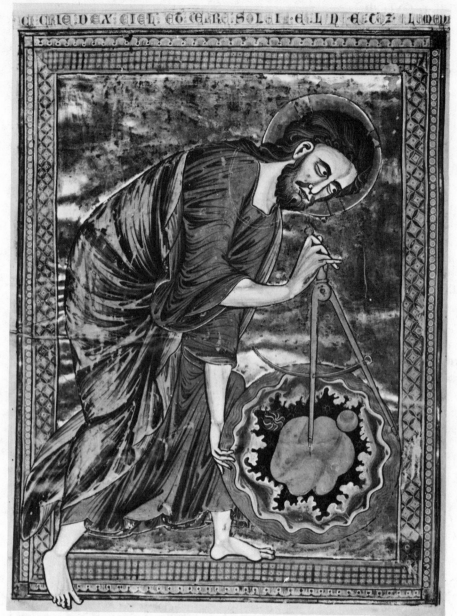

Figure 58 God as Architect of the Universe, *from a Bible moralisée (Cod.2.554, fol. I: Bildarchiv Öster-reichische Nationalbibliothek, Vienna).*

Furthermore, Gothic architecture involved a system of design every bit as complex as classical architecture: it had a *canon* too. This is a very abstruse subject which has occupied scholars for centuries, trying to discover exactly what the evident system of proportions employed in Gothic buildings was.[1] Because of intriguing evidence like the tomb of the architect, Hughes Libergiers at Reims, which shows the architect with the tools of his trade writers have toiled to interpret gothic architecture (Figure 59). I don't know that any truly satisfactory solution has yet been found, but what is important for you to remember is that the architecture of the middle ages was built according to a system. It is remarkable that this complicated system of building evolved at the same time as an equally complicated sort of philosophy: Hughes Libergiers has as cultural companions St Thomas Aquinas and St Bonaventure. Scholastic philosophy was subtle. For instance, there is St Anselm's proof of the existence of God in three stages:

1 It is true by definition that God is perfect and, also,

2 It is true by definition that a merely imaginary person or being is not so great as a real one, therefore

[1]The literature on this subject is enormous. If you want to get a taste I would recommend B. G. Morgan (1961) *Canonic Design in English Medieval Architecture,* Liverpool University Press.

112

3 If God did not exist, he would not be the greatest being imaginable, but since (1) says he is the greatest being imaginable, then, it follows that he exists.

Such subtlety was carried into the architectural design of the middle ages. Erwin Panofsky even tried to make a direct link between gothic architecture and scholasticism.[1]

Figure 59 Tomb of Hughes Libergiers, Reims (Photo from B. G. Morgan (1961) Canonic design in English medieval architecture, *Liverpool University Press, page 57. Reproduced by courtesy of Liverpool University Press and Archives Photographiques, Paris.)*

Naturally, when the period of investigating the past came about antiquarians throughout Europe were forced to discuss gothic architecture. Its very presence made it ineluctable: Gombrich uses an impressive photograph of Tournai cathedral in *The Story of Art* to illustrate the idea that the mediaeval cathedral dominated the town. How could those interested in the past fail to investigate the origins of these mighty buildings?

The path which most investigation took was the analysis of the pointed arch, the single most conspicuous feature of gothic architecture. In classical architecture we saw that the basic mechanical principle employed was the post and lintel. In gothic architecture the pointed arch has a similar role to play: it is the basic method of supporting the structure.

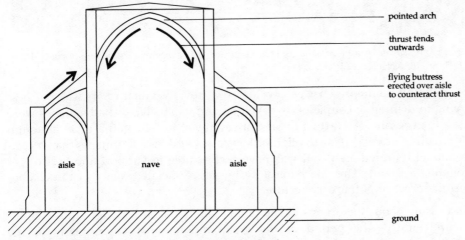

Figure 60 Schematic drawing showing thrusts of pointed arch.

[1]Erwin Panofsky (1951) *Gothic Architecture and Scholasticism,* Archabbey Press, Latrobe, Penn.

Figure 61 Villard de Honnecourt, Drawing of a pointed arch, from a thirteenth-century manuscript (Ms. Fr. 19093, fol. 10. Bibliothèque Nationale, Paris.)

Because the pointed arch was considered a novelty much effort was put into trying to define the course of its development; its mechanical advantages were clear to everyone. According to Sir Christopher Wren the gothic arch (although he used it so rarely) required lighter keystones and less abutments than a conventional rounded arch, but was nevertheless able to support another row of columns above it. This mechanical performance dictated many of the characteristic forms of gothic architecture.

Discussion about the origins of the pointed arch was at its height in the eighteenth century, the period of the great antiquarians, when many of the Academies and learned societies of Europe were being set up. Describing his own purpose in writing about the gothic arch, one of those eighteenth-century antiquaries, Matthew Young, said:

Notwithstanding the surprising things that have been effected by the architects of the middle ages, in raising such stupendous piles on so slight an apparent support as the pointed arch and slender Gothic pillar; it seems that their successes have not, with all the care which the subject deserves, considered how far any part of these great effects was to be attributed to the structure of the arch. (Matthew Young 'The Origin and Theory of the Gothic Arch' in *Transactions of the Royal Irish Academy* vol. III, 1789, page 55.)

He went on to lament the fact that so much attention had in the past been paid to Greek architecture that antiquarians had rarely had the time or the leisure to study gothic architecture, which he considered to be the work of our ancestors.

Young advanced five propositions about the origin of the pointed arch:

1 From Wren he got the idea that it might have been brought to Europe by the Crusaders who had seen Islamic architecture in the Near East.

2 It was created by the Moors in Spain.

3 From William Stukeley he got the idea that it was 'derived from the custom of worshipping in groves' and trees became translated into stone.

4 It was derived from the pointed arches perceived when a junction of round Saxon arches was seen obliquely.

and

5 It was derived from the pointed arches perceived when a junction of round Greek arches was seen obliquely.[1]

Young himself, a churchman who had great learning in mechanics, actually favoured a purely technical explanation for the origin of the pointed arch, that is to say that it was created because of the mechanical advantages which had been worked out by mediaeval masons like Hughes Libergiers. But that doesn't matter; what I hoped you noticed was Young's third point, the suggestion which he got from William Stukeley (with whom I began this unit) that there was a natural origin of the forms of gothic architecture and that it began by imitating nature.

Figures 62 and 63 Two illustrations by Hall, to support his theory of the origins of Gothic architecture. (Photos from Sir James Hall Essays on the origins, history and principles of Gothic architecture, 1831. *Reproduced by courtesy of the British Library Board.)*

[1]When Young says 'Greek' it is probably correct to assume that he means Byzantine, not classical Greek.

The idea is that in the north of Europe the primitive people used to worship their pagan gods in the groves in their dark, damp forests. Trees naturally form pointed arches when their boughs intersect and, if there is a clearing sometimes there is an appearance surprisingly like a church's nave, or so it appeared to Sir James Hall who read a paper on the origins of gothic to the Scottish Royal Society in 1797. He said that all gothic ornament derives from natural forms, and when he published the paper in book form in 1813 he demonstrated this with two striking illustrations, showing how the knobs, finials and crockets of gothic were, in fact, imitations of branches and knots of trees (Figures 62 and 63). Hall actually did this experiment and planted poles in the ground on the layout of a church and, to his satisfaction, found the poles sprouting foliage which looked like architectural decoration. . . Now, you don't have to 'believe' Hall, but you should be clear in your mind that theories like his were taken very seriously indeed in the eighteenth century. Schlegel, by the way, dismissed Hall's materialistic explanation of the origins of gothic and said that it began because of a simple love of beauty which found its expression in the architecture.

William Stukeley's explanation of the origin of gothic, Young's third point, is certainly the most poetic of them all. The idea of the northerners worshipping in wooded groves goes back at least as far as the Latin poet Lucan, in whose *Pharsalia* intersecting arches created by trees are mentioned, but there is no expression in the middle ages of the idea that trees gave birth to gothic architecture. I think that you should interpret the idea not literally, but as aspect of the eighteenth-century characteristic of wanting to explain everything in rational, straightforward terms. Despite what Lucan said I think that the story of the arboreal origins of gothic architecture is nothing more than intellectual dandyism typical of antiquaries like Stukeley and Young and an example of the ever present urge to assign causes. It is also, of course, according to the theme of this unit, an account in very literal terms of the role which imitation plays in the creation of styles.

Yet before I get too dismissive consider for a moment Figure 64. The argument of trees-to-gothic has been reversed: in Bechyne Castle, Bohemia there is an actual tree used as a column!

Figure 64 Column and vault from Bechyne Castle, Bohemia (Dr Eva Börsch-Supan, Berlin).

EXERCISE

If you have read the prescribed chapters in *The Story of Art* what would you say were the characteristics of gothic and of classical art? (Avoid precise historical definitions, or specific references, in your answer.)

DISCUSSION

By now you should have a broad understanding that classical means originally those works which were created in the fifth century BC in Greece, and by extension, to those Roman works which imitated Greek ones and, by further extension, to those Italian (and other) works which imitated the Roman. Gothic, on the other hand could be said to be, principally, the architecture of northern Europe which reached its height between the twelfth and sixteenth centuries.

Both terms are used principally to apply to architecture, but are used also of painting and sculpture and literature as well. Classical suggests both the accepted body of knowledge or the authority on any given subject, as well as all that is ordered and created according to given rules.

Gothic architecture also employs rules, but they are less clearly defined than classical. Because Gothic architecture originated in the north of Europe it was once felt that the term signified barbarism and crudeness. In literature, the term 'gothic' refers to anything that relies on extremities of emotion for its effect. Consequently, the formal conception of works in the gothic style have these things in common. 'Gothic' suggests both the church architecture of the European middle ages, as well as these other arts that have wild, spooky or mysterious characteristics.

5 GOTHIC REVIVALS

Gothic is a mode, as well as a style of architecture. In *The Story of Art* there are numerous examples of gothic painting and gothic sculpture; you will also have heard about the international gothic style. I don't think that gothic painting or gothic sculpture have anything like as clearly defined limits as gothic architecture; they are terms purely of convenience which help us to categorize a certain type of expression. Glass painting, stained glass if you like, is one of the most typical forms of gothic painting. Figure 65 is taken from an eighteenth-century book on art written at about the time Matthew Young must have been preparing his disquisition on gothic arches. The title of the book gives away the idea that the writer, John Carter, felt some distance between himself and the art he was describing: he calls it 'Ancient'.

The Penance of Henry II before the Shrine of Thomas Becket at Canterbury.
From a Painting on glass half the size of the original in the possession of M.ʳ Hecher, Oxford.
Pub.ᵈ as the act directs by J. Carter, Hamilton s.ᵗ Hyde Park Corner May 1ˢᵗ 1794

Figure 65 'The Penance of Henry II, before the Shrine of Thomas Becket at Canterbury', an engraving from John Carter Specimens of the ancient sculpture and painting now remaining in this kingdom, 1794, opposite page 70. (Reproduced by courtesy of the British Library Board.)

118

This distance was by no means the same as far as architecture was concerned. Indeed, it is still being questioned whether the gothic element in English architecture ever died out at all. Students of the gothic revival always have to face the question.

Everyone knows to an extent what the gothic revival was. The Houses of Parliament, even if they are familiar only from the labels of proprietary sauce bottles, are one of the major gothic revival buildings of the country and no town in the country was not affected by it. But did it really happen? Was there, in fact, a revival when forms were deliberately imitated, or was the gothic revival which took place in the eighteenth and nineteenth centuries nothing more than the last expression of the mediaeval architectural tradition? What was invention, and what was convention?

There is no simple answer to this. All I can do is set out the case for you. Some people say that the English classicism, so influenced by the *milordi* who traipsed around Greece, was nothing more than a temporary aberration, a parasitic growth of foreign architecture on a body of natural, northern gothic forms indigenous to this country.

Well, gothic certainly did not die out as early as some people might think. Throughout the seventeenth century, when the first classical buildings were beginning to appear in England, Oxford, for instance, had a strong tradition of gothic building. Merton Great Quadrangle dates from the first years of the seventeenth century and yet is wholly gothic, at least in its details (Figure 66).

Figure 66 Merton Great Quadrangle, Oxford (Crown copyright, National Monuments Record).

Merton Great Quadrangle is a fairly familiar but perhaps exceptional example of late gothic architecture, but without a doubt gothic remained the only way to build churches in country areas throughout the seventeenth century. Here the old traditions were still being handed down from the middle ages by local craftsmen. Thus, although it is very rarely illustrated, Staunton Harold church in Leicestershire is really a better and more characteristic of seventeenth-century architecture than the well known St Paul's Covent Garden by Inigo Jones, which is often illustrated in books on the period.

Figure 67 *Staunton Harold Church, Leicester (Crown copyright, National Monuments Record).*

Figure 68 *St Paul's Church, Covent Garden (Crown copyright, National Monuments Board).*

In fact, apart from St Paul's Covent Garden and a handful of other examples, no completely classical church was built in England before the Great Fire of 1666.

The gothic revival came about partly as a search for poetic expression, depending on an interest in ruined castles and abbeys somewhat influenced by the work and discoveries of the antiquarians, but it was essentially different in spirit and feeling to that traditional gothic which was being practised in country areas.

There are no links between the survival of gothic in the seventeenth century and its revival in the eighteenth.[1] The gothic revival was the creation of a new style, a

[1]There is a masterly article on this subject by H. M. Colvin in *The Architectural Review* March, 1948 pp. 91–8. In this Colvin tries to suggest that there might be a link between the survival and the revival by identifying one building which was made by a builder of the old school in the new style of the revival. That building was Alscot Park, built in the 1750s and illustrated in Neale's *Views of Seats*.

new way of thinking about building, but, as I hope I am consistently suggesting, the new style depended on the imitation of an old one.

If the gothic of the seventeenth century could be called Stonemason's Gothic (for that is what it was), then the first phase of the gothic revival should be called Carpenters' Gothic (because that is what it was). At the same time as the early antiquarian studies were beginning, unknown and unlettered craftsmen were beginning to publish pattern books with gothic designs in them for builders, keen on satisfying popular taste, to copy. Often gothic designs were confused with the Chinese, as was the case, in one of many possible instances, with Charles Over's *Ornamental Architecture in the Gothic, Chinese and Modern Tastes* of 1758. You can see what separate divisions Over made: Chinese, Gothic and Modern. To us they would all look virtually indistinguishable.

The best buildings in Carpenters' Gothic are very fine indeed, often in red brick with stone dressings followed the patterns suggested by the carpenters' books (Figures 69 and 70).

Figure 69 Speedwell Castle, Brewood, Staffordshire, before 1753. (Photo supplied by the Editor, North Staffordshire Journal of Field Studies, Keele. Copyright Stephen Bayley.)

Figure 70 Gothic decoration on a window, from B. and T. Langley (1967) Gothic architecture Gregg Press, plate 38 (reprint of the 1747 edition).

This taste for gothic decoration coincided with a literary taste for those aspects of sensation which we nowadays call 'gothic': gothic horror, the poetry of the night – there is even a style of poetry called 'The Graveyard School' of which Edward Young's *Night Thoughts* is the most well-known example. Horace Walpole's book *The Castle of Otranto* was published in 1765; it is a cornerstone of the gothic novel.

That would be merely an amusing aside were it not the case that Walpole is usually accredited with the building of the first gothic revival building in the world: Strawberry Hill at Twickenham (Figure 71). Many of the details of Strawberry Hill are shared in common with the books of the carpenters and much that is in it reflects Walpole's tastes as a connoisseur and art expert, but compared with the intensity of feeling which there is in another famous later building, William Beckford's Fonthill in Wiltshire, the gothic revival sentiments of Strawberry Hill are puny indeed.

Figure 71 Strawberry Hill, Twickenham, from the gardens (Photo A. F. Kersting).

In Fonthill we find the true expression of the gothic revival in its earliest, most emotive stages. Like Walpole, Beckford also wrote a novel. His was called *Vathek*; he wrote it in 1782 when he was twenty-three years old and he was unsurprisingly generally held to be precocious. Beckford was immensely rich, making money partly out of sugar plantations, and was prepared to spend it. He was an extraordinary eccentric and claimed to have been the author of 'Non piu andrai' from *Le Nozze di Figaro*, for it was Mozart who had taught him music.

Beckford had become tired of his father's classical mansion at Fonthill, a house known as 'Fonthill Splendens' (Figure 72) and decided to replace it with a monument in the gothic style entirely devoted to egotistical display. He gave his first instructions to the vagabond architect, James Wyatt, in 1793, was living in the new 'Abbey', as it was called, by 1801 even though the whole building was not finished until 1813. He lived in the finished building for a bare nine years and then moved to Bath.

Figure 72 Fonthill Splendens, engraving, from R. Colt-Hare History of modern Wiltshire, 1829, *plate IV (Reproduced by courtesy of the British Library Board).*

Looking at the soaring, unbelievably impressive scale of the building (Figures 73–5) you will not be surprised to learn that (because of faulty workmanship by the architect) the tower collapsed in 1825.

Figure 73 'Longitudinal section' through Fonthill, from John Rutter Delineations of Fonthill and its Abbey, 1823, facing page 9. (Reproduced by courtesy of the British Library Board).

Figure 74 'Interior of the Great Western Hall' from John Rutter Delineations of Fonthill and its Abbey, 1823, facing page 24 (Reproduced by courtesy of the British Library Board).

Figure 75 'View of the West and North Fronts' from John Rutter Delineations of Fonthill and its Abbey, 1823 facing page 67 (Reproduced by courtesy of the British Library Board).

Look at these illustrations long and carefully; it is they that will give you a proper understanding of the inspiration behind the aesthetic achievement of the gothic revival in its first phase. Wyatt was not really *imitating* anything particular in building Fonthill: he was not really knowledgeable enough to be able to do that, but he did capture the mood of the time, or, rather, what he felt it to be.

Perhaps the most significant publication in the course of the gothic revival was something printed in Smith's *Panorama of Science and Art* (Liverpool, 1812–15) by a local insurance clerk turned church enthusiast who had become professor of architecture to the Liverpool Academy, Thomas Rickman. It was Rickman who was the first person to take a good, long look at what gothic architecture there was around and to distinguish between the styles. Before Rickman, the word 'gothic' had been used to apply to everything built between the decay of Roman architecture and the sixteenth century.

Rickman's achievement was to distinguish between the different styles of gothic. This is what he had done in his piece for Smith's *Panorama* . . . which was subsequently published separately as *An Attempt to Discriminate the Styles of English Architecture from the Conquest to the Reformation* in 1817.

What Rickman did was create four style labels: Norman, Early English, Decorated and Perpendicular. Almost everybody is familiar with them; to an extent they are specious divisions, but what Rickman did was very clever. Now, why I am interested in bringing Rickman to your attention is that the purpose of his book was, in his view, to aid scientific restoration of old buildings. Indeed, so acute were historical perceptions becoming by the early nineteenth century that

124

much of the energy of architects was devoted to this end. As the pattern books of the carpenters had aided the creation of Rococo Gothic in the previous century, so Rickman's categories helped the work of the restorers in the nineteenth. Figures 76–79 show what the categories looked like.

Figure 76 Representation of the Norman style of architecture

Figure 77 Representation of the Early English style of architecture

Figure 78 Representation of the Decorated style of architecture

Figure 79 Representation of the Perpendicular style of architecture

Figures 76, 77, 78 and 79 are taken from Thomas Rickman An attempt to discriminate the styles of English architecture, 1817, plates ix, xi, xii and xiv. Reproduced by courtesy of the British Library Board.

Rickman also designed buildings himself (for instance, St John's College, Cambridge where he built the New Court in a gothic style) but his real contribution to the history of the study of style was as a human signpost. He absorbed the antiquarian interests of the eighteenth century and made them into the sterner stuff of the nineteenth. From Rickman there is a direct line to the buildings of the High Victorian period in England, those monuments to municipal pride and commercial success, buildings like Manchester Town Hall and the Prudential Assurance Building. These buildings were wholly modern in concept, built for purposes and on plans which would have been inconceivable in the middle ages, but which relied on the imitation of mediaeval architecture for their effect.

6 CONCLUSION

Throughout this unit I have been trying to show the transmission of styles across the centuries, and how these styles are often imitated after the period when they were actually created, sometimes for different 'philosophical' purposes than their creators originally intended. Naturally, it has been a very circumscribed survey: in a sense what I have tried to do is compress the whole, or almost the whole, of the history of western art into one unit. Do not get exasperated at the divergence of the ideas expressed here, but do have patience with the illustrations: they have been carefully selected on grounds of novelty and relevance. Many of them have never been reproduced in modern times. It was my intention in doing this (and in having so many) to, if not destroy, then at least to damage, the barriers against comprehension which are sometimes created by a prosaic selection of plates in an art book. I would say that if there is one single underlying idea to this unit it is to show you that the study of art has no limits, either chronological or geographical, and that any other limits imposed by conventional published works are false as well.

I mentioned in a footnote earlier in the unit that some people have observed that the various cultural and intellectual revolutions which we usually call 'modern' are in a large part due to the collapse of the classical tradition and, I suppose to a lesser extent, the gothic one too. There is certainly something in this, because knowledge has increased so rapidly in recent years that we cannot avoid feeling ourselves somewhat distanced from the architectural traditions of Greece or of the gothic north. As late as the 1840s, English merchant cities still considered themselves inheritors of the tradition of Greece. With us that is no longer possible: we are too self-conscious to turn to the past for aid or inspiration.

Yet that is not to say that the classic and the gothic have not provided a focus of attention, a point of reference, if you like, for writers and artists in the modern period. I don't say that our two traditions were *imitated* in this century, but that their force required artists at least to refer to them, even if sometimes only in a rather sardonic way. For instance, perhaps the most superficially 'modern' of all recent architects, famous in the text books, was Ludwig Mies van der Rohe. He became well-known for austere, restrained buildings like the School of Architecture at the Illinois Institute of Technology (Figure 80). But if you look closely at this building, and then at one of Mies' earlier works, like the project for a house

Figure 80 School of Architecture, Illinois Institute of Technology (Wayne Andrews, Michigan).

127

Figure 81 Project for Kröller House, 1912 (Collection, The Mies van der Rohe Archives, The Museum of Modern Art, New York).

for Mme Kröller (Figure 81) you will perhaps see a degree of classical influence. In fact, Mies was designing the Kröller house at almost exactly the same time as Fritz Stahl's first modern monorgaph on Schinkel was being published; both the house and the book testify to a taste for the classical.

A little later, in France, the Swiss architect Le Corbusier was happy to compare the beauty of the Parthenon with the beauty of the modern machines he so admired (Figure 82). And in this century also, two major churches have been built in the Gothic style! (Figures 83–84.) Neither Gaudi's church in Barcelona, nor Scott's cathedral in Liverpool has yet been completed, so it would be foolish so prematurely to speak of the end of the gothic tradition!

Figure 82 Page 125 of Le Corbusier Toward a new architecture, *Architectural Press, 1946 (Reproduced by courtesy of Architectural Press Ltd).*

Figure 83 La Sagrada Familia, *Barcelona (Photo: A. F. Kersting).*

Figure 84 *The Anglican Cathedral, Liverpool, from the south-east (Photo: A. F. Kersting).*

In the literature of art the philosopher, Nietzsche, used a classical background for his study of the relationship of art to society, *The Birth of Tragedy*, while one of the most significant theorists to affect the course of modern painting, Wilhelm Worringer, used the gothic as a foil to reflect his ideas about modern art. In his book *Formprobleme der Gothik*, published in 1912,[1] Worringer set up the gothic art of the middle ages as an exemplar of those attitudes, feelings and attainments which he felt to be appropriate to twentieth-century painting.

Picasso, for instance, is sometimes said to have had a neo-classical period, and Wassily Kandinsky and Franz Marc, authors of one of the well-known documents of modern art, the *Blaue Reitter Almanach*, were fascinated by the gothic. In fact, traces of classic and gothic in this century would make a book in its own right. Let me leave you with one quotation to ponder.

I have used chiefly illustrations of buildings to show the changing ideas about style which I wanted to introduce to you. I believe that the study of architecture has had too small a place in the history of art, at least as it is taught. I hope that I have been able to suggest to you that buildings carry many layers of meaning, as well as of masonry. In a play which is itself evidence of the points I want to make, *Eupalinos, or the architect* by Paul Valéry, Socrates says

'. . . de tous les actes, le plus complet est celui de construire. . .'

'. . . of all activity, the most complete is building. . .'

I think that is right and I hope you will agree that the most complete way to discuss how ideas of style and its creation and imitation have influenced the history of art, as well as the history of taste, is to look at buildings.

[1] The first English edition was published in 1927 as *Form in Gothic*, Putnams.

RECOMMENDED READING AND REFERENCES

Clark, Kenneth (1928) *The Gothic Revival*, John Murray. Paperback edition 1976. Clark's first book, both witty and informed. It is still the best book on the spirit of the Gothic revival, although many of the opinions in it are now dated.

Crook, J. M. (1972) *The Greek Revival*, John Murray. An excellent up-to-date book.

Frankl, Paul (1960) *The Gothic – Literary Sources and Interpretations through Eight Centuries*. Princeton University Press. An immense work of scholarship. Useful only for reference.

Holt, E. G. (1958) *A Documentary History of Art*, Doubleday.

Jaeger, Werner (1939) *Paideia: die Formung des griechischen Menschen*, translated as *Paideia: the ideals of Greek Culture*, Blackwell, Oxford. A subtle and complex account of Greek civilization.

Muthesius, Stefan (1972) *The High Victorian Movement in Architecture 1850–1870*, Routledge and Kegan Paul. A slightly confusing book, if you do not know the period well, but the best account there is of the climax of Victorian architecture.

Pevsner, Nikolaus (1960) *An Outline of European Architecture*, Penguin. An irreplaceable and very readable account of the history of architecture.

Pollitt, J. J. (1965) *The Art of Greece*, Prentice-Hall.

Praz, Mario (1933) *The Romantic Agony*, Oxford University Press. A fascinating and very rich study, but one which is a little dated. Useful for the cultural and literary background of the eighteenth and nineteenth centuries.

Rykwert, Joseph (1973) *On Adam's House in Paradise*, Museum of Modern Art Papers on Architecture, New York. A brilliant, complicated and idiosyncratic account of the earliest forms of architecture, and how the idea of the primitive hut has influenced the formation of ideas on classical and Gothic architecture.

Seznec, Jean *La Survivance des Dieux Antiques* translated as *The Survival of the Pagan Gods*, Pantheon Books, New York, 1953. One of the first studies of the Warburg Institute. An account of how the pagan gods of classical antiquity became translated into Christian terms: an excellent demonstration of the 'classical tradition'.

von Simson, Otto (1956) *The Gothic Cathedral. The Origins of Gothic Architecture and the Medieval Concept of Order*, Routledge and Kegan Paul. A very solid introduction to Gothic architecture.

UAA - DON'T FORGET *Oswald Hanfling*

(Please have Units 2B and 9 handy for this section.)

There is a story about a judge who was too easily swayed by fine speeches. One day, having heard an extremely fine speech from counsel for the plaintiff, he pronounced without further ado: 'The plaintiff is right.' The court was stunned at this breach of procedure. However, a little man at the back of the gallery spoke up: 'Excuse me, your Honour, but shouldn't you also hear what the other side has to say?' The judge therefore called on counsel for the defence to state his case. This man spoke with great feeling and conviction; it was a superb, an exceptional speech. No sooner had he finished than the judge pronounced: 'The defendant is right.' There was an awkward pause, and then the man from the gallery spoke again: 'Surely, your Honour, they can't both be right.' The judge reflected for a moment and replied: 'You also are right.'

Reading what some of the great artists have said about art, you often get this feeling. What *A* says seems so very true; and *B* was surely right when he said . . . And yet – aren't they contradicting one another? How can both be right? Here is what the painter Sir Joshua Reynolds said on the subject of artistic invention and genius (*Discourse VI*, 1774):

> The mind is but a barren soil; a soil which is soon exhausted, and will produce no crop, or only one, unless it be continually fertilized and enriched with foreign matter . . . it is by being conversant with the inventions of others, that we learn to think . . . The greatest natural genius cannot subsist on its own stock: he who resolves never to ransack any mind but his own, will soon be reduced, from mere barrenness, to the poorest of all imitations; he will be obliged to imitate himself, and to repeat what he has often before repeated.

About 1808 the poet and painter William Blake wrote some marginal comments in his copy of Reynolds' *Discourses*. (This copy is now in the British Museum.) You can easily tell that Blake disapproved of Reynolds, from what he wrote against the first sentence: 'The mind that could have produced this Sentence must have been a Pitiful, a Pitiable Imbecility.' He went on: 'I always thought the Human Mind was the most Prolific of all Things & Inexhaustible. I certainly do Thank God that I am not like Reynolds.'

Now what exactly did the disagreement between Blake and Reynolds consist in? If you agree with Reynolds, must you deny what Blake says: Or if you think Blake was right, must you contradict Reynolds? (Leaving aside the personal bits.) What do you think? Please give some thought to this question and then try the exercises that follow.

1 Please state Reynolds' view plainly, in a sentence.

An artist (or anyone) needs to study the works of others; otherwise he will soon run out of ideas and will only be able to repeat what he has done before.

2 Does Reynolds give an argument for his view? If so, please (a) set it out, (b) say what you think of the argument, and (c) say what you think of the premises. (UAA section 3.6 is relevant.)

The subject of UAA section 3.6 is analogy, and Reynolds is of course using an analogy in this passage. (a) He argues: the mind is like a barren soil; barren soil needs fertilizing; therefore: the mind needs fertilizing – or something analogous to fertilizing. (b) I can't see anything wrong with this argument. If the mind *is*

like a barren soil (in a suitable sense), then the conclusion is reasonable enough. But (c) is the mind like this? (Is this premise acceptable?) I would be inclined to say: yes, to some extent; depending on whose mind it is, at what stage of their life and so on. There is certainly a good deal of truth in this premise. On the other hand, in speaking of 'the mind' as he does, Reynolds seems to be saying that it is *always* as he describes (although he doesn't actually use the word 'always'; on this see UAA, page 14). If so, he is making a rash generalization. And someone (such as Blake) who thinks of *himself* as not conforming to that generalization will be especially likely to object to it.

3 To what extent, if any, can one agree *both* with Reynolds and with Blake? (If there is a crafty conflation – see UAA section 2.5 – in the quotation from Blake, please say what it is and how it affects the question.)

Blake runs together (conflates) two different notions, 'prolific' and 'inexhaustible'. But Reynolds has not denied that the mind is prolific; he might well agree that it is 'the most prolific of all things', as Blake says. What Reynolds does maintain is that the mind, if it is not to be barren, needs to be 'fertilized' regularly; thus disagreeing with Blake that it is 'inexhaustible'.

Well, what should we say about this disagreement? The intense irritation that Blake expressed in his marginalia is a sign of a deep difference between the outlook and spirit of these two men. But obviously we cannot pursue this subject here. Let us merely see whether the passages I have quoted are *reasonable* expressions of two conflicting views. It seems clear enough that, as they stand, they conflict. We cannot agree both with Blake that the mind is 'inexhaustible' and with Reynolds that it needs to be 'continually fertilized', failing which it 'will soon be reduced, from mere barrenness, to the poorest of all imitations', etc. But are we to take these statements literally? Or are they examples of something I discussed in UAA section 2.2?

4 (a) Would it be reasonable to accept either of the statements as they stand? If not, please say to what extent, or in what sense, we *could* reasonably accept them. (b) If there is such a sense, then what contradiction, if any, remains between Reynolds and Blake? (Please look at UAA section 2.2 before answering these questions.)

It seems to me that both writers are 'overdoing it', and perhaps being carried away by their hyperbolical turns of speech. (See UAA page 21 on hyperbole.) We cannot accept that the mind is inexhaustible, if that means – as it seems to – that it *never* runs out of ideas; or that an artist *never* needs to study the works of others. Did Blake really mean that? Perhaps what he meant, more reasonably, was that an artist (especially, perhaps, an artist of genius) may go far beyond what he picks up from others, that this plays only a limited role. But this much Reynolds (and anybody else) would surely accept. Reynolds on the other hand, is putting his case too strongly if he says – as he seems to – that the artist has *continually* to be getting his fertilization from others; that he goes into decline *as soon as* he ceases doing so. The reasonable way of taking Reynolds' hyperbole would be that contact with other minds *can* be very important, and that an artist's work *may* suffer from the lack of it. And this much again, must surely be acceptable to Blake.

UNIT 18 ART AND VISUAL PERCEPTION. FORM AND MEANING
(AARON SCHARF)
CONTENTS

PART 1 ART AND VISUAL PERCEPTION

1 INTRODUCTION

You will have gathered from these units on art that whatever the emotional, psychological or intellectual factors were that provided the main drive in the creation of what we call a work of art, the predominance of art produced in human history hinged in one degree or another on the artist's perception of the external world. That 'artist' may have been a palaeolithic caveman who, for the sake of survival itself, was compelled to observe the most minute characteristics of both the form and behaviour of those animals on which life depended (Unit 16 Figures 6–8). He might have been a Chinese landscapist whose contemplation of nature was as much a philosophical or religious act as an aesthetic one and whose work was less a mirror than a metaphorical interpretation of the outside scene (Figure 1). Or perhaps the artist was a French Impressionist whose essential motivation was to achieve an optical veracity of such magnitude that it proposed to capture the very *feel* of light and atmosphere in their ephemeral

Figure 1 Chinese landscape painting. Kao Jan hui Summer Haze, *ink and muted colour on paper, thirteenth/fourteenth century.*

Figure 2 Claude Monet The Thames and Westminster, *oil on canvas, 18½ × 28½ ins, 1871 (The National Gallery, London).*

passage through the hours of the day (Figure 2). Each of these artists, however dependent on the eye, had to apprehend nature not simply visually, but with the brain at work as well. And it is precisely this relationship between the eye and the brain with which we will concern ourselves here in this section. To a large extent you will have been prepared for this discussion in Rosalind Hursthouse's Unit 15 *Scepticism and Sense-Data* and television programme 15, *Appearance and Reality*, which accompanies it. Both unit and broadcast deal with the intriguing problems philosophically inherent in the use of the words 'appearance' and 'reality'. There, a great range of sensory experience is explored in order to demonstrate the varieties of ways one might perceive the external world and how in certain circumstances our senses may deceive us. Here, though much more briefly, we attempt to demonstrate that many of the ideas put forward in Unit 15 are central to any investigation of the history of style in the visual arts.

We want, however schematically, to determine the inter-relationships of mind and vision, and the extent to which one is able to supersede the other. To do this we must turn to a branch of psychology concerned with perception. Pioneer work in the psychology of perception began towards the end of the nineteenth century.[1] With the distinguished studies undertaken by Max Wertheimer and Wolfgang Köhler from the second decade of this century, and those of Kurt Koffka soon to follow, interest in the field accelerated. These investigations into what might be termed 'the meaning of seeing' come predominantly under the heading 'Gestalt Psychology', a term to which we shall return in due course. So far as art history and theory are concerned, Gestalt Psychology throws a great deal of light on questions having to do with artistic style. And this we shall make use of in trying to fulfil one of our principal objectives.

[1]George Stratton's unsurpassed explorations into the stability and inversion of retinal images were first made in 1896. By wearing spectacles which were designed to make everything in view appear upside-down, in one week he began to see things the right way round. It demonstrated the extent to which the human optical system will function to make the world perceivable in the habitual way.

2 THE EYE AS A CAMERA

So, to begin, we ought very briefly to consider the way the eye acts physiologically, that is to say with no voluntary references to the emotions or to the intellect. If you are especially interested in this aspect of perception and the rudimentary psychology associated with it a few convenient sources to pursue would be: Richard L. Gregory *Eye and Brain*; M. D. Vernon *The Psychology of Perception*, and Ida Mann and Antoinette Pirie *The Science of Seeing*.

The actual physical effect of the dark and light patterns (the tonality) and the colours of external objects is made principally on the retina of the eye. A self-generating chemical called rhodopsin or, more commonly, 'visual purple' is contained in the 'rods' of the retina. It is this light-sensitive vehicle which governs the contraction and expansion of the rods which with the 'cones' are in different degrees sensitive to light. Through a complicated nerve-fibre system, the 'messages' received are transmitted to the brain, though recent experiments attempting to provide the totally blind with some form of 'vision', indicate that the process is in some degree reversible; stimulation of the appropriate areas of the brain will produce sensations of vision.

Colour reception is even more complicated and less understood. It is also governed, but only in the first instance, by physiological responses (i.e. purely biological and relatively free from psychological factors). Thus we can verify the compensatory effects of complementary colours. These will be seen when the eye is exposed, for example, to blue, and will then 'correct' by seeing orange; what is often called a colour 'after-image'. All this is of necessity over-simplified here and you shouldn't be too concerned if we only touch on it for the sake of brevity. But what may be of special interest to us in the context of art is that, surprisingly, an *actual image* is, for a fraction of time, deposited on the retina. In fact, the whole ocular system functions in a remarkable degree like a photographic camera and, with the exception of being able to *fix* moving images, even like photographic plates. Scientists for some time have been moved to compare eye and camera closely. An exceedingly interesting and informative study of this kind was published by Dr George Wald in 1950 while he was Professor of Biology at Harvard University. It appeared in August that year in the periodical *Scientific American*.

Citing historical sources which date from as early as 1876, Wald and his associates actually removed the rhodopsin from the retinal rods of animals, and mixed the substance with gelatine with which dry plates were made. With these, Wald was able to demonstrate not only that rhodopsin plates responded to light photographically, but even that latent images could be produced and subsequently 'developed'. Wald's augmentation of the earlier experiments of other scientists, was a further confirmation of the discoveries of Franz Boll at the University of Rome in 1876 and Willy Kühne at Heidelberg a few years later. They agreed that with 'visual purple' the eye acted rather as a camera loaded with film. Kühne in 1878 actually exposed the eye of a living rabbit to the framed panes of a window seen from a dark room. He then killed the animal, immediately extracting the retina and fixing the image in alum (Figure 3). In 1880, a

Figure 3 Willy Kühne
Optogram drawing from
'fixed' retina of rabbit, 1878.

139

more gruesome trial was made by Kühne with the eye of a criminal executed by guillotine. The retina retained what was described as a sharply defined 'optogram' on its surface, though the source of that particular image could not be ascertained. It is perhaps not without significance that from the early 1860s, popular belief often held that the eyes of murdered people retained incriminating evidence of the misdeed (dead men *did* tell tales?) and there are several intriguing documents which carefully describe the efforts of photographers to capture the picture in the eye (on or through the irises and pupils!); to record the last image seen.

EXERCISE

Now what do you think might have given rise at that time to this conviction that the eye was capable of retaining images? What was happening in art that would support such convictions – can you say? Stop, for a moment, and give this some thought. It is not necessary for you to write it down.

DISCUSSION

My guess would be first, that reports of earlier scientific investigations along similar lines to those of Boll and Kühne were leaked out into the popular press and captured the public's imagination. Second, that apart from age-old superstitions about the power of the eye, it was quite understandable for people to believe that the camera was only a more mechanical version of the human eye which, like the camera, took in with precision all that lay in the visual field. Third, that the whole drift of European art at the time was towards visual objectivity.

EXERCISE

Now, despite the activity of retinal rhodopsin, can you say what the main shortcoming would be in any belief that the 'eye' records objectively? Before going on to the discussion, give your opinion in a short paragraph in the answer box.

DISCUSSION

I hope you've grasped the notion that what is registered on the eye (or the retina) and what one *sees* are two different things. What the eye takes in is edited, sometimes to an extraordinary degree, by the brain – or using a less physiological term, by the mind. The idea that the eye is 'charged with thought' is with little doubt a valid one. It has profound implications for art and not just style but for the *history* of style.

EXERCISE

I'd like to ask you yet another question. Consider it carefully, but it isn't necessary to put your thoughts down on paper. I know this is a difficult one to pose at this stage but try and guess just what a few of those 'implications' might be.

DISCUSSION

Have you seen that the main 'implication' here would be: for an artist at any period in history, the thought that above all would 'charge' his eye would be that concerning the character of the art around him; that which preceded him and that existing contemporaneously. Which is to say that it would be rare, if not impossible, for any artist, however acute his vision, to conceive his work with no reference (either consciously or subconsciously) to traditional and contemporary forms. However much the artist is motivated to create something new, something no one has ever produced before, however purposefully he works to that end, however active his imagination, he cannot (any more than can those in other arts and even sciences) totally evade the tenacious bonds of his aesthetic heritage. As a consequence of this, the very *way* in which the artist (or anyone else for that matter) perceives the external world must depend not just on what he sees, but on what he knows. Moreover, depending on the *quality* of this preconditioning (the 'education' of the eye we might say), he may become in one degree or another, either obtuse in his perception, or acute. The essential meaning of this idea might well be that any artist who deliberately 'blinds' himself to other art faces the risk of stultification and impotence. Such painters as Eugène Delacroix understood and commented on this. So did John Constable, however much he craved for 'scientific' objectivity in his own vision.[1] You've done well if you grasped even in a general way such implications or others, not discussed, but springing from them.

[1] Constable's painting, and his way of observing nature, will be discussed in more detail by Stephen Bayley in Units 22–23, *Nature, Work and Art*.

3 BELIEVING IS SEEING

Now we can turn to a most revealing study in the psychology of perception. It has much meaning for art. It will, I believe, serve to confirm the thesis I have set out which, restated, is that art comes at least as much from art as it does from life. The study was undertaken by F. J. Cole and is described in 'The History of Dürer's Rhinoceros in Zoological Literature'. Cole, quite astutely, turned to Albrecht Dürer's famous woodcut of a rhinoceros executed in 1515 (Figure 4).

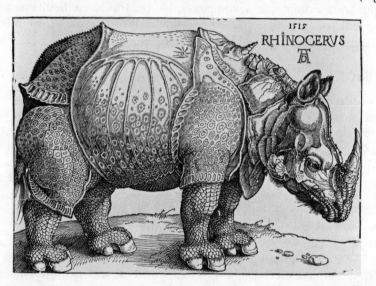

Figure 4 Albrecht Dürer Indian rhinoceros, woodcut, 1515 (Ashmolean Museum, Oxford).

Dürer, we know, had never seen a rhinoceros. But by assiduously piecing together sketches 'from the life' made by a contemporary of his, and guided also by verbal descriptions of the beast which had that year been presented to the King of Portugal by the Sultan of Guzerat, Dürer constructed his extraordinary animal. As you see in the illustration here the armour-plating is somewhat heightened, and an extra little horn appears on the rhino's shoulders. But in most other respects, the animal precisely conforms to the anatomy of the single-horned Indian rhinoceros. Compare it, for example, with Robert Stark's sculpture of an Indian rhinoceros executed in 1887, at a time when literal accuracy in such representations was an artistic imperative (Figure 5). Dürer's wood-

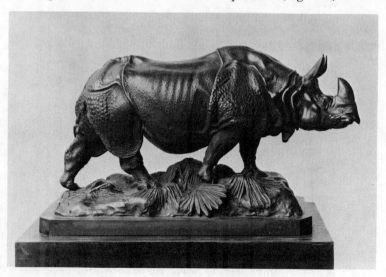

Figure 5 Robert Stark Indian rhinoceros, bronze, 17 × 30¾ × 10⅞ ins, 1887 '(Tate Gallery, London).

cut became so famous, so well known, that for more than two hundred years it served as the prototype for most representations of the rhinoceros.[1] And even though few artists admitted or (more to the point) even really knew their sources, they were (apart from other signs) 'betrayed' by their use of the dorsal horn which was completely fictitious and which was really an invention originating in Dürer. Now, what interests us here are not the obvious signs of artistic plagiarism, as in Gesner's direct copy in reverse (1551) of Dürer's animal, but those examples in which the artist claimed that his animal was observed *directly from life*. Ambrose Paré's rhinoceros of 1573 (Figure 6) and that by Tempesta in

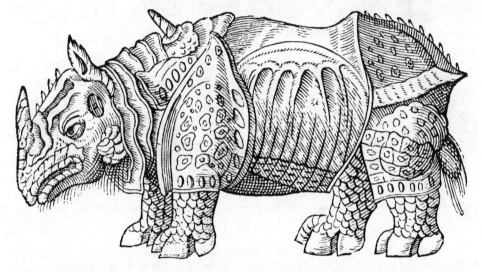

Figure 6 Ambrose Paré Rhinoceros, 1573. (Photo from E. A. Underwood (ed) (1953) Science, Medicine and History: Essays on Evolution, *Clarendon Press, Fig. 7, p. 343. Reproduced by permission of the editor.)*

1650 are only two of many other representations of the rhino which spring more from Dürer than from nature, though it is not certain that these two last-named artists intended to produce a 'true to life' image of the beast. But, in 1719, an artist named Kolbe gave accurate *verbal* descriptions of the African rhinoceros. Kolbe claimed that he himself had observed that animal, and he deplored the inaccuracies of previous representations of the subject. Yet for all his visual awareness Kolbe too, in his engraving of a rhino shown with an elephant (Figure 7), not only incorporated Dürer's shoulder horn (as you can see in the illustra-

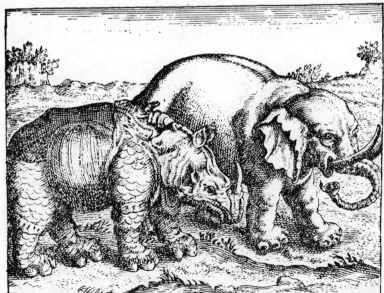

Figure 7 Kolbe African rhinoceros and elephant, 1719. (Photo from E. A. Underwood (ed) (1953) Science, Medicine and History: Essays on Evolution, *Clarendon Press, Fig. 21, p. 351. Reproduced by permission of the editor.)*

tion), but covered the limbs of his rhino with large fish-like scales (to simulate Dürer's 'armour-plating'?). It should be mentioned that Dürer's second dorsal horn may have appeared plausible to artists who knew of seventeenth-century literary references to a two-horned species of rhinoceros native to Africa, though not that both horns were on the nose.

[1]Cole shows 24 figures, most of them rhinos from many artistic sources.

Finally, in 1790, the explorer James Bruce published volume 5 of his *Travels to Discover the Source of the Nile*, containing an engraving (Figure 8) by James Heath

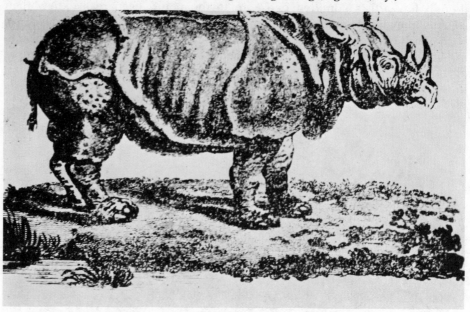

Figure 8 James Heath African rhinoceros, *from James Bruce* Travels to Discover the Source of the Nile, c. 1790.

of an African rhinoceros (said to be thirteen feet in length and almost seven feet high) bearing two horns, and this time with both of them up front where they belong. Bruce was even more aware than Kolbe of the significance of Dürer's woodcut and how it had served, even unwittingly, as a model ever since it first appeared. But this, he wrote (referring to Heath's illustration in his book), 'is the first drawing of the rhinoceros with a [proper] double horn that has ever yet been presented to the public . . . it is designed from the life, and is African'. And in that respect he was right. *But*, with the single exception of the rare white rhino from *central* Africa (near Lake Victoria) none of which until this century had ever been seen in captivity, *all* African rhinoceroses, as you can see in Figure 9, are relatively smooth-skinned, and lack the heavy sectional folds and studded hide typical of the *Indian* species.

Figure 9 White rhinoceroses in Hluhluwe National Park, Durban (Photo: J. Allan Cash).

We are therefore tempted to conclude that even with a knowledge of the history of rhinoceros misconstruction, and despite the accuracy in the arrangement of horns, Bruce and Heath gave to their animal the segmented armour and tubercular hide (though designing it 'from the life') which must ultimately have been derived from the compelling image of Dürer's rhinoceros.

Now let's examine, the same idea, but in a verbal context. An interesting example of the way in which perception can be directed by causing the observer to *expect* a certain form is cited by Vernon in *The Psychology of Perception*. Groups of letters such as 'SAEL' and 'WHARL' were presented at a fraction of a second to different groups of subjects: 'Observers [writes Vernon] who had been told that they would see words related to "boats" perceived these as "SAIL" and "WHARF"; while observers who had been told they would see words related to "animals" perceived them as "SEAL" and "WHALE".'

Even if no previous instructions had been given, I've little doubt that the tendency would have been to render meaningful those nonsense words. What has this kind of ambiguity to do with art? Let's take an example straight from literature. Lewis Carroll understood (as did other writers: Edward Lear and G. K. Chesterton are examples) the potency of 'almost-words' (if I may call them that). His frequent use of archaic English formulations as in Alice's poem, 'Jabberwocky', from *Through the Looking Glass*: ''Twas Brillig, and the slithy toves/Did gyre and gimble in the wabe. . .' exert a strange hold on the imagination. This is so not because they are remote, but because (like Vernon's examples) they verge on the intelligible. 'Somehow [says Alice] it seems to fill my head with ideas – only I don't exactly know what they are!'

An analogy exists certainly in the visual arts. So let us now concentrate on that.

EXERCISE

Will you look hard at the following four reproductions (Figures 10, 11 and 12 and the Colour Supplement, Unit 16 Plate 6)? Two of them may be said to be analogous to what Alice read to the White King in Carroll's book. Two are not. Can you identify the two groups, then give reasons for your selection? You may not have chosen the same pairs I have. But I *would* expect you to understand the purpose of the exercise.

Figure 10 Rembrandt
Self-portrait, *oil on canvas,*
44⅛ × 34 ins, c. 1660
(Louvre: Cliché des Musées
Nationaux, Paris).

Figure 11 Paolo Uccello The Rout of San Romano, *1454–7, 72 × 125¾ ins (The National Gallery, London).*

Figure 12 William Holman Hunt The Scapegoat, *1854 (The Trustees of the Lady Lever Art Gallery, Port Sunlight).*

146

DISCUSSION

I would say that the Rembrandt and Delacroix paintings belong together as do the Uccello and the Holman Hunt; the first pair being the more 'suggestive' ones. I wonder if you have chosen the same pairs? In any case have you been able to say something along these lines: that in the Rembrandt and Delacroix it is the incompleteness of form, the absence of full description in an intelligible context which serves as an inducement for the spectator to perform the act of completion? In art, even ambiguity may have its virtues. Thus in these two canvases by Rembrandt and Delacroix the shapes appear to lose their substance in shadows, contours are broken, the brushwork is open and more apparent and tends in places to obscure the finer detail. In the composition of the Delacroix especially, there is a certain instability suggestive of movement and vivacity which contrives to draw us in at an emotional level. Rather the opposite exists in the orderliness of the other two paintings. There, each object is carefully 'spelled out' in predominantly stable compositions, though you might make the case for a certain instability in the Uccello. We are not attempting here to make any value judgements as to the success or failure of either kind of painting, for each in its own way performs some special artistic function. Indeed, it might even be said that in respect of visual perception, the very relentlessness in Holman Hunt's pursuit of detail and possibly Uccello's too, has in the abundant descriptiveness a quality of poetic exhilaration which engages the spectator quite as much as the Delacroix and Rembrandt, though in a different way.

I've used the word 'completion' above quite deliberately. For psychologists over the past fifty years or so have devised a number of 'completion' tests (as they are called) to measure the manner and degree with which their subjects will, to state it crudely, 'fill in the spaces' (Figure 13). They have in their investigations

Figure 13 A Street completion test (Photo from R. F. Street (1931) A Gestalt completion test, Teachers College Press, New York, p. 55. Reproduced by permission of the publisher).

identified a characteristic propensity, or need, for completing, one way or another, the missing gaps in such forms as are presented to them. Think of the term 'the will to form' discussed in Part 1 of Unit 16. This, psychologists have given the German designation 'Gestaltung' and so have earned many of them the label Gestalt Psychologists (see p. 138). Such experiments bear heavily on education and learning processes. In their relevance for the visual arts, the experiments have gone well beyond completion tests into areas which among other categories bear on colour perception, the perception of scale and space, and of movement.

This apparently human need to find meaning in things ('the mind abhors a vacuum', is a phrase one used to hear in art teaching), to make the world perceivable in reassuringly habitual ways, is inherent in all the processes devised for mental conditioning, from the evil techniques of Dr Goebbels to the less sinister though still repressive injunctions which insist upon narrowly circumscribed conditions for artistic representation. This, ironically, though not surprisingly, has been more prevalent in times when the whole 'social current' was conducive to a greater liberation of the imagination. We are reminded of the Impressionists who were vilified for 'falsifying nature', for seeing the world through 'malformed eyes'.

Such controversy about pictorial truthfulness reached a high point in aesthetic polemics in the nineteenth century. Yet the *true* image of nature remained as fugitive and as unascertainable as it always will be. Clearly, there has never been in art such a thing as an absolutely truthful representation of nature, any more than there can ever be a completely objective perception of nature in so far as the human vision is concerned. The popular saying that the photograph never lies is itself an untruth. Though in some respects photographs convey something approaching a mathematically correct optical truth, more often than one thinks the camera fails to record nature with the accuracy attributed to it and is itself subject to the vagaries of accident and choice. A more generous appraisal would be to say that the camera doesn't lie, but that it tells the truth in a number of different ways – and I'm referring both to the still and cinematic camera.

4 BLINDNESS AND VISION RESTORED

There is, then, from all accounts, a propensity in humans to complete, to order, to exact an apparent logic from visual forms (as well as auditory and other sensations). Such a compulsion is for better or worse an invitation to learning. Perhaps we ought to start (in an optical sense) with a clean slate. So let us turn to a few revealing examples of investigations into the visual education of people born blind but with their sight later restored by surgery. You'd think that once vision had been gained the world would naturally appear as it does to us when we wake up each morning? Nothing could be further from the truth. Here are the observations of D. O. Hebb, comparing the response of one of his adult patients who had undergone successful surgery about thirty years ago with the recorded work on other patients by the psychologist, M. von Senden.

Hebb writes:

> . . .A patient was trained to discriminate square from triangle over a period of 13 days, and had learned so little in this time 'that he could not report their form without counting corners one after another. . .'. The shortest time in which a patient approximated to normal perception, even when learning was confined to a small number of objects, seems to have been a month. (*The Organisation of Behaviour.*)

Hebb found that even after the identification of an object was learned in a year's time, if it was put in another context or its position changed, or its colour changed, it again became unidentifiable. Clearly, the process of seeing is one of learning, whatever the maturity of the intellect – or unlearning, in such cases as are previously committed to sensations of touch. Though a few cases have been reported where the newly recovered patient can immediately perceive the differences between two adjacent and different figures, there are many who cannot. That is to say, extraordinary as it seems to us, the difference between a sphere and a cube was not always perceived. Colour identification, perhaps not surprisingly, was learned more readily than the identification of form.

In an earlier report by H. A. Carr in *An Introduction to Space Perception*, one of his patients, a thirty-year-old, had after the operation to rely mainly on his previous tactile knowledge of things, his feel of them, to locate objects in space and relate them in scale. The tendency was to see objects much larger and closer up than is generally perceived with normal vision; 'When he first looked out of the window at the pavement below, he felt that he could easily touch it with a stick.' Though we are not told how high the window was from the ground, or the length of the stick, it is evident what the findings meant.

The tragic consequences of an eyesight regained are told by Gregory in *Eye and Brain* in his work with the patient, S. B. So distressed was this subject at age fifty-two with the vision of a world in which previously security was vested in a habitual tactile and auditory understanding of it that he just retreated from life and let himself die.

EXERCISE

I'd like now to try a little experiment with you, to ram the point home. Look at this reproduction of Pears' (soap) nineteenth-century advertising picture-puzzle on the next page (Figure 14) with the silhouettes of Churchill, Salisbury and Gladstone reading obliquely from left to right. Which figure is the tallest, which shortest? There is no need to put this down on paper, but do it by eye; do not use any instrument for measuring.

Figure 14 Pears' picture puzzle from the Graphic, *1886.*

DISCUSSION

Unless I'm mistaken you've selected Gladstone as the tallest and Churchill as the shortest. But here is Pears' missing caption which I have had replaced: 'In the above silhouette Churchill does not appear so tall as Salisbury, nor Salisbury so tall as Gladstone, but if measured all will be found of equal height. N.B. – No other equality is to be inferred.' They are all of equal height!

Now, from what Hebb and Carr have told us, it is most likely that *their* patients, with newly restored sight, would have done exactly the opposite. They would have seen the three figures as equal in height.

150

EXERCISE

Can you say why? Write a short answer in the answer box.

DISCUSSION

The answer is that only after *learning* the meaning attributable to those converging lines and diminishing letters, would they have been capable of making the same *optical error* as you have. In their ocular innocence, they *had not yet become so sophisticated visually as to see incorrectly!*

To return then to art, we are again reminded of painters such as Claude Monet, the resolute nineteenth-century Impressionist who was so obsessed with the idea of being able to paint objectively, so determined to shake off the pervasive hold of visual tradition, that he is said to have remarked to a fellow painter that he wished he could have been born blind, then with his sight restored, to paint the objects before him *with no knowledge of what they were.* [1] We now know what problems would have confronted Monet in such circumstances. And we ought to know that however much his style of painting departed from painterly conventions (for they are but conventions) reigning at the time, in several essential respects his 'outrageous' techniques were nevertheless solidly founded on tradition. Later in this unit we will come back to Monet when we scrutinize more closely just what such Impressionist painting was intended to convey.

[1] A full and penetrating study of perception and tradition in the visual arts will be found in Ernst Gombrich's *Art and Illusion*, first published 1960. If ever you want to follow the theme more comprehensively I recommend this difficult but gratifying book. I can also recommend Rudolf Arnheim *Art and Visual Perception* which deals with more immediate conceptions of artistic form geared directly to studies in the psychology of perception.

5 THE INNOCENT EYE: COURBET AND HOKUSAI

For reasons not only artistic in origin, other artists too, at different times and in different places, struggled hard to shake off tradition's optical bondage. From the two examples which follow, we ought to be able to grasp the problem even more firmly. Artists who thought of themselves as 'realists' such as the Frenchman Gustave Courbet (1819–77) and the Japanese, Hokusai (1760–1849) were concerned with removing all traces of what they saw as 'style' or 'manner' from their work. To avoid passing on any vestiges of style still apparent in their pictures, they repudiated the idea of teaching art. Though they both had students, they insisted that from nature alone would those students learn the secret of pure artistic representation. We have available two useful documents in this respect which we can reproduce here. In the first, Courbet writes to his students, probably in 1861, saying:

> You have asked for the opening of a painting studio where you might freely continue your education as artists and you have kindly offered to place it under my direction . . . I cannot permit any relationship of professor and pupils to exist between us. Believing that every artist must be his own master, I cannot dream of becoming a professor . . . In painting, (especially), art exists only in the representation of objects visible and tangible to the artist . . . There can be no schools . . . artists will be my collaborators, not my pupils (and I can only teach them the methods I have learned) . . . leaving to each one complete control of his individuality, full liberty of self-expression in the application of this method. (*Le Courrier du Dimanche*, Paris, 29 December 1861. Transl. in Mack *Gustave Courbet*, pp. 162–3.)

This generous display of egalitarianism, with its romantic undertones is laudable, but there is a flaw in it. Keep it in mind but let's go on with the second document concerning Hokusai and *his* students. In the early nineteenth century Hokusai had already become so famous that artists aspiring to be his pupils came to him from all over the land. His immense production of woodcuts amounted to a magnificent cross-section of the character of contemporary life in Japan. His realism, though less 'photographically' correct than Courbet's, was even more punctilious in its observation of natural objects and natural conditions. Like Courbet, Hokusai was said to have told *his* pupils: 'There can be no teacher in painting. All you need do is copy reality.' But Hokusai's associate, the historical novelist, Kozan, tells us that the artist's pupils, from all appearances more discerning than Courbet's,

> . . . were hardly comforted by this statement, and someone who had heard it, spoke reprovingly to the master, saying: 'You are the founder of the Katsushika school. Naturally, those who feel drawn to your style wish to emulate it. But where else are they to find a teacher in this? With even the eyesight of Li Lou [he could see a hair at a hundred paces] or the skill of the master Kung-shu-tzu, how could one draw a perfect circle or square without using ruler or compass? If the students who flock to your gates are not given some kind of model from which to copy, they can hardly master the Katsushika style. Is this not clear?' and the master agreed that it was true . . . (Boller *Masterpieces of the Japanese Color Woodcut*, p. 150.)

And this was one of the reasons, according to Kozan, that Hokusai produced his great series of woodcuts in fourteen volumes called *Manga* (or *Mangwa*) which, roughly translated, means something like 'drawing things just as they come', a huge collection of sketches from everyday life to which his students could refer. So (think of it) even realism in art might be considered a style!

Courbet and Hokusai were both convinced that art demands that scrupulous attention be given to things in nature as they are. Both were scornful of any art which based itself on the work of earlier or even contemporary artists.

EXERCISE

I am sure you are aware of the contradiction in this, but let's put it to the test. We will illustrate here two typical works by Courbet (Figures 15 and 16) and two from Hokusai's *Mangwa* (Figures 17 and 18). Look at them and then in view of the foregoing discussion can you say what the comparison lends to our consideration of artistic styles? Do not write your answer down, but please think it out carefully before reading on.

Figure 15 Gustave Courbet The Winnowers, *1854. (Musée des Beaux-Arts de Nantes. Photo: Studio Madec, Nantes.)*

Figure 16 Gustave Courbet Still-life: Apples and Pomegranate, *oil on canvas, 38 × 51⅛ ins, 1871 (The National Gallery, London).*

Figure 17 Katsushika Hokusai (1760–1849) Harvesting and threshing rice. *Plate from the* Manga *(Tokyo National Museum, Japan).*

Figure 18 Katsushika Hokusai (1760–1849) Fruit and Vegetables. *Plate from the* Manga *(Tokyo National Museum, Japan).*

DISCUSSION

I realize we are comparing paintings with woodcuts here. Nevertheless you should be able to see that however devoted these two artists were to optical veracity, and assuming that the visual equipment of both was fundamentally the same, their styles betray them. Why is it, we might ask, that for all the realism in each of their works, the works are so different from one another? Why is it that Courbet's paintings are generically similar to those of *his* predecessors, and Hokusai's to his? Should we not then return to our main thesis: that art depends on art as much as it depends on life?

Courbet once recommended that all museums and galleries should be closed for about twenty years, 'so that today's painters may begin to see the world with their own eyes'. In the context of nineteenth-century academies and the powerful hold they had on art, and considering the ways in which European society was changing, Courbet's words may enlist our sympathies. But in another sense they may be said to be naïve. What would have happened had Courbet's wish been realized? Can you see that younger artists, deprived of the best examples of art from both present and past, would more likely have filled the stylistic vacuum by absorbing, even unwittingly, the art, and probably much indifferent art, of their contemporaries? There's the flaw! In my opinion it is not likely that blinding themselves in that way would ensure that they'd then see the world 'with their own eyes'. Hokusai's pupils had a powerful point. And Courbet's older contemporary, Delacroix, with his usual grave and pensive intelligence, noted in his *Journal* that only the painter who is a student of many, is the imitator of none.

In a search for accuracy of representation, whatever other considerations governed the forms art took in each historical period, we find many examples from the emerging of the Renaissance through the nineteenth century in which artists, each in their own time, were believed by contemporaries to have reached an apogee of perfection in illusionism. Thus it was said that Giotto rendered objects so that they seemed to be the things themselves rather than resemblances. Masaccio's figures were supposed to live and breathe. Raphael's were thought to be life in its utmost animation. Of one of Chardin's still lifes: 'We have but to take the biscuits and eat them, this orange open and squeeze it, this glass of wine and drink it'. (cf. Colour Supplement, Unit 16 Plate 2, Diderot on Chardin *Salon*, 1763.)

We are therefore left to ponder on the probability that, in art at least, reality is not a fixed thing. What is thought to be true in one age is not so in another. Has art then the marvellous faculty of creating its own, ever-changing, reality?[1]

[1]Indeed, this craving for verisimilitude has a longer history. In the first century the Roman satirist, Petronius, described in *The Satyricon* how Encolpius was awed by the pictures of Zeuxis and Protogenes 'which strove to embody the truth of nature herself' and Apelles whose figures were executed with such precision, 'that you might have said he painted the souls as well'.

6 MEANING IN AMBIGUITY

You may remember that in Graham Martin's and Dennis Walder's *Reading Poetry* (in Units 6–8, *Introduction to Literature*) William Blake's poem, 'The Sick Rose' is cited as a 'striking' example of metaphor used in a deliberately ambiguous if not perverted way to increase its mystery and heighten the sense of corruption. There also the example was used of the nonsensical advert 'YOUR POST OFFICE WILL', in which the peculiarity of the syntax invites one to try and make sense of it. A similar condition as we now know applies in the visual arts.

Returning then to the earlier references made above to suggestive form, and to the work of psychologists, I wonder if you are familiar with the test devised around 1940 by Hermann Rorschach (Figure 19)? The deliberate ambiguity of

Figure 19 Rorschach ink blot

these carefully selected coloured ink blots on a set of cards helps psychologists to discover in a general way what impulses seem to guide the perception of their patients. As such forms are susceptible of a variety of interpretations, any spontaneous 'reading' of them will help to reveal the mental preoccupations of the subject. Even a propensity for finding the image either in colours or in shapes is claimed to unveil certain emotional conditions. A marked leaning towards colour, for example, is said to indicate a more ebullient mood, a gaiety and emotional openness which in its extreme form may even be a sign of instability.

Well, I doubt that that will tell us much about Titian for example and his interest in colour, or Michelangelo and his concentration on form. Yet the Rorschach blots do very much pertain to one of our central considerations here, and not only to the artist, but to the spectator's share in the work of art. This again is manifested in that need to complete, of which we've already spoken, that urge to bring meaning and order to ambiguous or incomprehensible images. History records many instances in which the compulsion to 'give meaning to things' played a vital role in human communication. Whether in accounts of the cataclysmic eruption of Vesuvius which covered Pompeii in 79 AD, or the vivid descriptions of Daniel Defoe in his *Journal of the Plague Year*, the most melancholy premonitions of death and destruction took visual form in the canopy of fiery

smoke and rocks over the Bay of Naples and the lowering clouds over London in 1665 and 1666. Philosophers and writers like William James and Aldous Huxley who have dealt with visions, hallucinations and ecstasies, have supplied us with descriptions of observed experiences, those especially of a hysterical nature, in which the most extraordinary images are seen – indeed, astounding physical conditions incurred – as a consequence either of some physical stimulus (drugs, nitrous oxide, ether, etc.), or over-zealous conviction.[1] Now, I am not suggesting that such a heightened stimulus towards metaphysical activity is *strictly* comparable with art. But I *am* suggesting that at a lower temperature art may also involve similar experiences. The flying saucer syndrome is not so remote from art as one might think.

Leonardo de Vinci, for example, at the end of the fifteenth century, conceived of what he believed to be a new method for stimulating the imagination of artists:

> You should look at certain walls stained with damp, or at stones of uneven colour. If you have to invent some backgrounds, you will be able to see in these the likeness of divine landscapes, adorned with mountains, ruins, rocks, woods, great plains, hills and valleys in great varieties . . . and an infinity of things which you will be able to reduce to their complete and proper forms. (This is a very abbreviated abstract from Leonardo's *Treatise on Painting*, No. 76.)

EXERCISE

Study these Leonardo drawings (Figures 20 and 21) and in view of the artist's own words above, try in a few sentences to describe exactly what you think he was trying to do.

Figure 20 Leonardo The Deluge, *drawing,* c. 1504 *(Reproduced by gracious permission of Her Majesty the Queen).*

[1]See William James *The Varieties of Religious Experience* (1902) and Aldous Huxley *The Devils of Loudon* (1952) and *The Doors of Perception* (1961).

Figure 21 Leonardo Neptune, *drawing,* c. 1504 *(Reproduced by gracious permission of Her Majesty the Queen).*

Write in the answer space provided here.

DISCUSSION

Have you seen that Leonardo was quite likely using these drawings as means for assisting invention? While in one sense, they were meant as drawings complete in themselves, they may also have served, as would the stained walls of which he spoke, as a stimulus to the imagination – not only his, while the drawings were being executed, but that of his patrons and fellow artists as well.

We know that Leonardo advised artists not to be too meticulous in executing their drawings (though not so their paintings), for the accidents of form which inevitably appear in quick and untidy sketches might suggest things the artists had only peripherally seen or thought of. Thus he puts the subconscious to work.

Leonardo was neither the first nor the last artist to propose this method. Nor is it to be found only in the West. For as early as the eleventh century a Chinese painter, Sung Ti, recommended to artists the following:

> . . . take an old tumble-down wall and throw over it a piece of white silk, gaze at this until through the silk you can see the ruin with its prominences, levels, zig-zags, and cleavages, and when you have thoroughly

Figure 22 Wen Cheng-ming Seven Juniper Trees *detail from scroll, 1532.*

absorbed all this, when you have stored it all in your mind and fixed it all in your eye, when you have got it all thoroughly into you, then you will see mountains and water, ravines and streams, plants and trees, and men and birds moving and flying. And if you then apply your brush at your fancy the results will be of heaven, not of men. (See Figure 1. Cited by Sung Ti's contemporary, Ch'ên Yung-chih, in Giles, *An Introduction to the History of Chinese Pictorial Art.* cf. also Gombrich, *Art and Illusion*, p. 158.)

The image-evoking power of ambiguous forms need not always reside in shadowy indistinctness. Sometimes sharp, linear configurations, because they seem to describe more than the object they represent, may also perform as visual stimuli. When the sixteenth century artist Wen Cheng-ming executed his ink painting, *Seven Juniper Trees* (a detail of which you see here, Figure 22), the peculiar contortions of the subject's form must have excited his imagination. As the artist alternated between being a spectator and the originator of his own work, such a reciprocal sensuality must have brought a number of metaphorical ideas into play which conditioned the whole manner of the painting's execution. This is how Wen Cheng-ming described his juniper trees:

> Now they writhe like ape arms grasping at the shifting peak, haughty cranes now, bending their necks, combing their feathers . . . Writhing, twisted ropes dance they to the wail of the wind, as the chill spreads. Horns split, blunted claws, wrestling of dragon and tiger, whales rolling in the main. The giant birds snatch unexpectedly. Like ghosts, now vanishing, now re-appearing, in boundless intricacy. (Cheng-ming 1532, cited in Sherman E. Lee *Chinese Landscape Painting*, page 75.)

Figure 23 Alexander Cozens Ink Blot drawing, c. 1785. (Photo from A. P. Oppe (1952) Alexander and John Robert Cozens, A. & C. Black, p. 173. Reproduced by permission of the publisher.)

Perhaps the first artist to turn this aspect of ambiguity into a comprehensive and systematic teaching technique was a well-known landscape painter of the late eighteenth century: Alexander Cozens. In 1785–6 Cozens produced an extensive treatise which bore the title: *A New Method of Assisting the Invention in Drawing Original Compositions of Landscape.* Cozens knew and acknowledged Leonardo's seniority in this field, but *his* 'new' method was new by virtue of a greater technical elaboration in the making of the blots with colours, ink and water and instructions for sketching from them through transparent paper.

EXERCISE

Now once more I'd like you to lend yourself to a little experiment here. Will you look at this engraving dated 14 July 1794 (Figure 24) and before reading on take note of what you see. It isn't necessary here to put your observations down on paper.

Figure 24 The Missing Rulers of Europe, *engraving, 14 July 1794.*

DISCUSSION

No doubt you have guessed that the flags, cannon, drum, sword and flaming urn must all be meant to convey a special set of symbols. The date might help you know to which historical event these things refer. Is there anything else you see which appears strange? If I tell you that the event was the celebration of the fifth anniversary of the Storming of the Bastille and the onset of the French Revolution, does that enable you to see more? Do you now see something that the engraving quite cleverly conceals? If I say to you that somewhere hidden in the picture are the portraits of eight rulers of Europe at or about the time can you more easily find them? You must have them by this time.

Perhaps you'll scoff at me, saying this is all too easy? Probably you're right and I could have given you a much more difficult one to try. But I hope the point has been made nevertheless: that is that one doesn't 'naturally' see all there is to see in nature or in art until one has been alerted to it.

The profile silhouettes are probably as follows: at either side of the urn, the late King and Queen of France, below, flanking the rock pedestal, King George III and Charlotte; the other four are the Empress Catherine the Great of Russia, the Emperor of Germany, the Kings of Prussia and Poland.

Sometimes we see more than we ought. A recent example should give us pause to think. Turkish television viewers protested loudly when they discovered, in a map of North America which appeared on their screens, the image of Lenin. No doubt they thought they were being *eyewashed!*

The game of finding hidden forms in some ambiguous or specially articulated visual field certainly found willing participants, as you've just seen, among the people of Europe and elsewhere well before it came into the province of experimental psychology. As I hope has been demonstrated, it's one thing to let the eye roam over some visual field, dragging the imagination behind it, but quite another to compound the results by carefully directing the attention.

Now, if you can see the essential idea working in terms of arts such as painting, sculpture, architecture, and indeed, music and literature, and of course working more subtly, you may agree that the very banality of *The Missing Rulers of Europe,* its appeal to the less sophisticated, is a sign of its fundamental strength.

Now, in the final section of these units on art, we will concern ourselves with the skill of the artist. Not simply technical skill, but the power to organize the shapes, the colours, and other constituents of pictorial form, in order to provide such visual inducements as to encourage you to discover the nuances of form and their greater meanings for yourself.

PART 2 FORM AND MEANING

1 INTRODUCTION

John Ferguson, in his introduction to the course, has already provided an example of how two representations of the figure of Christ (Units 1–2A pp. 24–5) can, by the way in which each was conceived, elicit antithetical responses in the viewer. His point, you may remember, dealt mainly with expression, or lack of expression, in face and gesture and in the more descriptive elements of the compositions. What we now want to do is to examine a variety of ways in which visual representations in the history of art have been executed so that the shapes and colours, even the tones and use of space (that is to say the 'formal' qualities themselves) lend more (or less) meaning to the subjects they are contrived to convey.

You may also recall that in Unit 10, *Introduction to Music*, Gerald Hendrie uses the term, 'a web of sound-relationships' to suggest the interdependence of a variety of tonal, rhythmic and other elements of musical form which combine in different ways to produce one or another kind of musical composition. This 'web of relationships' occurs also in the visual arts. But as Gerald Hendrie suggests, each medium has as an intrinsic part of it, elements of form which pertain mainly to sensations which dominate in the perception of that medium. Thus rhythm in music is predominantly aural. Yet the term rhythm *can* be applied to painting and poetry too, certainly if poetry is read aloud, but even if it isn't. Though rhythm in any visual composition cannot strictly speaking be said to be aural, there are reasons to believe that what rhythmic arrangements are taken in by the eyes may in a subtle way reverberate in the ears as well. It is possible to speak of 'tone' and even 'colour' in literary works which pertain to subliminal *visual* sensations. In short, I am suggesting that in a curious way, all sensations are interpenetrable in one or another degree. Our language itself seems to propose this: 'That colour is soft'; 'I feel mighty blue'; 'He struck a sour note'; 'I don't like her loud way of dressing'; 'A bitter turn of phrase'. While working on this section in which we explore the 'meaning' of form, keep in mind that the visual elements in any pictorial composition, in one degree or another, have resonances which transcend pure visual sensations.

We have, I hope, laid the basis in the previous sections of these units on art for a detailed, though somewhat clinical, examination of the kind of artists' skills to which we've referred. I'd like us now in this final section to investigate some of the more universal and timeless aspects of pictorial form, and then look at the way artists from several epochs and different places have dealt with them. The object here is to make you aware not only of the many characteristics of formal manipulation possible in the visual arts, but also of the inventive means artists have devised to impart through form, a richer and more powerful meaning to the subject. You will frequently be asked to discover for yourself these means, and sometimes I will guide you a little with a few clues. But one thing must be said before we proceed. It is often argued that to explain or to analyse a picture is to diminish its power to communicate predominantly through the eyes. Yet many, perhaps most, works of art will never fully be appreciated unless one is aware of the contexts in which they were produced; aware also of the pictorial traditions from which they spring. Not least, one ought to be made conscious of the quality of visual perspicacity which must be brought to bear on the work of art if a greater *pleasure in understanding* is to be achieved. My own view is that the phrase, 'a picture speaks for itself' is a piece of modern sophistry, a cliché understandable in the context of twentieth-century art, but not to be taken at face value. For to close the mind in order to open the eyes would seriously inhibit a complete and more fulfilling experience. Obviously a balance is needed, and this would vary according to the predilections of each spectator. Certainly,

the pleasure of taking in a work of art has been killed often enough in the past by too glib an interpretation of what the artist intended, and too ferocious an inspection of his means. It *is* possible to talk a picture to death! Yet really discerning writers and critics, past and present, have been able to say just enough or just the right things, to open those little doors of perception to enable the spectators to make their own visual discoveries. Art history and theory is another matter, as you will no doubt have deduced from Stephen Bayley's comments in Part 2 of Unit 16; though it too, despite its investigative role, might profit from a similar kind of sensitivity. To have dissected Michelangelo, Delacroix and Degas with that kind of sensitivity does not in my opinion necessarily diminish any feeling for their work. Indeed, it ought to heighten it. And who can say that a deeper understanding of Michelangelo will not render an appreciation of Picasso more sensitive? Or the other way around?

2 LINE

Note carefully

For all the exercises given in this final section of the units on art, I would like you to put your observations in writing in your own notebook. None of the exercises here need take more than two- or three-hundred words. And don't forget that the prime purpose here is *not* to try and have you match the observations I make in the discussions, but to get you to look harder and more thoughtfully at visual representations – to exercise your eye and mind.

EXERCISE

Compare the three drawings illustrated here (Figures 25, 26, 27) by Ingres, Paul Klee and by the seventeenth-century Chinese master who contributed to the famous pattern book: *The Mustard Seed Garden Manual of Painting* (first edition 1679, complete edition 1701). Say what you think distinguishes one from the other in its use of line, and what 'Idea' (to use Schopenhauer's term) each conveys.

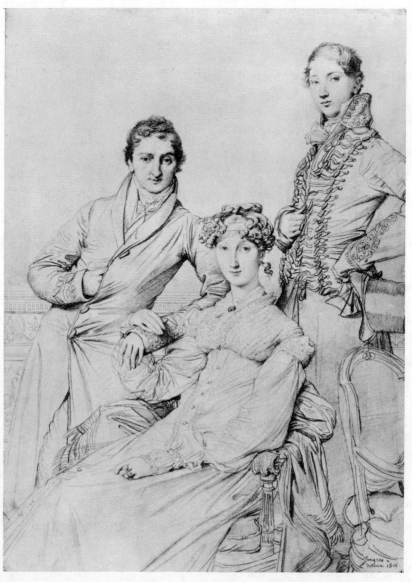

Figure 25 J. A. D. Ingres Mr and Mrs Woodhead and their friend Henry Comber, *drawing, 1816 (Fitzwilliam Museum, Cambridge).*

Figure 26 Paul Klee
Magicians in dispute, *pen and ink drawing,*
15½ × 23½ ins, 1928 (The Museum of Modern Art, New York).

Figure 27 Plate from The Mustard Seed Garden Manual of Painting, Brushstrokes like raveled-rope. *(Photo from Mai-mai Sze (1967) The Tao of Painting, Princeton University Press, Vol. 12, p. 189 (Bollingen Series XLIX). Reproduced by courtesy of the publisher.)*

DISCUSSION

I would say that the main stylistic factors which distinguish the linear treatments in the drawings are as follows: in the Ingres, the lines are austere, completely enclosing the shapes in unresilient contours and with little variation in texture or breadth. The effect is one of clarity, cold and brisk, finely-tuned like a high and piercing note from a violin. To achieve such linear refinement the artist must consciously have turned to a hard and highly sharpened pencil, though the medium might also have lent itself to a different treatment. In the pen and ink Klee drawing the line in a sense 'speaks for itself' for though it has the finesse of the Ingres, it is used not only to circumscribe the form but to evoke lightness and vivacity in the impish way in which it builds up the very structure of its subject. The line of the Chinese artist (drawing/brush painting) is of itself evocative in the manner in which it expands and contracts, in its broken contours, and in its 'speed' we might say. That is, it conveys to us a variation in the 'pace' of the brush, now moving, now hesitating when changing course, now stopping with the brush lifted from the paper – unlike the Klee which in this particular drawing suggests a greater and unhesitating continuity.

Klee was extremely conscious of line and its expressive potential. This he elaborated upon in his *Pedagogical Sketchbook* (1925), a short but carefully considered work illustrated with demonstration drawings to show the great range of communicative possibilities inherent in the treatment of line. Klee spoke of line as if *it* lived and breathed. A line, he felt, could be heavy or light. Its movements could be fast or slow. It could thrust forward, hesitate, change direction. It walked; it ran. It expanded; it contracted. It flowed. It unfolded. As a vital element of form it could be humble and tentative, or fierce and assertive.

Indeed, Klee looked at all elements of form in this way – as having the potential of an infinity of physical attributes and expressive moods. This attitude marked his teaching at the school of design in Germany called the Bauhaus (Gombrich discusses Klee's conception of art and nature in the chapter, 'Experimental Art' in *The Story of Art* which you should read if you haven't already done so).

Ingres' drawing techniques (for though generically similar there was more than one) were all consistent with his neo-classical style of painting (see the entry for Ingres in Murray, *Dictionary of Art*). *His* concern with line was one of control and authority in the command of technique. He aimed to produce a sense of solidity by the subtle deployment of contour. In its clarity of outline and shape, his linear method was for him the equivalent of sculptural form. Ingres' line was above all a vehicle for the realization of ideal form. It was neither expressive as in Klee, nor did it harbour associative meanings as in the Chinese line drawing. For if the *Mustard Seed Garden Manual* underlines the nature of Chinese painting and drawing, it is quite the antithesis of Ingres. Though it too is very respectful of tradition, the larger idea behind Chinese art embraces a concept of form in which metaphor is predominant. Thus in our illustration here, the brushstrokes are said in the *Manual* to be 'like raveled rope'. The characters in the drawing are translated:

> This is an example of the brushstrokes for modelling called 'raveled-rope strokes.' Only Wang Shu-ming used this type of brushstroke, and the result was beyond description. He also combined it with *p'i ma ts'un* (brushstrokes like spread-out hemp fibres) and *fan t'ou ts'un* (brushstrokes shaped like alum lumps). Many painters have tried to copy this style but they did not really grasp the method and produced brushstrokes which were stiff and angular. These make up one group of brushstrokes for modelling (*ts'un*). (Mai-mai Sze *The Tao of Painting*, Vol. II a translation of the *Chieh Tzu Yüan Hua Chuan* (*Mustard Seed Garden Manual of Painting*), Books of Rocks, Plate 61.)

We find, in the various 'books' of the *Mustard Seed Garden Manual* (Book of Trees, Rocks, Book of the Orchid, Bamboo, Plum, Chrysanthemum, Grasses, Insects, etc.) continual references to the styles of earlier artists. Thus are described Fan K'uan's method for painting trees without foliage, or Wang Wei's double contour manner of outlining even the smallest branches, or Wu Chên's use of

variety in painting tree tops with fat branches juxtaposed with thin, and the directions of lines reversed to augment the dynamism of the representation. Wang Shu-ming's brushstrokes are here likened to the line inscribed in the sand by a crane's beak: 'His brushstrokes were pointed but in no sense weak, powerful but not stiff at all, rounded but not like balls of fur, square without corners' (Inscription on Plate 60). And so the Ancients are assembled in force to present to the budding artist all the aesthetic wisdom of the past. We are reminded of Delacroix's thoughts (page 154 above) about the source of artistic knowledge. Among the fundamentals of painting set out in the *Mustard Seed Garden Manual*, no doubt to take the edge off its 'painting by the rules' aspect, are these wise words: 'If you aim to dispense with method, learn method. If you aim at facility, work hard. If you aim for simplicity, master complexity.'

In 1900, the popular English illustrator, Walter Crane, published his book, *Line & Form*. Influenced as many illustrators were at the time by Japanese art, a heightened sensitivity for line is most apparent in artistic production of the period. Some of Crane's observations are, I think, useful to us in the context of our discussion. After describing various methods of linear drawing Crane speaks of the 'Quality of Line' in a way reminiscent of the *Mustard Seed Garden Manual*:

> If we are drawing a plant or flower, for instance, we should endeavour to show by the quality of line the difference between the fine springing curves in the structure of the lily, the solid seed-centre and stiff radiation of the petals of the daisy, and the delicate silky folds of the poppy. (*Line & Form*, page 12.)

Speaking also of the 'Linear Expression of Emotion' Crane sees in line an abstract medium for conveying 'the idea of praise or aspiration and ascension', not simply in the *quality* of the line, but in its *direction*. He illustrates as contrasting examples, the upper register of William Blake's *Morning Stars* from the *Book of Job*

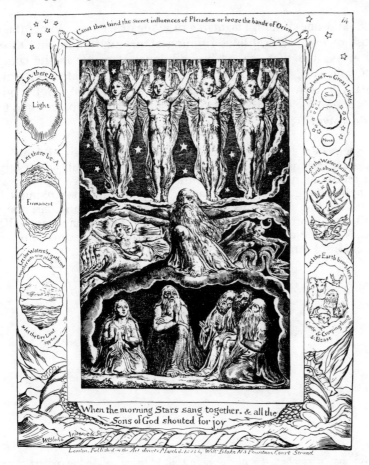

Figure 28 William Blake When the Morning Stars Sang Together, *engraving, from the* Book of Job, *1825 (Crown copyright. Reproduced by courtesy of the Trustees of the British Museum.)*

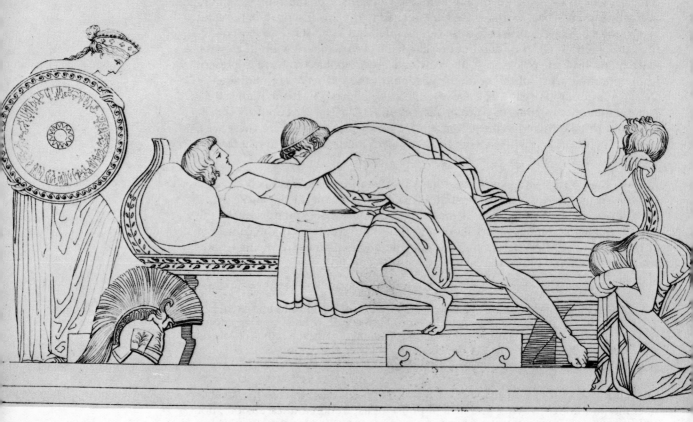

Figure 29 John Flaxman Achilles mourning Patroclus. *Plate from the Homer Series, 1795 (Crown copyright. Reproduced by courtesy of the British Library Board).*

(Figure 28) and one of John Flaxman's drawings based on Homer (Figure 29).[1] Blake's use of long vertical lines running along each figure and through the upraised arms, and that echoed by additional elements in the composition, form, as Crane says, 'a kind of vertical crescendo . . . elevated in feeling' which helps greatly to convey 'exaltation and rejoicing in unison'. On the other hand Flaxman's lines of dejection and despair are manifested in 'bowed and bent lines tending downwards':

> We seem here to discover a kind of scale of linear expression – the two extremes at either end: the horizontal and the vertical, with every degree and modulation between them; the undulating curve giving way to the springing energetic spiral, the meandering flowing line sinking to the horizontal: or the sharp opposition and thrust of rectangular, the nervous resistance of broken curves, the flame-like, triumphant, ascending verticals. Truly the designer may find a great range of expression within the dominion of pure line. (*Line & Form* pp. 20–1.)

[1]Flaxman, you may remember, was discussed in Unit 17 (page 103) in the context of neo-classical sculpture.

3 FORM (SHAPE)

Line of course impinges on 'form' which in its more specific meaning is synonymous with shape or mass. The linear structure, for example, of Michelangelo's *Jeremiah* (as we've seen in Part 1 of Unit 16 here, page 36 is inextricably bound up with the figure's massiveness – its form or shape. So what can we make of some of the characteristics of form?

EXERCISE

I'd like you to compare two paintings illustrated here (Figures 30, 31), one by Giotto, the other by Picasso, and two architectural structures (Figures 32, 33): the *Ca' d'Oro* in Venice (1422–40) and the near contemporary Palazzo Medici-Riccardi in Florence (begun 1444). Please describe the kinds of form used in each set, try to say what they convey to you, and whether in any respect the paintings can be compared with the buildings.

Figure 30 Giotto St Francis renouncing his heritage, *Bardi Chapel, Sta Croce, Florence, 1320s (Alinari).*

Figure 31 Picasso Portrait of D. H. Kahnweiler, *oil, 39 5/8 × 28 5/8 ins, 1910 (Courtesy of the Art Institute of Chicago).*

Figure 32 Ca' d'Oro Palace, Venice (1422–40), full front view from the Grand Canal (Mansell Collection).

Figure 33 Michelozzo Palazzo Medici-Riccardi, Florence (after 1444) (Alinari).

DISCUSSION

We'll take the paintings first. To me the Giotto presents the notion of solidity; the Picasso fragmentation – or characteristics to that effect. In the painting by Giotto even the garments have a massiveness of structure which, but for their colours (not shown here), might be likened to stone. In the Picasso, I think you'll agree, the forms seem to be an interspersed assemblage of cut and tinted sections of cardboard. But not quite, as they have about them a slight translucency. No light can penetrate the opacity of Giotto's form. Indeed, can you see that even the more lifelike gestures of the bothersome children at both extremities of the composition, transmit a sense of stiffness and immobility which is quite consistent with the whole conception of the painting? Have you seen that the stone wall too, not only serves as a kind of backdrop to the two groups of figures, but that in its static appearance it seems to reinforce the solemnity of the occasion? Even the expressions on the faces here embody in their suppression of emotion and in their tightly packed forms, a highly charged power. How well Giotto has conveyed, with the relatively limited techniques at his command, the schism between the young St Francis and his father and the latter's pursuit of material wealth, for that is the subject of the painting. Can you see how the compositional device of an empty space between the two ideologically opposed groups, fused into two massive blocks, points up their irreconcilable natures? Unlike the Giotto, the formal handling of Picasso's painting is not in this instance an attempt to convey something about his subject, the art dealer Daniel Kahnweiler, Picasso's friend and early supporter. The translucent and interpenetrating forms, fluctuating in a limited depth of space, is a way of exploring volume consistent with the propensities of artists at the time to discover new and modern means of representing their subjects. To my mind, such explorations convey a sensitivity about space and time and the structure of matter, echoing the theoretical concerns of mathematicians and physicists at the turn of the century. If you want a further discussion of Cubism, I suggest that you read the appropriate section in Gombrich, *The Story of Art*, in the chapter 'Experimental Art'.

Now, turning to the two palaces here, something similar occurs; the formal conceptions of these structures communicate on an even more abstract level. They have no subject, but they 'speak' to us nevertheless. What have you noticed in the appearance of the Medici-Riccardi Palace which contributes to its heavy solemnity? Have you seen how the massive cornice jutting out almost oppressively over the building, adds to that heaviness? Or how the rough surface of the stonework at the lower level visually helps to plant the building firmly on the ground? Like the fortress it really was in the uncertain political atmosphere of fifteenth-century Florence, it served as a psychological as well as a physical deterrent to the enemies of the wealthy and powerful Medici family. Perhaps *that* is the 'subject' (if we can call it a subject) of the building? But life in Venice at the time must have been more serene, if the *Ca' d'Oro*, 'The House of Gold' is any indication. Have you compared the cornices of the two buildings? How different their shapes are, and what contrary sensations they evoke! All that tracery in the façade of the building, the finely wrought architectural embellishments surmounting the unobtrusive cornice, the penetrability of the windows, doorways and balconies (so unlike the uninviting fenestration of the Michelozzo palace), impart to the building a physical sense of lightness and a welcoming character. Indeed, the building opens up at ground floor level onto the Grand Canal, still serving as a gondola landing. You may not know this but consistent with the whole 'feeling' of the building, parts of the exterior were once painted and gilded, as was the interior. You may well have called attention to the contrasting shapes of the window frames and other openings in these palaces which in each case reinforces the essential 'expression' of the structure.

If you now take time out and find the works listed below in *The Story of Art* you will see how in some of them a strong 'architectonic' sense of form manifests itself not only in architecture or sculpture, but in painting as well (Piero della Francesca, neo-classical art, Mondrian, as examples). In others, such firm structure, sturdy and clear, is neglected, played-down, or deliberately avoided (e.g.

in Chinese landscape painting, Persian manuscript illumination, Turner's sea-scapes, Impressionist paintings in general and those of Jackson Pollock).

A cogent point which can be made here is that there is no such thing as a meaningless element of form in itself. All convey *something*. But as Bell and Fry would insist, some forms, and certain arrangements of form, can be made to 'say' more, and more powerfully, either by themselves or in the context of an intelligible subject.

I ought to mention just one other aspect of form (i.e. shape). It is called 'negative' shape, 'negative space', but is hardly negative in its effect. The term has emerged in the artistic vocabulary of the present century, though its pictorial effectiveness had been understood much earlier. It refers to those spaces which remain as 'gaps' when other objects in a composition have been rendered as in the engraving 'Missing Rulers of Europe' (turn back to Figure 24). It applies not only to painting but to sculpture and architecture as well, and to other visual arts not excluding typography. Analogies also exist in musical and literary form.

How we respond to 'negative' shapes has been an object of psychological research since 1921. The term 'figure-ground' is the one used in such studies.[1] These studies are consequently concerned with the ways in which the shapes in question might be reinforced by contour, colour, and other elements of form to increase or diminish their appeal to the eye. No doubt sensitive artists have always had at least some threshold awareness of the shapes created residually as one would when cutting out figures from a sheet of paper. Cézanne and Roger Fry were no doubt concerned quite consciously with it. And artists later in this century, Ben Nicholson, Joan Miro and Hans Arp as examples, the last quite likely with some knowledge of the studies of psychologists, produced works which for their effect depend greatly on the shapes described by other shapes (Figure 34). This 'dual function' of shape and contour has been extraordinarily well realized in the somewhat playful graphic work of M. C. Escher and it makes the point very nicely for us (Figure 35). Figure-ground relationships must obviously concern the more sensitive and discerning architects in a considerable degree.

Figure 34 Hans Arp Configuration, *painted relief on wood 58 $^1/_5$ × 46 $^1/_5$ ins, 1927–8, (The Emanuel Hoffmann-Fondation, Kunstmuseum, Basle).*

[1]The 'figure' of the urn and its rock pedestal in the 'Missing Rulers' engraving stands out against the 'ground' which happens in this case to form the contours of the heads of four European Rulers – the 'negative shapes'.

Figure 35 M. C. Escher
Circle Limit IV: Heaven
and Hell, *woodcut, 1960*
(Escher Foundation, Haags
Gemeentemuseum, The
Hague).

4 TONE

Our next consideration will be tone. The term, in general, usually refers to the intermediate range of greys between the extremities of black and white, or in colours, to their 'values' between the fully saturated and the insipid, or to the scale of variations between colours mixed with black and those mixed with white. But tone is also bound up with light, and a tonally bright representation or a 'lowering' one are references to the general cast of light (or its absence) in, most often, paintings, drawings, prints and photographs. Consequently, tonal conditions characterized in the Renaissance, for example, by the terms 'chiaroscuro' or 'sfumato' (these terms are discussed in Murray, *Dictionary of Art*) have essentially to do with the overall light and dark structure of the representation. Let us now try to distinguish between two tonal styles, though the range and combinations of types are far greater than what we can provide here.

EXERCISE

Try to describe the kind of tone used in the Colour Supplement, Unit 18 Plates 1 and 2 and try to say what they convey visually about the subject.

DISCUSSION

1 I should suggest something like the following: de la Tour's stark transitions in tonality help to dramatize the subject. The concentration on the lighted elements of the composition, tend to reduce all other parts to a background foil. Moreover, the starkness of the lighted shapes against the unarticulated dark areas flatten those areas in such a way as to lend greater force to their shapes. Note the delicacy and clarity of the 'negative' shape between the head and arm of the Magdalene and the candle, and even more, that beneath the table as described by the line of the legs. This treatment of light and dark (called 'Caravaggesque' after the style of Michelangelo Caravaggio, see the entry in Murray *Dictionary of Art*) not only tends to heighten the mystery of the subject, but exudes a tranquillity quite appropriate, given its pensive aspect.

2 Ingres's portrait, consistent with his drawings, produces a sense of delicacy, even fragility, in the porcelain smooth handling of the flesh. This is manifested in the imperceptible transitions of tone (which I trust will be conveyed in the quality of the reproduction – always an uncertain thing!) through a subtle range of greyed hues and an avoidance of dark areas in the head and in those parts of the body which show. The dark background, incidentally, is quite possibly a device, as is the oval frame of the painting, for producing a cameo-like effect, an obeisance to antiquity. The glazing of the colours helps also to augment the kind of sculptural lucidity which so much attracted neo-classicists. Madame Rivière, a wealthy and educated lady of Napoleonic France is well-portrayed, for the refinements of technique employed, and the worldly goods so exquisitely displayed, are most appropriate for the subject.

5 COLOUR

Colour is next in our categories of form, and as indicated earlier (page 156), it is believed to appeal more directly to the emotions than other aspects of form. There must, I think, be some significance in the fact that those among the blind who have had their eyesight restored, encounter much less difficulty in learning to distinguish between the different colours than they do form. This would seem to be confirmed by Arnheim, for example, who suggests that 'in colour vision, action issues from the object and affects the person; in order to perceive shape, the organizing mind goes out to the object' (*Art and Visual Perception* page 274).[1] Obviously, in creative artistic activity, no such passivity in respect of colour can obtain.

In the annals of experimental psychology one comes across extraordinary examples of the impact colour can make on the mind's eye, ear, nose and throat to put it crudely. Designers of aircraft interiors work hard in devising colour schemes which will promote a sense of tranquillity and well-being. They are careful to avoid colours which are known to produce nausea, vomiting and other commercially undesirable responses in their passengers. Heavy black boxes in a factory were painted green to produce a psychological effect of lightness and it was discovered that as a result workers became less conscious of the weight. An experiment with colour in a large office block demonstrated that a considerable saving in heating fuel could be made by painting the offices in appropriate hues. When comfortable offices coloured yellow were repainted pale blue, and as before heated to 72°, their occupants complained of the cold and the temperature had to be raised to compensate for the psychological effects of the new colour. Perhaps there is more to 'warm' and 'cold' colours than meets the eye!

EXERCISE

This exercise is designed not so much to test your colour responses as to get you to see how three different painters made use of colour to lend force and meaning to their work. (Colour Supplement, Unit 18, Plates 3, 4 and 5.) The plates here are undertaken with some trepidation as the accomplishments of high technology do not always extend to colour reproduction processes. So please bear with me. Study each of these paintings in turn, beginning with the Poussin, also paying attention to the titles given in the captions. Say how you think the artist contrived to enhance the subject through the use of colour, and how the colour relates to other forms.

DISCUSSION

Obviously, I could not expect in such a brief discussion to describe all the nuances of colour related to other compositional elements I may detect, nor even then hope to match all of your own observations. So, though we may not coincide on specific points, the manner of observation as a means for guidance ought itself to be instructive.

The Poussin painting seems to me to exude serenity. That, quite likely, is the atmosphere in which this artist wanted to couch his antique subject, that of a virtuous Athenian governor denied a funeral by ungrateful and vindictive compatriots. The velvety monochromatic cast of the colouring (though due partly to old coatings of varnish and the pervasive yellow-green film it produces) is an effective means for obtaining the desired tranquillity. For even a verdant landscape may be painted with clamorous colours if necessary. Contributing to the

[1] I interpret this as meaning that colour imposes itself on one emotionally without any need to 'understand' it, while to comprehend shape one must set the mind to learning what it means.

soporific stillness of the pastoral scene is also the deliberately static conception of trees, architectural forms and the carefully organized 'layers' of horizontality. More can be said of the internal framing of the scene and the placement and dispositions of the tiny figures as additional means for creating the desired mood. Moreover, the limited use of any 'aerial perspective' (see Murray *Dictionary of Art,* under 'Perspective') by which a transition in depth may be shown by tonal changes in the colour, adds to the quiescent, if not dream-like cast of the picture. Poussin confines such changes in colour tone to the very far distance unlike that to be found, for example, in the landscape backgrounds of Leonardo's paintings or in the paintings of Delacroix, Turner or Caspar David Friedrich examples of which you will quite likely find in your edition of Gombrich's, *The Story of Art.*

Looking at the Delaunay painting you may have noticed that, as suggested by the title, myriad discs of colour move apart, coalesce, interpenetrate, in a dynamic chromatic display which rather than describing some external form, seems to be self-contained and radiant with its own light. We can no doubt read a single representative object here: the sun, and perhaps its colourful corona at the left. If you've guessed that Delaunay's subject here is colour itself, and conceivably radiated light, you've done very well. For the artist explicitly was attempting 'pure colour painting' in which colour itself, divorced as much as possible from clearly delineated shapes, becomes both form and subject of the painting. Hence the broken contours and interspersing of the discs and the ragged edges of the patches of colour. And to intensify the power and brilliance of the colours, you may have noticed that the artist not infrequently juxtaposes complementaries (see the entry in Murray, *Dictionary of Art*) such as yellow and purple, orange and blue, red and green, in addition to employing colours adjacent to one another in the colour scale. So, if you also suspect that there is a bit of science here too in the calculated use of optical effects, you'd be quite correct.

Let's turn then to Fernand Léger's *Luncheon* or *Three Women.* Unlike the Delaunay painting it would be difficult here to assess the content of the colours independent of the forms they describe. If you've seen both the shapes and the flat planes of colour as rather mechanical or machine-like, as though the figures especially, not to mention the cat, were constructed of tinted, slightly curved, sheet metal, you'd be getting close to one of Léger's essential motivating ideas. For in witty, rather instructive, paintings of this kind Léger is commenting on modern industrial and technological civilization. Do you see that the overall mood. Moreover, the limited use of any 'aerial perspective' (see Murray *Dictionary of Art,* under 'Perspective') by which a transition in depth may be shown by the decorative structure and the colours seem to communicate a pleasant sense of reassurance, muted and modest through a subtle use of greys and the slightly metallic cast with which some of the other colours are conceived. To humanize the subject, the artist seems deliberately to make references to culture and the artistic past: to nudes, odalisques and *déjeuners*; and to culture, in the iconographic symbol of the book.

6 SPACE

We now come to an aspect of form which for centuries has been the subject of many learned theses, particularly as it pertains to 'linear' or 'rational' perspective, that great discovery of Renaissance artists and mathematicians. But linear perspective is merely one aspect of such arrangements of visual form which are intended to create a sense of spatial depth. For the relative distances of objects from one another may be conveyed by their scale, by the overlapping of forms, by 'aerial' perspective in the use of colour tones, and even by pure patches of colour alone. This last factor, one much discussed and employed by artists in the past hundred years, is governed by a psychological reading of colours in which, generally speaking and with no regard to form, warm and bright colours tend to advance, while cold and subdued colours tend to recede.

Contradictory or ambiguous conditions in spatial arrangements have sometimes deliberately been contrived to serve some artistic purpose,[1] that for example of bringing the objects in the representation up to the picture plane itself; defying the illusion of deep space – a purist reaction against traditional concerns with Renaissance perspective and the ideals of an illusionist art. In an instructive satire on perspective, William Hogarth in 1754 produced the engraving which we illustrate here (Figure 36). Can you identify the distortions of rational space

Figure 36 William Hogarth False perspective, *engraving, 1754. (Photo from John J. Kirby (1754)* Dr Brooke Taylor's method of perspective made easy . . . *frontispiece. Crown copyright. Reproduced by courtesy of the British Library Board.)*

[1] Not unlike Alfred Hitchcock's contradictory techniques used in film (see reference to this in Unit 16, page 41).

created by the illogical tangencies, superimpositions and scale of many of the objects in view? But recalling my previous statement that there is no such thing as a meaningless form in itself, the very aberrations we notice in the Hogarth print become for such artists as Gauguin and Cézanne (and many others) positive instruments in the fulfilment of their aesthetic ideals.

EXERCISE

Let us now turn to three illustrations here (Figures 37, 38, 39) each of which in some special way is concerned with a kind of spatial arrangement designed to enhance either the subject or some other aspect of the representation. Will you make note of the manner in which the *last two* artists render space and, if possible, say why it might have been done that way before going on to the discussion of their works. I will comment on the first, to give you some idea of how the spatial organization of a visual representation might be examined.

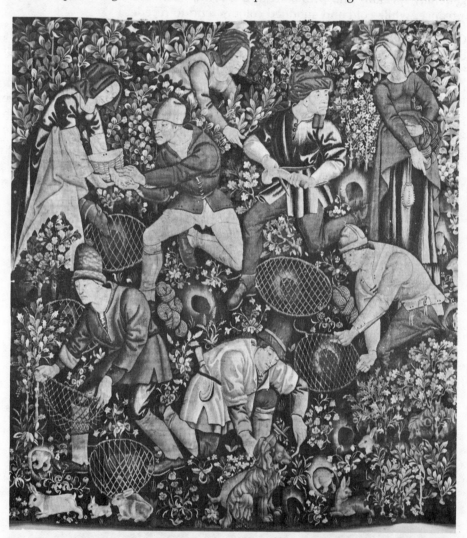

Figure 37 Franco-Burgundian tapestry Peasants hunting rabbits with ferrets, 120 × 115 ins c. 1460–70 *(The Burrell Collection, Glasgow Art Gallery).*

The first and overriding impression we may get of space in the tapestry representation (Figure 37) is of the ground being tilted up (not unlike that in the Chinese commune painting shown earlier, Colour Supplement, Unit 16 Plate 9) so that the scene tends to exist on the flatness of the picture surface and not in deep space. As a consequence of this, the figures in depth are those higher up in the composition with their spatial differences marked somewhat by the overlapping of their forms though not by any changes in their scale. Have you noticed also that the flatness of the composition is reinforced by the strictly vertical elevations of the plant forms and by the tendency to show the rims of the rabbit

nets not in a receding ellipse but, as one finds centuries later in a Cézanne compote (see Unit 16 Figure 14), as though in ground plan?[1] There is yet another, and more subtle, way in which the artist strengthened the flatness of the design. It is something you have seen in the Hogarth satire on perspective, and I wonder if you can spot it here? I am referring to the carefully contrived tangencies of form which serve to deny or contradict spatial recession. We find it in the contiguous lower limbs of the two peasants at the bottom of the picture, in the legs of the two male figures above them and, though less evident, in a few other areas of the composition as well.

What, we may ask, was the reason behind such compositional techniques, and what are their effects? Tradition, of course, plays a major part here, though you will know from reading Gombrich that at that date, even in France, one might have expected the artist to be aware of Renaissance perspective. Perhaps the reason has more to do with the medium, an unframed tapestry, hung vertically, and designed more for pleasure and decoration than as an artistic statement about illusionism. Now see what you can detect in the spatial composition of the next two works reproduced here (Figures 38 and 39), before going on to the discussion.

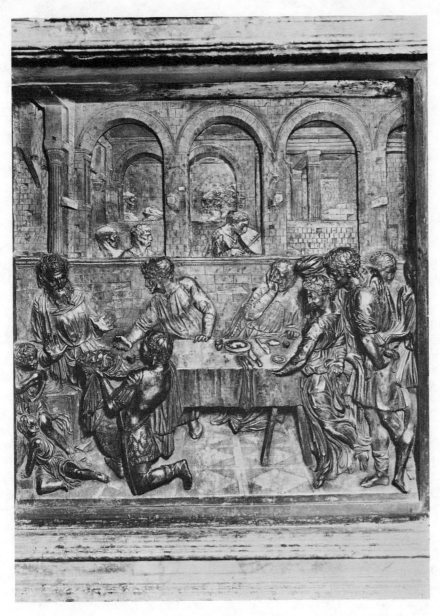

Figure 38 Donatello The Feast of Herod, *bronze relief, 1425–7, S. Giovanni, Siena (Alinari).*

[1]See also the table in the central panel of the *Mérode Altarpiece* (Colour Supplement, Unit 16 Plate 8).

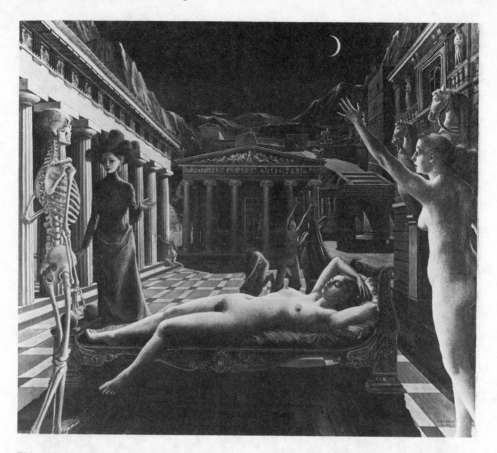

Figure 39 Paul Delvaux Venus Asleep, *oil on canvas, 68 × 78 ⅜ ins, 1944 (Photo by Tate Gallery, copyright SPADEM Paris, 1978).*

DISCUSSION

Turning to the Donatello relief (which you may have noticed was executed more than thirty years *before* the tapestry above) we find quite the opposite from the flattened space of the Franco-Burgundian work. The floor plane, only slightly tilted to conform with the spectator's view point, recedes and gives the impression of converging both through the use of the patterned pavement and the grouping of the figures in the foreground register. The perspectival use of architectural elements and a change in the scale of figures in the three spatial registers, reinforce the illusion of depth. But note the extraordinary delicacy with which this is done, given the limited dimensions of a flat slab of wax or clay from which the bronze relief was cast.

Donatello was demonstrating his prowess as a sculptor at a time when the rules of 'rational' perspective were still being formulated. But in at least one respect he reverts to older conventions. Study the drama of the beheading of the Baptist and try to say what this older convention is. Have you seen that there is a time factor employed here? The head of St John is, in the front register, presented to Herod who reels back in dismay. It again appears in the distance. This use of sequential events in a single composition, each 'frame' often isolated by some architectural element is called 'continuous representation'. It was employed earlier, among others, by Giotto as a useful means in pictorial narrative (see Colour Supplement, Unit 16 Plate 1). But while Donatello looks back to a more mediaeval form in one respect, he also anticipates a compositional technique not thoroughly realized until the nineteenth century and the work of Edgar Degas (see Figure 41). You may have noticed, in the Donatello relief, the foreground figure cut off by the frame at the right, and also that wielding the head of the Baptist in the background, left. Would you agree that this compositional method is an effective means for implying both movement and space beyond the lateral

confines of the scene depicted? It is, in our own terms, a psychological device and modern in its synthesis of time, space, and movement. In my estimation it is an astounding example of artistic prescience.

There are, of course, several other ways in which space may be used in pictorial art to enhance subject or content, or for that matter in sculpture and architecture too. You will find examples of such usage illustrated in Gombrich *The Story of Art*, notably the low-level viewpoint favoured by Mantegna to dramatize his subjects, the attenuated perspective used by Tintoretto in the *Finding of St Mark's Remains* which, with its peculiar play of shadow and light, heightens the mystery of the scene. And you will see an exaggerated use of deep space employed as a necessary stylistic but also spiritual vehicle in Baroque ceiling decoration.

Not unlike Tintoretto, so-called 'metaphysical' painters working in the manner of Giorgio de Chirico, and Surrealists such as Salvador Dali or Paul Delvaux (Figure 39) are able to augment the sinister or dream-like content of their paintings by employing long perspective vistas accompanied by a rapid diminution of scale. You may well say, 'but Degas does this and there is nothing sinister or dream-like about his compositions'. I'd agree. For no aspect of form by itself will convey only one meaning. *It is the context that counts, both the formal one and that of the subject too.* In the Delvaux painting shown here, the strangeness of the subject coupled with the harsh and artificial quality of light in the nocturnal setting, gives the attenuated perspective an expediency remote from that achieved by Degas using similar perspectival means.

7 MOVEMENT

We now turn to the final category of form we will discuss here. There are others, certainly, such as symmetry and proportion with its intriguing concept of the 'Golden Section' (see Murray, *Dictionary of Art*). There is the question of texture, which is to say paint quality, and also surface modelling in sculpture and architecture. More obliquely, expression (including pose or gesture) and symbolism are two relevant categories, though these reach out to embrace other aspects of perception which quite transcend form. But we are inhibited unfortunately by the dimensions allowed for these units, and cannot include them in our discussion.

Movement is at least implicit in many if not most of the works we have so far discussed. It is an essential element in palaeolithic art. We find it in Giotto's *Feast of Herod* with its intriguing fiddler (what might the strange diagonal bands cutting across his garment mean?) and continuous representation (Colour Supplement, Unit 16 Plate 1). Quite possibly it was an accidental but then meaningful feature in the multiplicity of limbs seen in Leonardo's *Neptune* drawing (Figure 21).

In conveying sensations of movement, such evocations of form need not always reside in the human figure. Movement may be conveyed in architectural structures, for example, in rhythmic repetitions or contrasts of shapes, in the patterns of dark and light they produce, and in the interpenetrations of form which are suggestive of continuity. Even in the profile of a piece of pottery, or a typographical form, a lesser or greater sense of movement may be transmitted through the peculiar articulation of the lines and curves.

EXERCISE

Compare the three illustrations given here (Figures 40, 41, 42) and comment on the different ways in which movement is conveyed. Try to say what each technique represents in terms of the subject and of our perception of moving objects in nature.

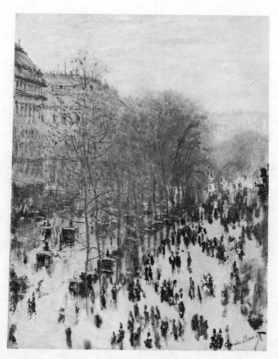

Figure 40 Claude Monet Boulevard des Capucines, *oil on canvas, 31¼ × 23¼ ins, 1873–4. (William Rockhill Nelson Gallery of Art Atkins Museum of Fine Arts, Kansas City, Missouri. Acquired through the Kenneth A. and Helen F. Spencer Foundation Acquisitions Fund.)*

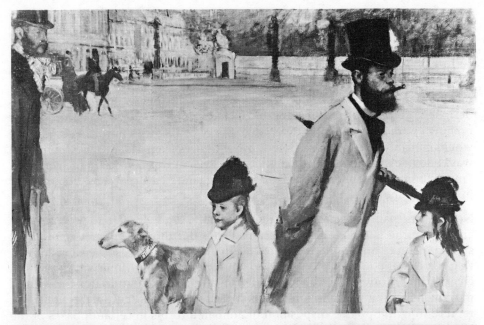

Figure 41 Edgar Degas Place de la Concorde, *oil on canvas, 31¾ × 47 ins, c. 1875 (Durand-Ruel et Cie, Paris).*

Figure 42 Umberto Boccioni States of Mind I: the farewells, *oil on canvas, 27¾ × 37⅞ ins, 1911. (Collection of Nelson A. Rockefeller. Photo by Charles Uht.)*

DISCUSSION

You may have noticed that I have deliberately chosen urban subjects for each example. I did this because each artist represented wanted to capture the frenetic character of city life in the modern era, though each attempted to do it in a different way.

If you look closely at Monet's view of the Boulevard des Capucines you may understand why, unlike Degas' of the Place de la Concorde, Monet had to place himself well away from the subjects. Can you see why? Isn't it because *his* way of communicating a sense of movement was by blurring the figures and other objects in view in a way hardly possible close-up considering even the radicalism of his methods at the time? In this way Monet is able to convey to us a sense of flux and vibrancy very suitable for such a subject. By his use of an open

brushstroke and the consequent ambiguity thus imparted to all forms, a further advantage is gained in the creation of an almost tangible but ephemeral light and atmosphere – an atmosphere that moves.

What Monet's technique in terms of perception suggests is a use of forms which tend to concur with our physiological sensations of movement. We see rapidly moving things as blurs; our optical equipment, probably for survival reasons, is designed to perceive movement in such peripheral areas of vision where nothing else *but* movement is detectable. But of course with normal eyesight one would certainly not see those slow-moving figures from Monet's viewpoint that way. I do not want to suggest that the artist's vision was faulty. On the contrary, I mean to say that Monet has deliberately exaggerated a visual sensation in order to augment the content of his painting.

Now Degas' painting, and others like it, is quite another matter. As you probably know, he is called an Impressionist too. But though in agreement about subject matter, and united in their antipathy for the artistic establishment, Degas' aesthetic ideology is considerably different from Monet's. Apart from Degas' desire to represent modern life close-up, he communicates the idea of movement not by references to physiological sensations, but intellectually, by representing the precise disposition of animated forms in certain phases of the spectrum of movement. He selects just those which convey, in their frozen instantaneity, the fractional idea of time past, present, and future. As you can see in the background figures of our earlier reproduction of Degas' *Foyer Before the Dance* (Unit 16 Figure 29), and certainly in many of his other works, there is always the suggestion of both time interrupted *and* temporal continuity which sets up an unusual pictorial tension. Degas enhances this manner of depicting movement, as you can see in both reproductions here, by avoiding stereotyped poses and gestures, and by presenting us with an apparently random (thus 'natural') placement of the figures in the composition. This is further enhanced (as we've noted when discussing Donatello's bronze relief) by the way the figures are cut at the frame.

When I look at the Boccioni *Farewells*, to me this view of a railway station evokes sensations of movement both physiologically and by references to clearly delineated though abstract forms and signs. These latter are meant to convey not so much the *sensation* but the *idea* of movement: repeated snaking lines, fragmented and interpenetrating forms, the profile of the engine cab, the engine number, the displaced smoke stack and, though difficult to read, the figures entwined in their farewell embraces. The title of Boccioni's painting may be significant too. For by *States of Mind* the artist seems to suggest that the painting is an attempt *not* simply to represent a scene at the Milan railway terminal, but to present to the spectator a bewildering coalescence of chaotic sensations which encompass speed, noise, even hopes and regrets. Moreover, the Roman numeral 'I' in the title is an indication that the dynamism implied in the painting is also a sequential one. For in fact there are further versions of the *States of Mind* plus a number of studies which seem themselves to be as much elements in the sequence as they are preparations for the painting.

CONCLUSION TO UNITS 16 – 18

Whatever else you have learned from *Introduction to Art*, we hope you've been made aware of one crucial factor which underlies most of what we have written. It is that appearance is not accidental. That is to say that art teaches us to see. In a considerable degree art governs the way we look at things. It has the power either to inhibit our vision – or to liberate it. Art can enlarge our perception of the world. Art can alert us to things both in nature and art itself which might otherwise elude awareness. When you come to think of it, through art, nature is reborn.

FURTHER READING AND REFERENCES

Arnheim, Rudolf (1956) *Art and Visual Perception*, Faber and Faber. A very readable though more clinical discussion of the constituents of form pointed up by studies in the psychology of perception. Not too difficult.

Gombrich, E. H. (1960) *Art and Illusion*, Phaidon. Extremely pertinent to our study here. A highly original work, imaginatively illustrated, but difficult for beginners. Nevertheless, worth attempting.

Gombrich, E. H. (1963) 'Expression and Communication', an essay in *Meditations on a Hobby Horse*, Phaidon Press. On the 'language of the emotions' relating the visual to other sensations.

Gombrich, E. H. (1966) 'Leonardo's Method for Working out Compositions' an essay in *Norm and Form* (Studies in the Art of the Renaissance), Phaidon Press. A bit difficult but relevant for our discussion. Will be included in your Supplementary Texts.

Gregory, R. L. (1966) *Eye and Brain*, Weidenfeld and Nicolson. A very useful and well illustrated guide to physiological and psychological optics. Easy to read. Contains a useful bibliography if you want to delve deeper.

Wind, Edgar (1963) 'The Mechanization of Art', in *Art and Anarchy*, Faber and Faber. Based on the Reith Lectures, 1960. Make sure you read the extended notes which go with this essay. Wind incorporates in his discussion references to several other arts and visual media.

Boller, W. (1950) *Masterpieces of the Japanese Color Woodcut*, Boston Book and Art Shop.

Carr, H. A. (1935) *An Introduction to Space Perception*, Longman.

Cole, F. J. 'The History of Dürer's Rhinoceros in Zoological Literature' in E. Ashworth Underwood (ed) (1953) Vol. 1 *Science, Medicine and History*, Clarendon Press.

Crane, Walter (1900) *Line & Form*, Bell and Sons.

Giles, H. A. (1905) *An Introduction to the History of Chinese Pictorial Art*, Kelly and Walsh, Shanghai, Leyden.

Hebb, D. O. (1949) *The Organisation of Behaviour*, Wiley.

Lee, Sherman E. (1954) *Chinese Landscape Painting*, Cleveland, Ohio, Museum of Modern Art.

Leonardo (ed A. Philip McMahon) (1956) *Treatise on Painting*, No. 76, Princeton University Press.

Mack, Gerstle (1951) *Gustave Courbet*, Rupert Hart-Davis.

Mann, Ida and Pirie, Antoinette (1946) *The Science of Seeing*, Pelican.

Sze, Mai-mai (1957) *The Tao of Painting*, Routledge and Kegan Paul.

von Senden, M. (1932) *Raum- und Gestaltauffassung bei Operierten Blindgeborenen* (Space and Shape Comprehension by those Born Blind with Sight Restored).

Vernon, M. D. (1962) *The Psychology of Perception*, Penguin.

ACKNOWLEDGEMENTS

Grateful thanks is made for use of the following material: page 74, figure (a) Luther as Hercules Germanicus, Department of Prints and Drawings, Zentralbibliothek, Zurich; page 75, figure (b) Roman statue of Herakles, Mansell Collection; page 91 figure (a) Laokoon, *c.* 175–150 BC, Vatican Museum, Mansell Collection; page 91 Figure (b) El Greco *Laokoon*, 54½ × 67¾ ins, National Gallery of Art, Washington DC, Samuel H. Kress Collection; page 110 Ruined Column House from the Desert de Retz, photo from Rose Macaulay (1953) *Pleasure of ruins*, Weidenfeld & Nicholson, figure 5; reproduced by courtesy of George Widenfeld & Nicholson Ltd.

A101 AN ARTS FOUNDATION COURSE

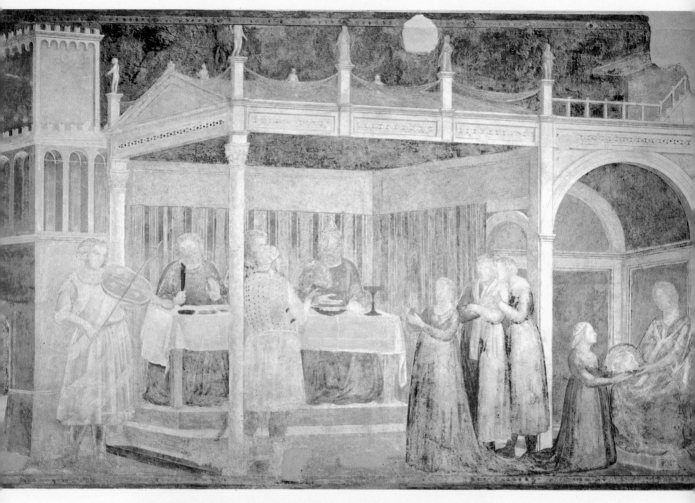

Unit 16 Plate 1 Giotto, *The feast of Herod,* Peruzzi Chapel, Santa Croce, Florence (Photo: Scala).

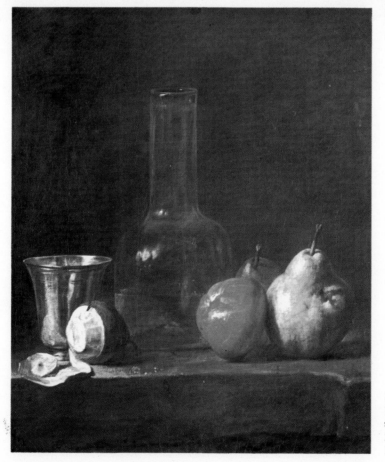

Unit 16 Plate 2 Jean-Baptiste Chardin, *Still life with flask,* oil on canvas, 21¹¹/₁₆ × 17¹¹/₁₆ ins (Staatliche Kunsthalle Karlsruhe).

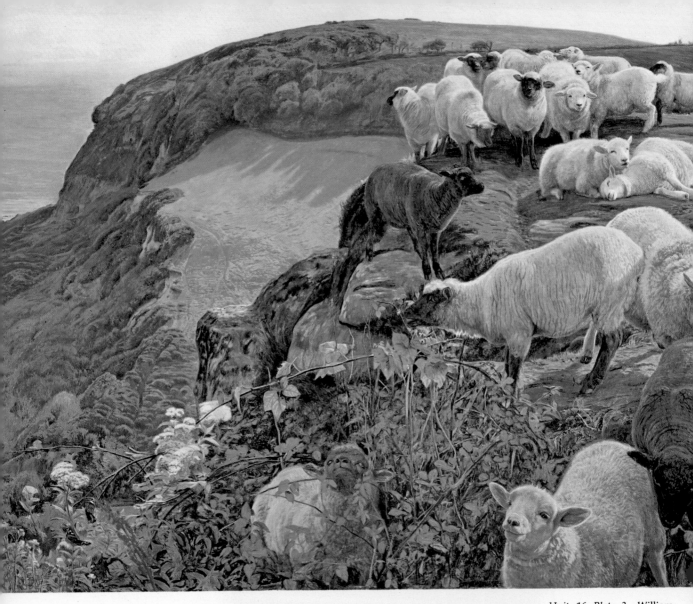

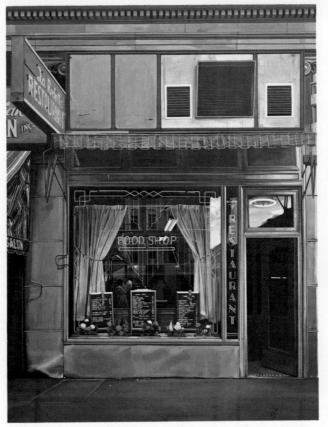

Unit 16 Plate 3 William Hunt, *Strayed sheep*, 1852 (Tate Gallery, London).

Unit 16 Plate 4 Richard Estes, *Food shop*, 1967, oil on canvas, $66^2/_3 \times 49^2/_5$ ins (Wallraf-Richartz Museum, und Museum Ludwig, Köln).

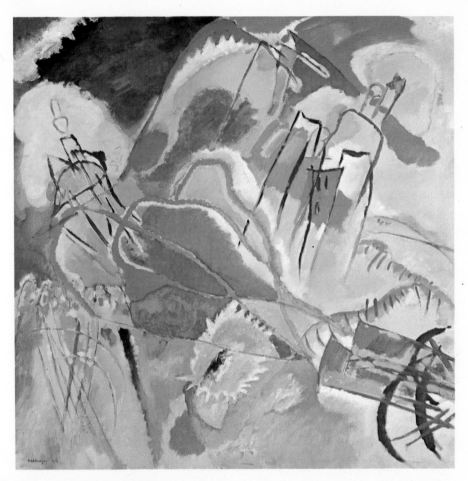

Unit 16 Plate 5 Wassily Kandinsky, *Improvisation No. 30*, 1913, oil on canvas, 43⅝ × 43⅝ ins (Courtesy of the Art Institute of Chicago).

Unit 16 Plate 6 Eugène Delacroix, *Tiger hunt*, 1854, oil on canvas, 29½ × 37 ins (Louvre, Paris).

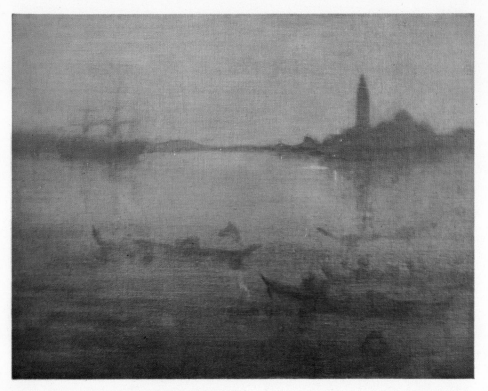

Unit 16 Plate 7 James McNeill Whistler, *The lagoon, Venice: nocturne in blue and silver*, 1879–80, oil on canvas, 20 × 25¾ ins (Museum of Fine Arts, Boston, Emily L. Ainsley Fund).

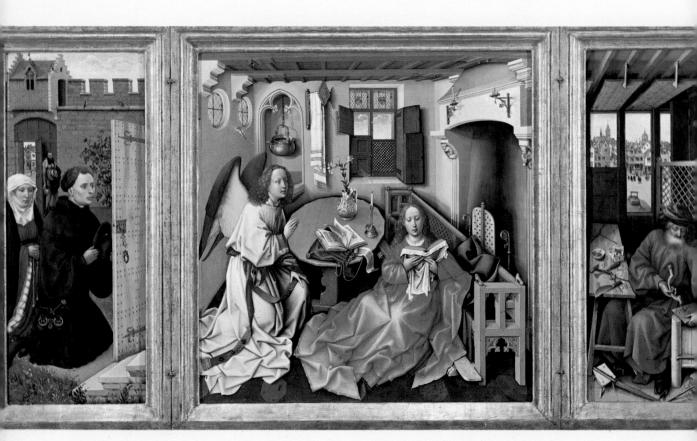

Unit 16 Plate 8 Robert Campin, *Merode altarpiece, c.* 1425–28, (Metropolitan Museum of Art, New York).

Unit 16 Plate 9 Hang Chin-pu, *A barren hill transformed into an orchard*, gouache (Colour slide supplied by the Arts Council of Great Britain).

Unit 16 Plate 10 Peter Paul Rubens, *Descent from the Cross, c.* 1611–14, Antwerp Cathedral (Courtauld Institute Galleries, London, Lee Collection).

Unit 17

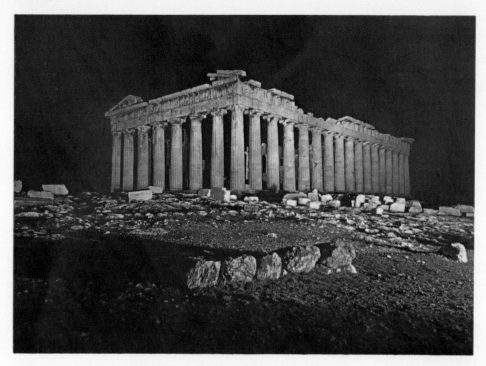

Unit 17 Technicolour postcard of the Parthenon.

Unit 18

Unit 18 Plate 1 Georges
de la Tour, *The Magdalene*,
c. 1640 (Louvre, Paris).

Unit 18 Plate 2
Jean August Dominique Ingres, *Portrait of Mme Rivière*, 1805, oil on canvas, 46¼ × 33 ins (Louvre, Paris).

Unit 18 Plate 3 Nicholas Poussin, *The funeral of Phocion, 1648 (Louvre, Paris)*.

Unit 18 Plate 4 Robert Delaunay, *Discs,* 1913 (dated on painting 1912), oil on canvas, 53 in diameter (Museum of Modern Art, New York. Mrs Simon Guggenheim Fund).

Unit 18 Plate 5 Fernand Leger, *Three women (Le Grande déjeuner)*, 1921, oil on canvas, 72¼ × 99 ins (Museum of Modern Art, New York. Mrs Simon Guggenheim Fund).

Jane Eyre Supplement

Jane Eyre Supplement Charlotte Brontë, *The bay of Glasstown,* watercolour (Reproduced by kind permission of the Rector, Rev. B. A. Ashdown, MA, of Haworth Parish Church. Photo BBC-Open University).

Printed in Great Britain by
Eyre & Spottiswoode Ltd., Grosvenor Press, Portsmouth